The SECRET LIFE of LOGOS

THE SECRET

Behind the Scenes with

HOW

LIFE OF LOGOS

Top Designers

as told to **LESLIE CABARGA**

The SECRET

11 10 09 08 07 5 4 3 2 1

Distributed in Canada by Fraser Direct, 100 Armstrong Avenue, Georgetown, ON, Canada L7G 5S4, Tel: (905) 877-4411. Distributed in the U.K. and Europe by David & Charles, Brunel House, Newton Abbot, Devon, TQ12 4PU, England, Tel: (+44) 1626 323200, Fax: (+44) 1626 323319, E-mail: postmaster@davidandcharles.co.uk. Distributed in Australia by Capricorn Link, P.O. Box 704, Windsor, NSW 2756 Australia, Tel: (02) 4577-3555.

Library of Congress Cataloging-in-Publication Data

Cabarga, Leslie, 1954-
 The secret life of logos : behind the scenes with top designers / Leslie Cabarga.
 p. cm.
 Includes index.
 ISBN-13: 978-1-58180-868-1 (hardcover : alk. paper)
 ISBN-10: 1-58180-868-2
 1. Logos (Symbols)—Design. I. Title.
 NC1002.L63C332 2007
 741.6--dc22 2006023118

Written and designed by Leslie Cabarga
Front cover logos by Ben Couvillion, courtesy of J H I
Back cover logos by Woo, courtesy of Astro Studios
Front cover Illustration by Leslie Cabarga
No graphic designers were injured during the production of this book.

fw
F+W PUBLICATIONS, INC.

LIFE of LOGOS

Acknowledgments

It hasn't been easy for my many contributors who indulged me for countless hours as I rifled through their private files and personal hard drives, interviewed their kids and spouses, crashed on their floors, ate their granola bars, and generally imposed myself upon their gracious hospitality for weeks on end just to ferret out the stories behind their logos. So my chief acknowledgment is to the designers themselves who made this book possible. Next, I want to acknowledge *HOW* managing editor Megan Patrick, for coming up with the idea and title for this book and asking me to put it together. Thanks also to the folks at HOW Books, Amy Schell, Jane Friedman, Grace Ring and Jean Privett. Additionally, Claudia Vossanine was kind enough to lend her profile to the cover. Lastly, thanks to my wife Marga, and kids Anna and Kodo, who wish there would have been less book and more papa.

About the author:
Since 1976, Leslie Cabarga has written over thirty books on design, typography, animation, illustration, and spirituality. They include *Logo, Font & Lettering Bible, Learn FontLab Fast, Designer's Guide to Color Combinations, Progressive German Graphics,* and *Talks with Trees*. As an illustrator, his work has appeared in such publications as *Time, Newsweek, Rolling Stone, Esquire* and *The New York Times*. Leslie is also the designer of such classic fonts as Magneto, Streamline, Casey, Raceway and Rocket. He lives in Los Angeles. In his spare time he enjoys writing brief autobiographical sketches in the third person.

CONTENTS

INTRODUCTION

Behind every logo is a story.

A story of tears, laughter, triumph, exultation and occasionally too, the heartbreak of rejection. If the stories behind each and every logo in creation were to be revealed, it would be … really boring. But just a few of those stories, perhaps, can be enlightening and instructive, especially to those of us who proudly hang the mantle "logomonger" upon our mantels, next to our Oscars and Golden Globes.

It was this very intention—of hanging out all the dirty laundry and hearing all the sordid stories from those who have been through the logo wringer—that motivated the book you hold in your hands. It has been said that "those who don't know history are condemned to repeat it." Our version of that might read, "those who don't know how to make good logos are condemned to make bad ones."

But securing the secrets behind the logos is a story in itself! The Freedom of Information Act was of little use here. Instead, clandestine back-alley midnight meetings, with designers who "can't talk freely" within the confines of their design studios, were a frequent occurrence. Furtive, heavily redacted faxes, with scrawled messages of "Top Secret," and "Destroy immediately," were not uncommon. And several designers who were brave enough to come forward were, sadly, whisked away in the night by the private armed operatives maintained by all large corporate clients, and haven't been heard from since. But all such "cloak and dagger," or should I say "mouse and T-square" tactics, the bugging and wiretapping and the ominous threats, could not deter me from my mission of bringing forth the truth behind logo creation, or I wouldn't receive the second half of my book advance.

Presented here are abbreviated case studies of 150 logos, running the stylistic gamut from

Most every finished project is preceded by scads of discarded concepts, and this book cover is no exception. The question is, would you have purchased this book if one of the rejected cover concepts, left, had instead adorned the cover?

8

Questions For Discussion

(A model client-brief form)

Some design firms use questionnaires to help identify their clients' needs. The questionnaire below is real and may be used as a basis for creating one of your own. Of course, I couldn't resist filling in the form myself, as a typical client might, to provide tongue-in-cheek examples of the often contradictory requests we designers receive and must unravel for our clients.

Part 1—YOUR IMAGE

Business Name: *Swiss Cheese Depot*

1. What is the essence of your business? *Swiss cheese*

What is your projected evolution? *Gouda*

What will you be in five years or twenty years?

5 yrs.: A household word; 20 yrs.: Fortune 500

2. Choose three words you want people to associate with your business when they see the new identity.

Delicious, Nutritious, Hole-some

Choose three words you *don't* want people to think of when they see the new identity.

Square, Cheesy, Stinky

3. Related to the above question, create a list of "tensions" pertaining to your business identity. For example: Venerable vs. Venturesome / Distinguished vs. Edgy / International vs. Local

Simple vs. Complex, Staple vs. Impulse, Domestic vs. Import

As a visual identity cannot communicate all aspects of your business, it is necessary to prioritize the communication goals. With that in mind, please choose two of the above characteristics that you feel most closely embody the essence of the mission of your business.

Simple, Staple

4. Of the identities you have used to date, what was problematic about them? Are any aspects of these identities still relevant?

Nephew did old logo. Cheese slice looked like moth holes.

5. Are you interested in a wordmark only (like FedEx, Braun, or Sears), or do you want a symbol as well (think Motorola or BMW)?

No opinion. Whatever you think, as long as it's what I like.

6. Are there any aspects of your business that should be de-emphasized or avoided in an identity? *Mold, Constipation, Lactose intolerance*

Part 2—YOUR AUDIENCE:

7. Describe your primary audience. Will this audience change over time?

Connoisseurs of fine Swiss cheese; mice. Change? Are you nuts? The love of Swiss cheese is forever!

8. To whom does the identity most need to appeal? Please rank from most important to least important:

Wholesalers [*2*], Retailers [*4*], Competition [*3*], Retail Customers [*1*],

9. Who is your primary competition and how do they identify themselves? (Please provide web site addresses.)

"Larry's CheeseFaire," up the street (no web site, the bum).

10. What differentiates you from your competition? In what ways are you superior, or do you provide a distinct experience? (Please describe.)

We give samples. Larry (the big cheese) is too cheap. Plus, we have punchcards: After 10th punch, a free ballpoint pen.

11. Of the samples of our work you've seen, are there any identities that you particularly like or dislike? That seem appropriate or inappropriate in tone or feel?

Loved your logo for Mikerosoft—hated your CheeseFaire one.

12. Can you name one or two identities from both inside and outside your particular field or industry that you particularly love? What do you like about them? Why do you think they're effective?

Inside: "Cheese-R-Us": Classy! Outside: "IBM": Simple, slick!

13. Any last thoughts? Anything else I should know? Any clichés or solutions that should be strenuously avoided?

Make it ultra-simple: Just show a field with a barn and herd of cows—Herefords, preferably—but make it elegant, classy, sophisticated, and edgy—but not so much to turn off my working-class customers. Think: what is the most memorable thing about Swiss cheese? Oh, and did I mention:

*Think **simple!***

Turn the page to see my final logo design, based upon careful consideration of this hypothetical client's answers, plus extensive research into the highly competitive world of retail cheese.

Here is my final logo for the fictitious Swiss Cheese Depot. The client is delirious with joy! He's even getting T-shirts and ballpoint pens printed up. **Note:** In the following pages, look for logos in the red-outlined, rounded-corner boxes, like this. These are the final, selected logos.

fun to functional, and from cool to conventional. Along the way, the fascinating details of how other designers do their work will provide valuable lessons in what to do and what *not* to do.

Every logo starts with an idea. Sometimes the idea comes as a flash of imagery that crosses our minds when a project is first described by the client. Sometimes it germinates from a comment mentioned in the client brief or from our own research. I asked lots of designers how they evolved their concepts (hoping one of them could tell me where you purchase the magic wand), but no one could quite say—or else they were holding out on me. Contributor Raúl Santos said, "That's the whole point about creativity: you don't know where the hell it's hidden, but somehow ideas come when you need them."

Fortunately, most aspects of identity creation are less elusive to describe. Although there were plenty of differences in approach between the designers I interviewed, I found the areas of consensus to be most interesting. They hint at pathways that we may follow to find success. Some examples:

• The brief. All agree that the initial accumulation of information from the client—whether by taking notes during a face-to-face interview or having them fill out a questionnaire—is our most important first step. Designer Rod Dyer says, "Within the brief is always the solution. Once you find out what they want to achieve, the answer is always there, right in front of you."

Then it's just a matter of knowing the right questions to ask. And for the swiftest resolution of the project, it becomes as important to define parameters as to refine them. Designer Michelle Suazo says, "Eventually, you get everyone to agree to mutually accepted terms. So later, nobody will say, 'I don't like green.'"

Designer John Homs says, "You really need to understand your client very thoroughly before you get started. [Logo design is] never shooting in the dark. It's just the opposite. In this business you lose money with poor project management."

• Research. Almost all the designers I spoke with began their projects by learning about their clients' businesses. This included general reading on the specific industry itself, sometimes on its history, and on the client's competitors. Where budgets allowed, the opinions of focus groups were gathered and analyzed.

• Reference. This is a branch of research, though not necessarily into the client's business. It is visual research in which we seek out a look, a style, an approach or an attitude, usually to attain a period or retro look with which we are unfamiliar; or to refresh ourselves as to what is currently popular. We may also refer to the work of other designers to understand the qualities that constitute successful design. Designer Wendy Stamberger said, "I look more for techniques and to ask myself why a certain logo looks corporate, or what makes a really good health care logo. Or, for example, why do I like this logo and dislike that one?"

While some designers reject use of visual reference, preferring only to leaf through their own mental sourcebook, others insist that doing so is limiting. Designer Paul Howalt states, "When you look beyond your own creative horizons, it pushes you down the road. If you don't do that, you're operating in a vacuum."

• Concept. Some designers are concerned mainly with the graphic style and image of a piece, while many others strive to create logos that convey deep meaning or contain some sort of visual puzzle. Such logos may make a bigger impact on the viewer, who will have to 'solve' it, consciously or not.

Designer Roland Murillo says, "Whenever I do a design for somebody, I want to feel that I achieved something unique or different. It may take someone a moment to notice [this aspect, but] it adds a dimension to the experience and to the identity."

• Objectivity. Students in yoga class learn that *savasana*, or the restorative break period, is as important as the *asana*, the posture itself. Designer Alexander Fjelldal says, "Taking breaks is as important in creative work as in physical work. It's so easy to get stuck in a creative cul-de-sac and to grow tired of a project. By doing anything else for a period of time, your ideas mature and develop in the back of your head." Then, when you go back to the task, you seem to face it with renewed enthusiasm, insight and objectivity.

• Expertise. Some designers seem to view themselves as contractors, taking orders and trying to execute them according to the client's wishes—be they silly or sensible. They don't bother advising on design matters because most clients think money is wisdom. But other designers take control of the process and seek to build long-term relationships. They position themselves as experts, like lawyers or accountants, whose job it is to guide clients toward more effective solutions. It's great when it works out as designer Tyson Mangelsdorf describes, " … I focused on the client's vision of the marketplace, and he relied on my design expertise."

• Presentations. How many designs we present to a client varies widely. Some designers limit their client presentations to very few designs—usually selecting only the ones they personally love. Others show a wide variety of designs because it can be hard to gauge a client's taste. As designer Claudia Renzi says, "I will usually try to do some typographical, some abstract, some symbolic, and then a combination of these different approaches." Sometimes we keep going just because it's fun.

• Sketching. Some designers sketch on napkins, some in sketchbooks. And sometimes the free-association nature of sketchbook sketches can produce concepts applicable to future projects. Other designers figure they can sketch just as well on the computer as on paper. Designer Rian Hughes says, "Often there are no preliminary thumbnails at all. A lot of what I draw I see in my mental eye quite clearly."

• Celebration. When the job is finally finished and approved, 31 percent of designers celebrate by drinking beer—but only those quasi-classy beers like Guinness or Heinekin, because after all, we're designers! Then 12 percent of us

turn to the heady rush of chocolate, and 22 percent just catch up on sleep. The remaining 35 percent can't celebrate because we must start on the next logo job.

When a client contacts us for a logo, most often he or she has only the slightest notion of what the end result might become. Through our research and attempts to interpret the brief we strive to create that "one" absolute mark. But, given the same assignment, one hundred other designers would evolve one hundred other solutions, few of which would resemble another. Though we may endlessly conjecture as to what makes a logo "good" or "bad"—factoring in ephemeral tastes in design, typography, and concepts that seem mind-bogglingly clever—in the end, the ultimate arbiter of logo greatness may only be the satisfied, paying client.

Thanks to all the designers contributing to this book who were unafraid to air their dirty laundry in the form of early sketches and comps, many of which were never even seen by their clients—until now. As we look at these preliminary designs, we may gasp at the rejected gems, but it's often readily apparent why certain designs weren't chosen—they stunk. The secret moral to this story, therefore, is to work hard, but not be too hard on your first concepts. As Thomas Edison said, "When everything is tried and discarded, then what remains must be the right solution." This is why we've dealt so extensively here with the secret lives of logos. The process itself is the key to ultimate success.

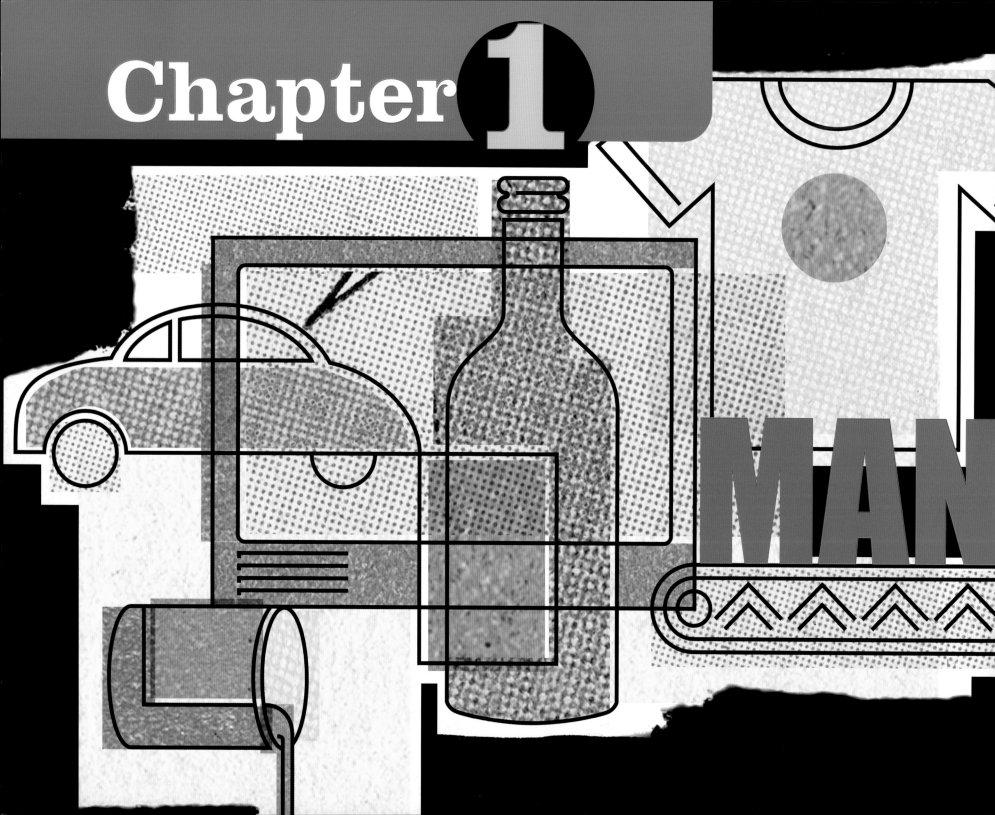

Chapter 1

What factors differentiate logo design for a manufacturing firm from that for a firm marketing intangibles, such as insurance services? What we find in general is strong design mirroring the tangible quality of the product and logos of a more representational nature—since there is something solid to portray—unless the designer chooses to go entirely abstract. In product coverage, we run the gamut from heavy industrial products, such as the aerospace lubricant Multan, to the sugarless snack, Planet Krunch. And stylistically, we go from the wispy sketchiness of Coexis Project© to the geometrical solidity of Python Tools.

UFACTURING

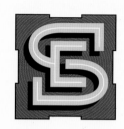

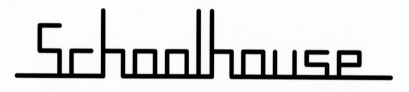

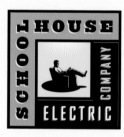

Paul Mort
Designer

**Don Rood
Nicole Misiti**
Creative Directors

The Felt Hat
Agency

Schoolhouse Electric
Client

Casting old lights in a new light was the task faced by Portland, Oregon agency The Felt Hat when it took on identity-creation for Schoolhouse Electric, a retailer specializing in antique reproduction lighting fixtures—from original molds.

Paul Mort, who designed this logo, says, "We consider ourselves a research-based firm, so we looked into things such as competition, and finally about American industrial design. We go into pretty standard kinds of inquiry: what motivates the client; why is he in the business? Values? Goals? Why does he bother to get up in the morning every day?

"But after all the thinking and reading, you just start. My background is in illustration, so I tend to think graphically, and I can play with an idea, going back and forth. It was lots of fun drawing the man in the chair and working out

the shading. But eventually we arrived at the insignia look, based upon classic lamp shapes from that period.

"For the lettering of the final, I initially chose some typefaces from that era, but they didn't have as much character as I wanted. So I drew the word 'Electric' by hand, and the word 'Schoolhouse' was set in Agency Bold, which I then modified with special serifs, an outline and a drop shadow.

"In this case, it took the client a while to get excited. Color was interesting. He really liked a certain palette and brought some things in like old products and labels. It was a very personal thing for him, and we worked hard to try to appeal to his taste."

Mort's design for the Schoolhouse Electric logo authentically evokes the 1920s, yet with its contemporary flair, no one would mistake the company for being outdated.

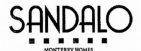
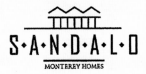
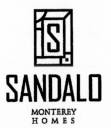
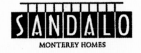

a

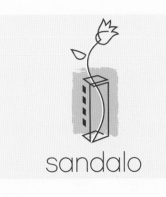

b

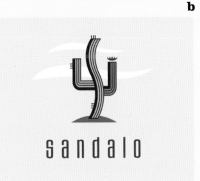

d

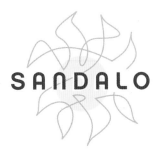

c

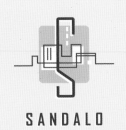

e

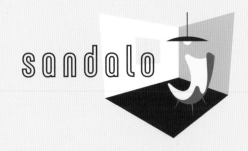

Paul Howalt
Designer

Paul Howalt / Cam Stewart
Creative Directors

Tactix Creative
Design Studio

Monterey Homes
Client

"It's tough to work for conservative clients. There are so many visuals that need to be retired, and the clients tend to want them," designer Paul Howalt laments. "I hope I never have to draw another palm tree or cactus. Or crests, wings, sunbursts and swooshes, either. This client would have loved a sunburst with a crest and crown on top of it with a banner going across. They don't want to show things people haven't seen before—somewhat understandably—so it's an effort to sell something out-of-the-box."

Having frequently worked with Monterey Homes, the developer of Sandalo, an ultra-modern condominium complex located in Phoenix, Arizona, Howalt knew that the company tended to be conservative, so he presented some very dry comps [**a**], but then became inspired to push past the client's usual boundaries [**b** through **e**].

"Rather than being conceptual, many of our logos for this client end up simply decorative—that's the direction they tend to choose," Howalt says. "We then presented a lot of very stylish, 'moderne' concepts to them and naturally, the most conceptual directions did not get picked. For example, I personally liked the saguaro cactus as an *S,* and I also liked the linear flower in the vase that's actually a building.

"But I am very happy with the final choice. Originally, I had a sculpture of an *S* on a pedestal in the room, but it looked too stinkin' busy, so I deleted it before I showed it."

So how did Howalt get this very unusual and highly avant-garde logo approved by his conservative client?

He says, "They showed this logo around to the younger people in their office, and they really responded positively, and that sold it."

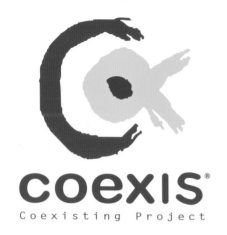

coexis®
Coexisting Project

Tobin Dorn
Designer

Isabella Dorn
Art Director

New Level Design
Design Studio

YD Confeções
Client

The Now logo and icons associated with the brand follow through in the same handmade style.

16

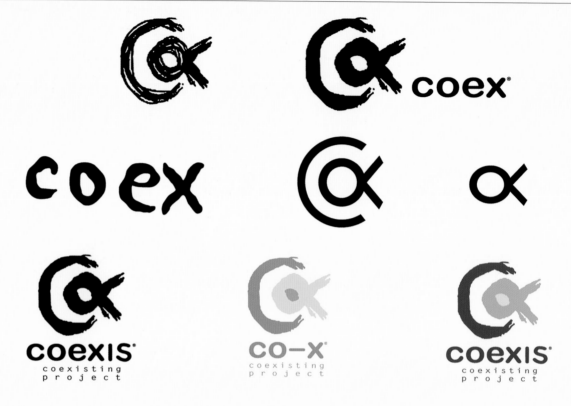

Hyping the concept of "all-natural" is a popular approach these days, but the Coexis Project,© designed by Tobin Dorn for YD Confeções in São Paulo, Brazil, takes the idea to new levels. For the past twenty years, this company that owns and operates jeans factories has developed natural pigments and dyes from the Amazon, plus organic cotton, recycled denim, and a purified water treatment system. They have also set up and taught communities of Brazilians how to use these processes, enabling them to have jobs and the means to boost the economy.

Dorn says, "I always start logos and icons on paper and use pencil or pen to quickly generate my ideas. Most of the time, the logos are then scanned into the computer to be vectorized. In this case, we actually decided to keep the hand-drawn look as it really related to the concept of the

Coexis Project©. Natural and handmade objects are a great part of the culture and really show off natural and artistic talents. The style of the icon was to look like indigenous hand-drawn symbols that can be found in the Amazon.

"For the icon, I decided to use elements representing a fish, water and the forests and jungles of Brazil. The fish looks like an *O* and an *X*, while still looking like a fish. So this worked out great, as I encircled the fish with a large *C* image in green. The splash of blue added the concept of Brazil as these three colors are from the flag. The final icon is quite simple, and all of its elements 'coexist.'"

The Coexis Project© is also said to imply that this vital interaction with nature is an ongoing project without start or finish. Other icons designed to go with this group [sidebar] also show this hand-drawn and natural style.

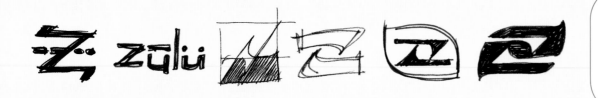

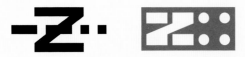

Woo
Designer / Creative Director

Astro Studios
Agency

Zuluworks
Client

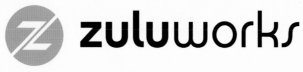

Pilots refer to Greenwich Mean time as Zulu time, which is the military time reference system for all of the time zones around the globe. As to the genesis of the term *Zuluworks*, company principal Jordan Reiss explains, "I connected that term 'Zulu time' with how I felt on my first private pilot lesson; it was like being lost in a jungle of new terms, instruments, controls … Thus our tag line: 'It's a jungle up there.'"

To aid in sorting out that jungle, Zuluworks makes specialty products such as flight bags and flight pads for pilots.

As for the logo, Woo, of Astro Studios, began his process with many pages of neatly-drawn pen sketches [top row] and went on to produce dozens more vector versions in Adobe Illustrator. Woo says, "In my early sketches, I kind of wanted to work Morse code for letter *Z*—two dashes, two

dots—into the logo, but it ended up looking too forced and made you want to pronounce it in Swedish or something.

"Then I wanted to create an icon that represented flight, and through the process, I discovered that I could get two arrows worked into the *Z*, symbolizing taking off and landing. I also made some attempts to indicate airplane wings."

"The color green was a prerequisite relating to an earlier logo of the client's and to the tagline, so they wanted to stick with it. We tried different shades of green and the chosen one—a middle-value green—worked well against both light and dark backgrounds."

I wish there was space to show more of Woo's sketches and comps, to demonstrate the progression of one idea leading to another, then to the final version, a logo whose design insinuates taste and high-quality manufacturing.

17

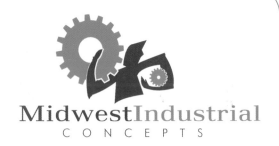

Hilary Clements
Designer

Angela Neal
Creative Director

Snap Creative
Design Studio

Midwest Industrial
Client

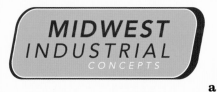

a

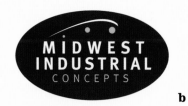

b

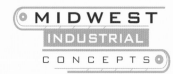

c

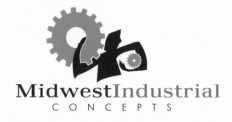

d

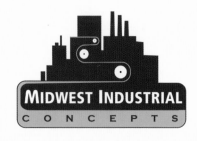

e

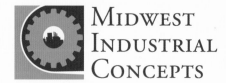

f

Conveying the meaning behind a generic name like Midwest Industrial Concepts was the task set before Snap Creative, the St. Charles, Missouri, design firm. The client is a manufacturer and installer of conveyor belts. They wanted to stand out in the marketplace, but with such a generic name, they'd need a dynamite-looking logo.

"Right off the belt, however, they badly needed a visual identity that would inform their potential customers what the company actually does," says designer Hilary Clements. "I thought maybe I could play off the idea that a conveyor really just takes something from point A to point B. But that was way too abstract. Sometimes you just have to chuck 'conceptual' because it's not going to work."

Gearing up for the task, Clements "littered my desk with every photo of actual conveyors I could find—thanks to Google's image search! I debated how to simplify the image but not lose recognition. I tried a retro twist [**a**], then abstraction [**b**, **c**]. Do I crop? Show a piece [**d**], a part? But during our critique, all the options still looked boring. Sure, I'd shown the company's purpose, but there was no personality."

Moving right along, Clements decided to "make it mean something by adding a story, such as a conveyor snaking through an industrial skyline [**e**] to highlight the importance of the company's relationship to the factories they service. I also presented a strongman silhouette holding two cogs [**f**], brimming with a trustworthy 'we-can-do-it-all' attitude."

As these logos rolled off the line, the client got it and identifed with the human element in the second option. They also loved the green and gray, which still felt industrial but also somehow fresh and new.

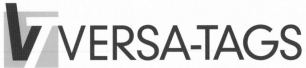

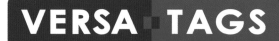

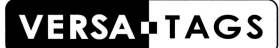

VERSA-**TAGS**

Sarah Gries
Designer

Angela Neal
Creative Director

Snap Creative
Design Studio

Versa-Tags
Client

As a major player in the vinyl products market, Versa-Tags believed that creating a new, strong and versatile image would further differentiate them from the primarily mom-and-pop shops competing in their market.

Their old logo was a complex, 4-color job replete with color gradations and drop shadows, and they realized they needed something more simplistic. From the beginning, anything representing an actual tag—which would have been similar to the original logo—was outlawed.

"With this in mind," designer Sarah Gries says, "a more conceptual approach became necessary. The client also suggested a 'strong, masculine presence,' as well as the possibility of implied motion. To spark our creativity, the client even suggested we try to mimic auto makers and their automobile logos.

"Another thing they suggested was a separate mark—as opposed to a logo-plus-graphic—that could stand on its own. We began to explore slanting and aggressive Vs and Ts; however another company in a similar business already had legal claim to many V–T variations, so for legal reasons, we decided to steer clear of this direction.

"Before abandoning it completely, however, we did explore a variety of VT combinations, all utilizing strong colors and italicization for the feeling of motion."

In the end, however, a most corporate-looking logo won out. With the name VERSA-TAGS completely enclosed, a positive/negative interplay has been achieved that fulcrums on a split hyphen to create the clean, simple mark the client was looking for. A black and white version is also shown that highlights the logo's versatility.

19

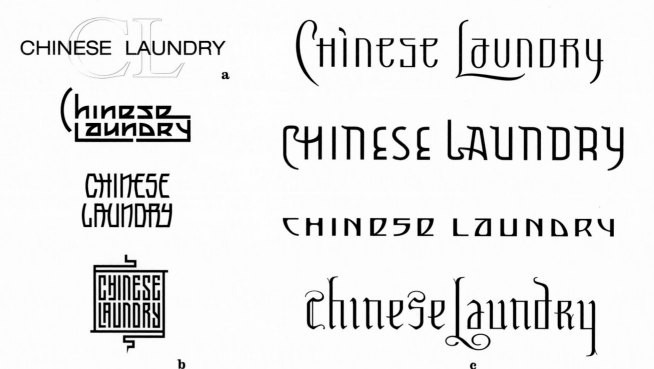

This attractive border design is used in connection with the logo on packaging and website.

A well-heeled client gave Chase Design Group an opportunity to spread their wings in a massive campaign that involved many related brands and over a year's effort.

As Margo Chase describes the process, "We were hired to develop a strong coherent strategy for the brand, followed by a new identity. Chinese Laundry is known for reasonably priced, fashion-forward, sexy, often high-heeled shoes.

"The original Chinese Laundry logo is a non-proprietary font that was a knock-off of the Calvin Klein CK logo [**a**]. Not only was it derivative, it wasn't sexy or feminine, either. Our goal was to create a new identity that would elevate the brand, give the client a memorable icon, and ultimately look as sexy and fashionable as the shoes themselves.

"We spent quite a bit of time doing research, interviewing sales people, buyers and customers to determine what wasn't working about their current branding and to discover how much equity, if any, existed. We did persona studies, mood boards and other strategic work to identify the right look and feel for the new brand before we started design.

"Chinese Laundry was the only brand name with any equity, but the Chinese allusion was touchy—it can suggest old-world quality workmanship, or be a racial slur—so we avoided straight Chinese style and opted for a more exotic feminine look that can't be placed ethnically.

"The logo went through a few early internal phases that were never presented [three examples, **b**] We thought they were too ethnic and masculine for the sexy and feminine target we had identified. We presented the client with quite a few different 'sexy and feminine' ideas in the first round [column **c**]. After seeing some early production tests of

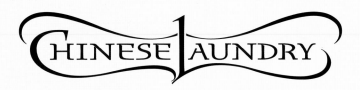

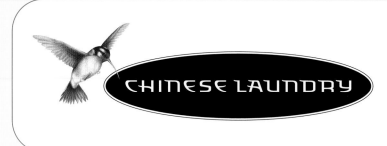

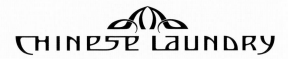

CHINESE ✦ LAUNDRY

CHINESE LAUNDRY

CHINESE ❋ LAUNDRY

d

**Maria Gaviria / Amy Tsui
Tatiana Redin / Margo Chase**
Designers

Margo Chase
Creative Director

Chase Design Group
Design Studio

Chinese Laundry, Inc.
Client

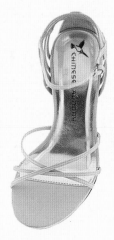

The logo was tested inside the shoes themselves to be sure that it would hold up in reproduction.

logos applied to the shoe liner (called 'the sock'), we realized that simpler, bolder lettering without too much detail would work best. The second round [**d**] reflects a simplification of the letterforms as well as first ideas for icons. We went through many refinements before settling on the final logotype. Much of the work we presented was custom lettered and finished on the computer by the talented designers on our staff. In this case, the logotype that was eventually chosen was lettered by me, but it was a group effort."

The extravagant floral motif that adorns shoeboxes and web site [sidebar, opposite page] was illustrated in-house by Maria Gaviria using a combination of watercolor backgrounds and Illustrator drawings that were collaged in Adobe Photoshop. Gaviria also created the hummingbird by hand, with colored pencil, watercolor and ink.

Chase says, "A hummingbird appeared, almost incidentally, in one of our early designs and the client fell in love with it. We were at first a little hesitant to use it as the brand icon since we weren't sure it would hold up on the sock. As you can see, the hummingbird worked out great [sidebar].

"This description is a super-simplification of a very involved process that took several months and now includes a four-logo system linked by consistent letterforms and the hummingbird icon. The style guide for the Chinese Laundry brand family is one of the most complex we've ever done."

The client launched the first two rebrands at the WSA shoe show in February with great success. Even before its retail debut in fall 2006, the new look has generated lots of positive buzz. But, of course! With Chase Design Group on the job, any company is a shoe-in for success.

21

gorenje

a

b

c

gorenje

The Gorenje logo, before ... *and after* the logo competition. The company decided to keep its original logo as it was.

Competition is good if it doesn't kill initiative through comparing yourself with others. Competitions are good—if you win. And they may still be helpful if you don't. Slovenian designer Jelena Drobac's competition entry for Gorenje, a Slovenian manufacturer of household appliances, was not chosen, which is a shame, because it's really nice.

Drobac says, "Loosely translated, gorenje means *to burn, work, fire*. The company organized an invitation-only visual identity contest for redesign of their logo and the best proposals were exhibited in Ljubljana.

"From the start I had an idea just to create some new letters and perhaps a small symbol to go with it. My first attempt [**a**] utilized thinner, but somewhat similar letters to the original Gorenje logo [shown at left] along with some stylized flames. I then rounded up the letterforms [**b**] and moved the flame symbol above the *j*. In [**c**] the logo is falling together: I've opened the gaps in the letter *e* and completely rounded the *g* to make it more unique.

"In the final logo I rounded and lowered *j* to make the flames fit naturally. And I changed the color to make it friendlier and more up-to-date. What I like about this logo is the repetition of circles and letter shapes—they just flow."

"As I think about a logo or trademark that I am working on, I have several questions that I always ask myself, such as: Is this going to look dated five years from now? Will this be understood in another country—Japan, for example? Will someone who doesn't speak my language understand what kind of product this company produces?"

Personally, I'd have picked Drobac's design. But, eventually Gorenje decided to stay with their original logo.

Jelena Drobac
Designer
Gorenje
Client

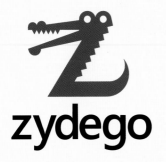
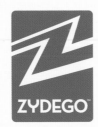
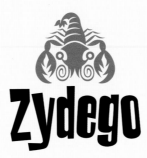
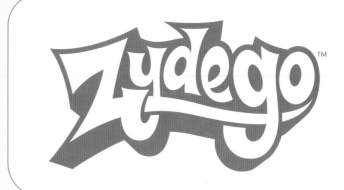

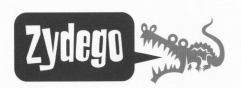
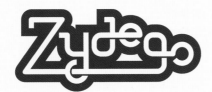

Von R. Glitschka
Designer/ Creative Director

Glitschka Studios
Design Studio

Zydego
Client

Zydego is a start-up collectible toy company from Louisiana whose name was derived from the Zydeco music genre and the word "go," which indicates motion and also signifies a "product on the go." The company wanted a logo to market their new type of dashboard hula girl, which uses their own signature motion.

"The client stressed that he wanted to see a washboard worked into one of the designs presented," says Von Glitschka. "Personally, I thought that customers might assume it's a music-related company. The client also wanted to give a nod to the 1970s, the era of the original dashboard hula girl.

"So my creative gumbo included: Cajun genre, washboard, Louisiana Gulf Coast, fun, and product-on-the-go.

"I have to admit I envisioned and even doodled out an Elvis alligator [sidebar], but then refocused my attention and continued working on other approaches. Included in the mix were a few hand-lettered treatments, one of which ended up being the final logo picked for use.

"During our meetings, as often happens, the client tried to 'Frankenstein' his washboard idea onto the logotype he selected. I talked him out of that. Collecting graphic parts from different designs to make one new option is never good design. You end up with a design solution worthy of a mob carrying torches and pitch forks."

Both client and designer are happy with the final logo, which captures a 1970s vibe without being too retro. The fun of the word itself is reflected in the custom letterforms, and the color is an appropriate Cajun orange.

"And if you know anyone who might need a funky hip alligator," Glitschka says, "tell them to give me a call."

Were you the client, might this have been your logo choice? Hmmm.

23

Brian Zick
Designer
REO
Client

a b c

REO makes flat screen displays for advertising; a kind of cross between print and TV. With a couple of these babies in your supermarket, for example, you can quickly swap out or update your video or Flash animation to make instant changes to your signage.

When Zick first saw the unit, he envisioned creating a gallery art exhibit featuring his Flash artwork as a movable feast for the eyes. So he suggested a trade: He'd design a logo in exchange for a screen. Goods for services is a great option for designers, especially if a fair trade turns a guy who might be reluctant to pay for a logo into a client.

The offer was accepted. "I did two rounds of logo comps in various styles [columns **a**–**d**]," Zick said, "but I couldn't get a sense of how the client was leaning.

"The client suggested overlapped letters or ligatures, and

after solving the technical issues, I found I didn't like the result [columns **e** and **f**]. Time passed and then he showed me some ideas he'd worked up using a mix of elements I had done. So I said, 'You need to have consistency, so let's choose one letterform but apply it in different ways.

"So it took going through all of those versions to get from point A to Z. I utilized the final logo in its basic form and embedded it into 'orbs' with graphic illustrations [sidebar, opposite page], each reflecting a different division of the company."

Zick offered us this hot "tip," passed down from one of his art school instructors who once had worked with Raymond Loewy, the famed industrial designer. As Zick recalls the story, "Loewy went to meet with the President of the Lucky Strike cigarette company and his board of directors in

d

e

f

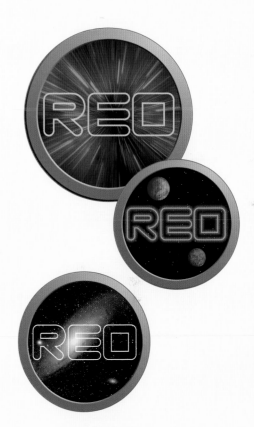

their huge, panelled meeting room. After he had presented many different logo comps, Loewy turned to the president and asked 'Which one do you like best?' Now this important man was put on the spot and had to make a decision. He picked one and Loewy exclaimed, 'That's *my* favorite, too!' And the logo was sold!"

But that's not the end of the story, Zick tells us, "Years ago, I was working with illustrator and designer Dave Willardson on a logo for a radio station. We went down to meet the client in this little teeny office. I laid the comps out flat on the guy's desk and asked him, 'Which one do you like best?' He pointed to one that I thought was in fact my favorite (it was hard to see in that tiny room), and Willardson thought, 'Oh, Brian's pulling that Loewy trick.'

"Then I realized the guy had pointed to a different logo,

and I started to say, 'Oh well, that's good, too but … ' and Willardson kicked me under the table. So I shut up and the deal was made."

I asked Zick whether the moral of the story is that a client can be manipulated into accepting almost any logo.

"Not at all," he says. "Usually the client is calling the shots. With REO, for example, my role was first to try to decipher what was in his mind and second, to guide him toward what I felt was the wisest choice.

"Logo selection gets down to a real personal, subjective notion of what works and what doesn't, and what will do, even though something else might be better. I'll always try to do what the client asks of me, and I'm always happy to cash a check, but if I hate the outcome, I certainly don't show that work to anybody."

Brian Zick's illustration experience was called into play in the creation of these REO orbs containing the final logo.

Chris Parks
Designer

Up Design Bureau
Design Studio

Python Tools
Client

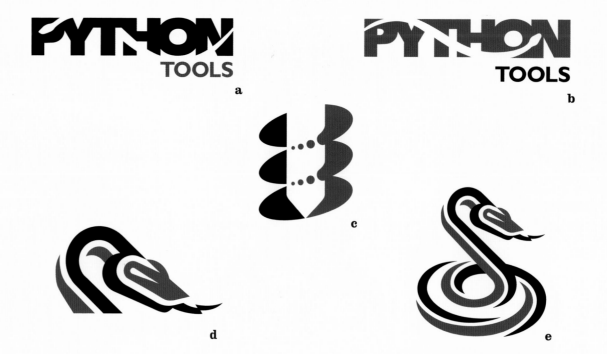

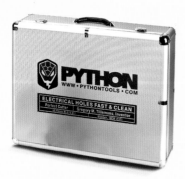

You can trust the electrician who carries a spiffy case like this.

26

Sometimes there is no getting around clients who won't budge on what they want. When Python Tools asked Chris Parks to develop an identity for their new product aimed at the construction and electrical trades, they were adamant in wanting to include a snake visual.

"I broke it down into three areas I wanted to explore," Parks says. "A type-only solution, a simplified corporate symbol direction, and a boiled-down, yet very literal direction. The client had an existing logotype and had asked for it to be simplified, so that helped me quickly blow through the first direction [**a, b**].

"In the second group, I briefly played with a visual that related to the router and spinning bits [**c**]. But again, they had it in their head it was going to be a snake.

"For the third direction, I turned to the tool itself, which was basically a router attached to a vacuum. I played with the similarity of the vacuum hoses to the coiling up of a snake [**d, e**]. Wanting some detail relating to the electrical trade, I threw in a little lightning bolt tongue action. I knew the client would be cool with this, because they were very literal, but I felt I could still get it boiled down even more (and these seemed a bit soft for the 'manly' tool trade).

"I was starting to like just the head of the snake in my third group, when I started looking at snake scale shapes and how they might relate to the tool. Then I worked the simplified geometric scales into the symbol to relate to the various geometric templates used by the tool to cut out holes, and built a symbol with a more head-on view."

The final logo has a powerful wordmark plus machismo, electricity, and tongue action … and it's drawn to scale!

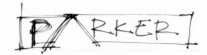

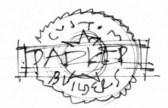

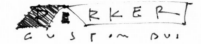

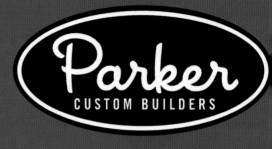

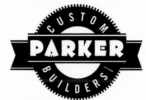

Bob Delevante
Designer

Relay Station
Design Studio

Parker Custom Builders
Client

Many a client expects to get his logo for a song. Nashville designer Bob Delevante, also a professional musician and photographer, can provide both.

For Parker Custom Builders, a company that makes environmentally conscious though not necessarily 'contemporary' homes, Delevante tried to create "…something that looked like a stamp that could be burned into wood; something that looked like they'd been around a long time. I love the old logos that tend to look really powerful and classic-looking logos that you can't tell whether they were designed this year or fifty years ago.

"In approaching the design, the words that came to mind were 'custom' and 'fine', as in fine furniture, and 'strength'. These were the ideas I was trying to get in there. I liked the final choice, but I also like the Parker in the white oval with the little roof. My least favorite was the seal that went too far in the old direction and looked like a seal of approval.

"I spend a lot of time experimenting when doing a logo. You gotta get all that stuff out first, the stuff you're not going to use. So I chase a little further on a few concepts that I'm dubious about, but you have to go that route to find out if it's going to work or not. And by disproving one route, it seems to validate the other one."

Many of us who do art also seem to make music. I asked Delevante if there is a connection. "They're both creative processes," he says, "that come and go in my life and career. When I did a record for Capitol a few years back, my design and photography took a back seat. They complement each other, too. If I can't get somewhere with a song, maybe I can achieve that same satisfaction from a photograph."

27

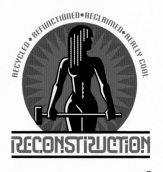

RECONSTRUCTION

Leslie Cabarga
Designer

Reconstruction
Client

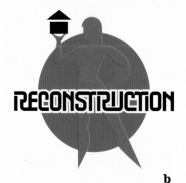

a

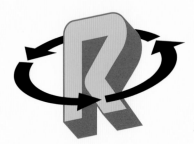

b

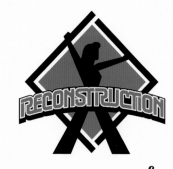

c

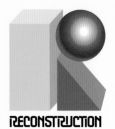

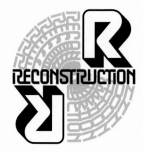

I just ate a persimmon, the weirdest persimmon ever. I could feel my mouth drying up like some alien creature in a sci-fi flick, bent on conquering earth designers, was sucking all the moisture out of their bodies. I still feel a little tinglingly dehydrated, and if I don't make it through the rest of this description, please alert somebody!

The design of this logo, for a company that recycles old furniture in novel ways, started out as so many do: You provide all these great, interesting ideas, and in the end, all they want is something simple and boring. It's like clients are persimmons who suck all the moisture out of your designs, leaving you sort of puckered and gasping.

I really loved the logo, [a], with the strong, Art Deco image of a woman holding a sledge hammer. But the client objected to being portrayed naked, which, OK, I can under-

stand. She didn't care for any of the other female-figured logos [b, c], either. And perhaps that made sense, too. In this day and age, the fact that a woman owns the company is, thankfully, no longer so exceptional.

But now, what was I supposed to grab onto for imagery? I played with the initial R, which is always a fallback idea, and used the recycling arrows motif and the spinning initials idea, plus some drop shadows—all highly-guarded type tricks designers have to procure on the black market.

And eventually, by chipping away everything sort of fun, we ended up with the final logo at upper left, which is really not so bad after all. So you kind of get to the point where you begrudgingly accept that sometimes clients may have a better perception of their needs than you do. But do they ever warn you never to eat *unripe* persimmons?

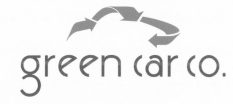

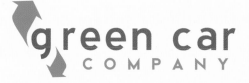

Noah Bell
Designer

Sara Pickering
Art Director

Design Elements, Inc.
Design Studio

Green Car Company
Client

When is a bug not a bug? When it's a green car.
Introducing the Green Car Company [applause], based in Kirkland, Washington, that specializes in the sale and service of alternative fuel and high efficiency vehicles.

Now enter our protagonist, Design Elements, Inc., a Seattle, Washington design shop. The company spokesperson, Noah Bell, announces, "When the Green Car Company approached us for a logo, they were a working business *with no current or prior branding*" [Audience: boo, hiss].

"They wanted their logo to portray their company as professional, clean, eco-friendly and modern," Bell continues. "They needed a timeless icon that would remain viable through the rapid evolution of alternative-fuel vehicles.

"One of the GCC's featured 'makes' is the VW bug, a powerful icon in our culture and in the automotive industry, and for this reason, the GCC wanted its image loosely tied to that of Volkswagen, while at the same time maintaining an independent identity."

The challenge with this request, however, [tension mounts] was to pull inspiration from the VW bug's aesthetic and design without infringing on its existing brand. A large part of the final back-and-forth between the designer and the client dealt with simplifying and altering the shape of the VW bug so that it was still recognizable, yet unique to the Green Car Company.

The GCC's final selected logo is a strong icon with a fresh, modern aesthetic. It has an environmentally-conscious feel but is not too literal. As the GCC's products evolve over the years, the simplicity of the logo will hopefully stand the test of time [happy ending; applause, tears].

29

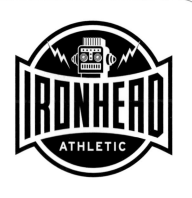

Tim Frame
Designer

Tim Frame Design
Design Studio

Ironhead Athletic
Client

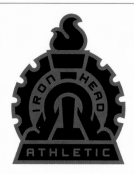
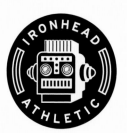
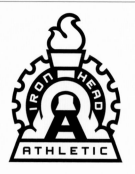

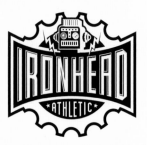
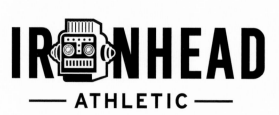
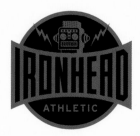

"Total creative freedom and all the time I needed." That's how Tim Frame described this "dream client," Ironhead Athletic, a manufacturer of hip athletic wear.

"It wasn't a typical job," Frame says, "because there was no real deadline. It took me a really long time to actually get to the work, and I kept contacting them and apologizing for not having done anything after significant periods of time had passed. They had seen some of my work in a publication and really liked it, so they kept telling me they still wanted me to design it and I could take as much time as I needed."

I asked about the client's requirements for this logo.

"Again, this is a little unusual for a logo project, but there were really no requirements other than to come up with something different. They were just looking for something that was consistent with the quality and style of my work."

And just how does one define that style? Tim Frame has made his mark making marks with boldly outlined, strongly iconic designs with simple, appealing imagery that utilizes a dynamic and well-balanced interplay of negative/positive fills and thick/thin strokes.

Of course, Frame himself defines his approach to the Ironhead logo much more pragmatically. "The main thing was to come up with something unique that had a very masculine and industrial feel," he says, "so I started thinking of things that were made of iron or metal that might lend themselves to imagery I could incorporate. Naturally, the idea of using a robot came to mind."

The final logo will look great on sportswear. I love the nod to Everlast in the double-bowed Ironhead lettering.

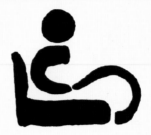

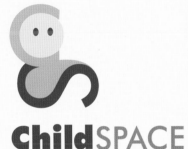

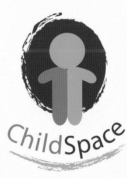

Carol King
Designer
ChildSpace
Client

ChildSpace is a children's furniture company that manufactures clean, modern, and well-designed children's furniture products. So it was only natural that they'd require a clean, modern, and well-designed logo. Enter Manhattan-based designer Carol King.

"I immediately envisioned a logo," King says, "that contained a graphic of what the company does—such as the child and the furniture—that could also be combined with the initials of the company. I did a lot of pencil and marker sketches playing around with the letters *C* and *S*, and kept working at it until I got the kind of symbol I wanted. Fortunately, it was one of those cases where the client let me run with my idea and truly develop it without much interference."

I asked King if her use of contrasting font weights was purely decorative, or if form in any way followed function.

"I chose to differentiate the bold font of *Child* from the thinner *Space* because the chunkier weight of the Futura Bold font had a more childlike element, and it contrasted nicely with the thinner weight of Futura Medium used for the word *Space*. I love simple type treatments, the use of bright and powerful color, and creating dual imagery, such as I used for this logo."

So why, I asked, did you do the other, different versions?

"Even though, as I said, my first concept was creating an interaction between *C* and *S*, in *ChildSpace* I played with a few additional concepts, such as the toy block and the standing child, for variation and as back-up ideas, you know, in case the client wasn't keen on my own preferred solution."

31

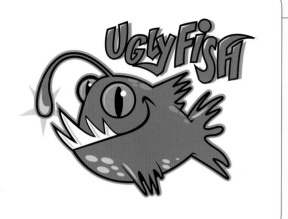

**Justin Peterson,
Greg Mortenson**
Designers

LogoWorks
Design Studio

Ugly Fish
Client

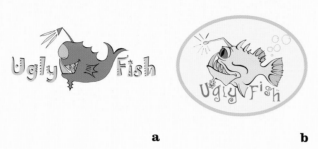

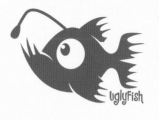

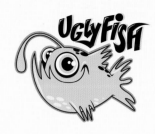

a b c

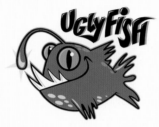

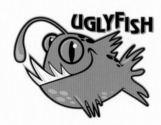

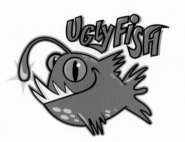

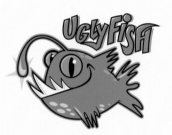

"A pukey green that little boys can relate to," was the edict from the client, Ugly Fish, a start-up making children's clothing for little boys. And as the saying goes, the customer is always right!

According to Justin Peterson, a staff designer with the online logo-creation firm, LogoWorks, "The client had an image already that they wanted to update or get new ideas for. They asked if we could provide something different based on a type of fish called the angler fish. I did some research, looked around to see what it looked like, and came up with the two concepts that I did.

"I thought about what my own kids would relate to, and I came up with the cartoon fish. One of the things I submitted was a flat-color icon [**c**] because the client had said they wanted to embroider the logo. But the client chose to go in

a more complex direction. Personally, I think parents would have preferred the flat icon.

"At LogoWorks, several of us may be working at the same time on designs for the same job. I was sitting next to Greg Mortenson [**a**, **b**] and it's nice because you see what the other is doing; it inspires you to push yourself a little more. And it's great to be able to step back and ask another designer, 'Hey, what do you think of this?'

"I actually sketched out, scanned, and traced the fish I drew, and mine was the design the client chose. I like to do my own illustrations whenever possible to avoid searching for an image that might end up looking clip-artish."

I asked Peterson to define "clip-artish."

"Something that is clearly plugged in," he answered, "that has no relationship to the style of the other icons or fonts."

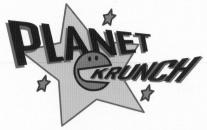

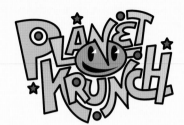

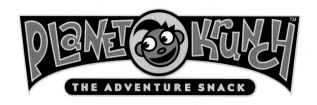

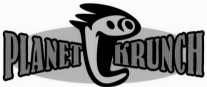

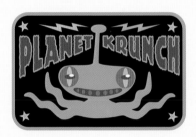

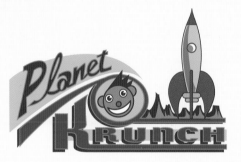

Mark Fisher
Designer

Bruce Crocker,
Creative Director

Crocker Inc.
Design Studio

Bob Krinsky
Client

When Bob Krinsky wanted a sugarless snack for kids, he created Planet Krunch then contacted Crocker, Inc. to help create an identity and packaging that would be whimsical, fun and have plenty of kid appeal. Bruce Crocker brought in artist Mark Fisher.

"Initially," says Fisher, "they weren't sure if the central character should be a kid or a 'kreature.' The packaging and point of purchase displays were to have whimsical machines and animals in a cosmic environment—right up my alley!"

Many of the objects Fisher draws have a retro aesthetic, "when machines looked like machines," he says. The influences of comic books and sci-fi in his work are also evident.

"Starting a job, the first thing I do is sketch without any reference, relying on my initial instincts. After a direction evolves, I start to seek printed references like old books with inspiring images. Often times I find that my earliest ideas are the ones I'm most excited by. Overly researching a job can take away from the personal feel of a piece."

Rather than present digitally rendered ideas, Fisher prefers to show pen sketches, waiting until the client chooses a direction before he proceeds to computer. "For example, recently I did some lettering," Fisher says, "and developed it to a high degree on the computer—too early in the process. The client kept asking for changes in scale and ratio, so of course I had to rework line weights and letter spacing, and it drove me crazy. It taught me not to overrender roughs."

Unfortunately, the grand vision of Planet Krunch, the healthy alternative snack, fizzled—not unlike the planet Krypton. Why? The logo itself was a resounding success, but as Fisher tells it, "The public demanded sugar!"

Here are just a few of the fun alternate heads Fisher created for the final product.

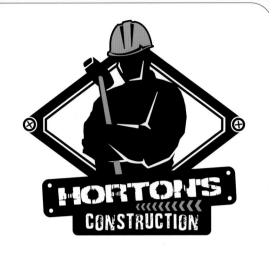

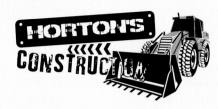

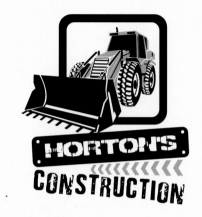

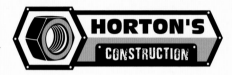

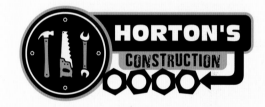

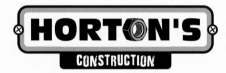

Jeremy Bohner
Designer/Illustrator

Tim Ellis
President/Creative Director

Inertia Graphics
Design Studio

Horton's Construction
Client

We must attract jobs by any means necessary. In addition to other methods, the staff of Inertia Graphics in Hagerstown, Maryland, finds local bulletin boards useful.

"We have an attractive single-fold business card that we put up anywhere we go," says staff designer Jeremy Bohner, "and this contractor saw our card, pulled it off a board, came to us and said, 'I want something like this.'

"We had him sign a contract, of course, and I went to work. I started looking at fonts for something distressed, like it'd been run over or gotten pushed around on a construction site. Then I drew some appropriate tools and machinery.

"For the colors I thought about the orange and yellow 'Caution' signs that you'd see on a construction site. And we wanted to use black because of the hardness of that color. I mainly envisioned an all-inclusive design, like a stamp or a patch that you could place on the side of a vehicle, rather than an open logo, although I tried that approach, too.

"We try not to limit our thinking to just a logo, but will try to upsell the job when possible. So we considered shop and truck signage, stationery, pamphlets and what have you.

"We try to present only five logo ideas—there's a thin line between showing too many and too few—but on my computer screen I'll open one huge Illustrator file and start going wild. When I'm designing, one idea will lead to another, so my canvas contains lots of logos everywhere. Then the team sits down and we'll put a square around the best ones.

"We tell our clients to show our logo comps around, because the public will see them differently than we do. As a designer, it's not just pleasing the client. You really have to put yourself into the head of the client's audience."

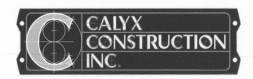

a

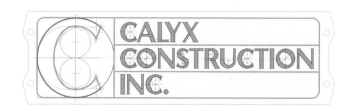

b

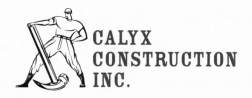

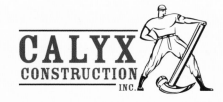

c

Tyson Mangelsdorf
Designer

Tyson Mangelsdorf Illustration
Design Studio

Calyx Construction, Inc.
Client

Logo construction is easy when you have a plan. Tyson Mangelsdorf's approach generally begins as intuitive and moves into the methodical. "When I start a new logo project," he says, "I usually instantly see some sort of imagery that comes to mind, and if it works, I'll pursue it. Other times, I look for literal tangents I can take.

"I started a scrapbook in which I draw, write, and paste scraps of magazine cut-outs, photographs—everything that inspires me. So when I'm empty, I just start flipping through, and the creativity starts running again. All ideas come from other ideas, just assembled in new combinations.

"On this logo for a construction company, I came up with three concepts. The first one was a blueprint idea [**a**], which seems appropriately linked with precise construction—it all starts with a plan, right? The second idea was something a bit more contemporary, with a strong typeface [**b**], and I was able to use the negative space in the *C*s as nail heads. This was by far my favorite idea, since as we designers know, it's not always easy to integrate a second layer of meaning into the typeface.

"Finally, the last idea [**c**] had more of a retro feel. The huge guy with a huge hammer and a tiny head was based on a character I had created years before but never used. Appropriately, I used the classic Rosewood Fill typeface. It looks like a font that could be engraved in metal or wood.

"In the end, the client liked the blueprint idea, although my first pick was the reversed-nails-out-of-the-type idea. That just goes to show that you should really like all the ideas you submit to a client, since a great deal of subjectivity comes into graphic art."

35

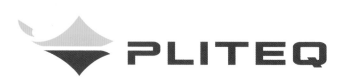

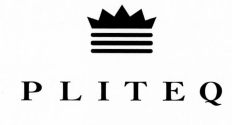

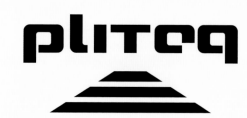

Christina Maynard, Rick Sato
Designers

Rick Sato
Creative Director

Ricksticks Inc.
Design Studio

Pliteq, Inc.
Client

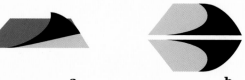

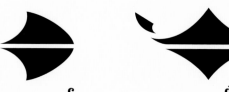

a b c d

Intuitive creativity (or good luck) played genie for the Ricksticks organization when they slam-dunked this assignment for Pliteq, Inc., a manufacturer of elastomer (rubber) alloy products for the construction industry.

"We were contracted to build a complete corporate identity, including a company name," Rick Sato says. "For the logo, the client wanted something that would appeal to engineers and builders, his primary audience. He also said he wanted to stay away from certain overused industry imagery, such as triangles, waveforms, and dots.

"To begin, we researched the industry and studied applicable trends. We conducted multiple brainstorming sessions with the rubber products in front of us. On one occasion, the client was present. We kept the mood upbeat. Working with concepts reflected in the multi-layered prod-

uct, I had an idea to demonstrate its composition by illustrating it bending [a]. Then one of the designers brought two of the barriers together and bent them in opposite directions [b, c]. What resulted was an object that looked very much like the finished logo. A corner flip was then added to subtly emulate a genie lamp [d].

"When shown the completed concept, the client immediately noted the magical reference. Further, he called the concept 'ingenious' because we had unwittingly illustrated the layering method of constructing the product."

In the final stages, the Ricksticks crew went through over forty different type choices before settling on one in which the initial *P* carries through the thrust of white space between the genie lamp layers—a nice touch! The client was reportedly "quite happy with the results."

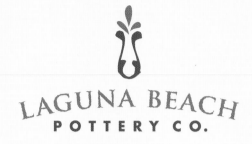

Geoff Akins and Jeff Parker
Designers

Geoff Akins and Jeff Parker
Creative Directors

AkinsParker Creative
Design Studio

Laguna Beach Pottery Company
Client

"We need a logo that we can press into clay." So instructed the owner of the high-end gift and home accessories store in Laguna Beach, California. The shop features work by local artists and craftsmen and occupies the same property that had been "The Pottery Shack" for many years—a real landmark at the beach.

Designers Jeff Parker and Geoff Akins began the project, naturally enough, by doing pottery research. "We started looking at the marks other pottery makers had used to imprint their work over the years," Parker says.

"One thing we kept in mind on this project is that when we work for retail places that are trend-driven, we want to avoid a logo that makes too much of a stylistic statement that might become dated down the line."

"We felt a little pressure in that the store would be fea-turing the work of other artists, and we wanted our logo to be worthy of all that talent. It also had to look good tagged to woven baskets as well as on modern pieces of play sculpture. Other than that, the client gave us a lot of leeway. He entrusted the vision part of it to us.

"They are marketing toward high-end shoppers, and we wanted to attract the touristy beach shoppers as well, so the forms are based on Laguna Beach tee shirt art, yet giving it a boutique store twist. And the color palette pulled in the sand and beach and those sorts of seaside shades. It really needed to connect to the casual, easygoing, earthy feel of the town, not only to honor the store's heritage but to promote the most unique part of the brand—its location."

The final mark has a hand-done look that is designed to produce a good impression … literally!

MEDIA & ENTERTAINMENT

We tend to think of the entertainment and media fields as calling for graphics of a more extravagant nature. Certainly, that's true in general. But still this category of logos is as diverse as any other. Here are logos for recording, television, comics, film, radio, and music and sports festivals. They range from the grunge-punk of logos like Lila and Make Some Noise, to the merely stone-washed look of the National Folk Festival and Brown Box Theatre logos. There are slickly-drawn, iconic logos, such as those for Batgirl and Inside Out, and collaged and spray-painted logos, like Spinout and Reason To Live. At the very least, all of them should prove entertaining.

TV

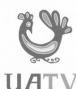
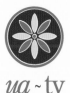
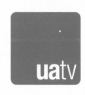
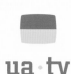
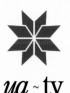

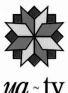
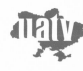
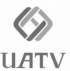
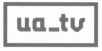
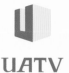

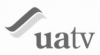
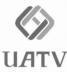
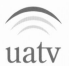

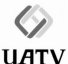

Claudia Renzi
Designer

UATV
Client

UATV is the official Ukrainian TV station in America, headquartered in Chicago. Like any other foreign channel in the U.S., *UATV* tries to bring to the Ukrainian community some of the culture that they might miss from their native country by airing news and popular shows.

To get a handle on the task of designing the *UATV* logo, designer Claudia Renzi entered into what I call "immersion," or the initial research phase of a project.

"The client did not really articulate what they wanted in the logo," Renzi says, "so I simply started by writing down all the words that came to mind when thinking of TV. I also did a lot of research in order to glean insights into the Ukrainian culture. This was something I do every time I have to work on a logo—I find it incredibly helpful.

"Ukrainians are known for pysanka, the art of painting intricate patterns on eggs with designs that symbolize love, happiness or wealth. My favorite image is the bird, messenger of the sun and heaven that helps push away evil. It also symbolizes fertility, the fulfillment of wishes and a good harvest. But the idea did not fly with them.

"They ultimately chose a logo that had the letters *U* and *A* interlaced, but … oh no, they asked me to turn the letters so they could be straight up and down rather than angled the way I presented it! As a designer, you learn this happens sometimes. All you can do is fight hard, yet know when to give in. Sometimes it's healthier to let it go and be happy that the client loves it."

Although Renzi states, "When it comes to logos, less is more," it often seems to turn out that the client—as in this case—is the enforcer of this axiom.

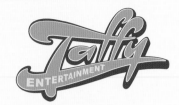

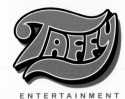

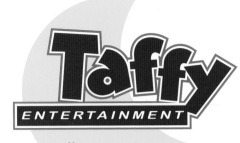

a MoonScoop Company

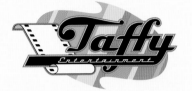

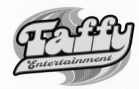

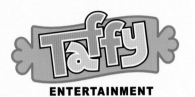

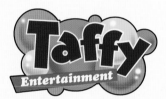

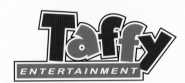

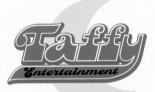

Leslie Cabarga
Designer

William Schultz
Creative Director

MoonScoop
Client

Saltwater taffy is mostly unknown in Europe where MoonScoop, the parent company of Taffy Entertainment is headquartered. Therefore, I was told that the new logo I'd been hired to design should avoid the obvious reference to candy … unless maybe just a little bit.

And with these instructions, I set to work for this company that produces children's animated programming. As usual, my first designs were broad and varied, just to see which way the wind might blow. While many of my designs had taffy candy references in the stretchy letterforms, pastel colors and candy shapes, I figured that, even if taffy is unknown in Europe, candy colors were still viable for a company that created kids' programming.

At the second meeting, it was divulged that the company would be producing a series of cartoons featuring superheroes, and so the logo shouldn't look exclusively childish. Oh … okay.

So I set to work creating different color schemes on a few of the lettering styles they liked. Upon presenting these comps, a question arose as to whether the logo might incorporate the half-moon image that was also a part of the parent company's logo. Oh … okay.

Well, this presented a dilemma as there was apparently no logic behind adding a moon under the word Taffy, until at last the subtitle, "a MoonScoop Company" was added, and then it all seemed to make sense.

The final logo is still composed in happy colors, but not so exclusively childish that the logo will look out of place promoting superheroes. For myself, I'm still wild about the taffy-pull first logo design I did (top row, left).

41

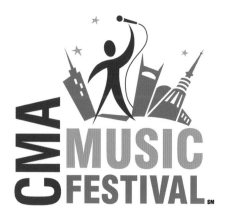

Wendy Stamberger
Designer

The Stamberger Company
Design Studio

Country Music Association
Client

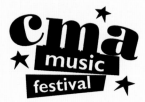

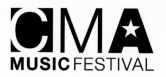

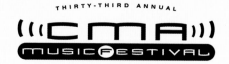

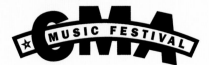

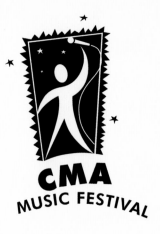

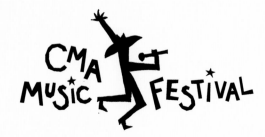

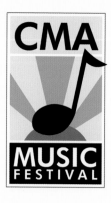

In a blatant attempt to discover how this designer gets her ideas, I asked Wendy Stamberger if she ever steals from design magazines. "When I flip through magazines," she said, "I'm looking more for techniques and asking myself why a certain logo looks corporate, or what makes a really good health care logo. Or, for example, why do I like this logo and dislike that one; what makes a good logo?

"Generally, I begin thinking not so much what the logo should look like but what it's supposed to do. Based on the reasoning behind it, the challenge then becomes how to make it look great, too."

So, getting down to specifics, I asked Stamberger what sort of parameters she'd been given for this logo of the CMA (Country Music Association) Music Festival, described as "country music's biggest party," a four-day orgy of concerts and star appearances held in Nashville each year in June.

"They didn't give me a lot of direction," she said, "which is why I gave them many different choices, some that were a little more corporate looking and others that were looser.

"The main thing was that this logo would establish a new name for this festival, traditionally known as 'Fanfair,' which the CMA felt sounded too fannish. Fanfair had always been held at the National fairgrounds where you could park your RV and just hang out and party.

"Of all my logos, the client liked the guy in the cowboy hat dancing, but they didn't like the hat. When the Festival name was changed, it was also moved to downtown Nashville, which has a really identifiable skyline. So for the final logo they asked me to add the skyline behind a dancing figure and we chose simple type to offset the illustration."

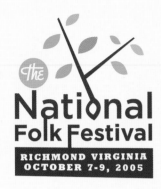

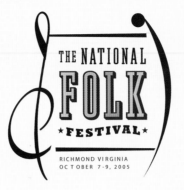

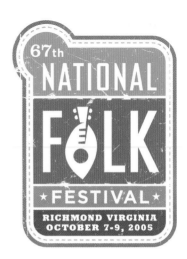

THE
NATIONAL FOLK FESTIVAL
RICHMOND VIRGINIA | OCTOBER 7–9, 2005

Ben Couvillion
Designer

John Homs
Creative Director

J H I
Agency

The National Folk Festival
Client

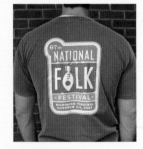

The National Folk Festival logo was ubiquitous throughout Virginia during and *after* Folk season.

When a logo must be approved by committee, the likelihood of ending up with something great shrinks in direct relationship to the number of people involved. But by anticipating this scenario, it was smooth sailing for J H I.

The National Council of the Traditional Arts, sponsor of The National Folk Festival, works closely with representatives from each city that will host the traveling event to develop marketing materials and programming for that locale. J H I was chosen to create an identity for the festival's tenure in Richmond, Virginia, from 2005 through 2007.

"We realized that a lot of people were going to be involved in the process, and we had to find an effective way to invite input while protecting the quality of the end result," says Jo Watson, J H I partner and strategic planner. "So we put together three packages, each containing examples of logos, to facilitate the discussion of what kind of logo might be most appropriate. The packages really helped the group to focus and more clearly express their thoughts. Then we asked them to define three criteria the logo must meet. Everyone played by the rules and the whole process went surprisingly smoothly."

"We wanted to give the logo the distressed feel of old metal signs on backcountry roads and Hatch show prints," says J H I Creative Director John Homs. "But the festival also features contemporary artists from lots of cultures, not just bluegrass or country, so we created an imaginary 'world instrument' for the *o* in *Folk*, and used more modern fonts."

The logo established a strong and attractive visual identity for the festival. "I guess it was a success," Jo Watson says. "We're working on the festival again this year."

43

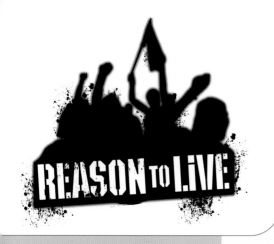

Andrew Wright
Designer

Breath of Fresh Air
Design Studio

Reason to Live
Client

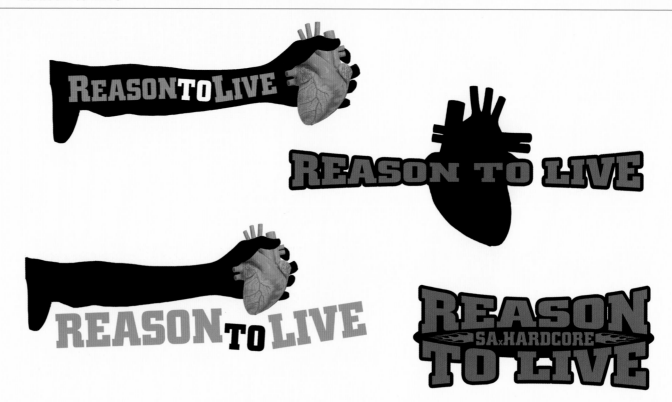

Sometimes you'll spend hours working on a logo in a certain direction, and then—usually while taking a shower—you suddenly hit upon a different and much better concept. Perhaps the flowing water transports you into a creative dimension. The trick is to not forget the idea by the time you dry off.

Andrew Wright describes a similar experience. "This was an exciting and yet challenging logo assignment. It was for a hard-core band whose lyrics are very politically correct and address various issues such as politics, sexism and racism. Once again, I started off with the obvious images and ideas that came from the name. For example, the heart is needed to live. But I was not purely happy with those images myself. So then I took a completely different route and aimed at another concept, which is that everyone has

a reason to live and a reason to fight for what they believe in. This is a band that is loud and in your face … just like a riot or demonstration. The whole graffiti and stencil look is also characteristic of demonstrators and the hard-core music scene. The band was blown away by the final idea, and I have to admit all the other logos should never even have come to light."

I asked Wright if he ever designs "nice" logos.

"Ha, ha, ha, I do actually. Not too often though, and that's quite alright with me. Most of my clients approach me because they know I understand their background, lifestyle and culture. But, as a designer I have to—and am glad to be able to—design any kind of logo for any client. I have to admit it is good to design a 'nice' corporate logo every now and then."

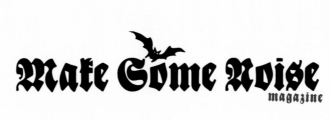

a

Andrew Wright
Designer

Breath of Fresh Air
Design Studio

Make Some Noise
Client

As long ago as 1890, parents were complaining about "these loud, raucous young folk and their dag-blasted barbershop quartets." Then came Ragtime, Swing, and the Sex Pistols. Yes, kids of every generation want to make some noise to express themselves, and designers like Andrew Wright want to express that noise in logos.

When asked how he chose this approach, Wright responded, "It was the obvious choice. The magazine is called Make Some Noise, so the look of the logo related to the title, and the magazine is aimed at young people who are into the noisier type of music."

So, how does Wright actually distress those logos? Does he start with fonts and scan in paint droppings?

"Most of the time," Wright says, "I start with a font and play around with it in Photoshop. But there are times when a hand-drawn font or 'paint droppings' scanned in, come in handy. Every logo and design starts off in a different way. That's what makes design so exciting. No day is the same."

I asked about the gradated logo with the curved baseline [a]. In the old days that would have been sketched with a pencil and then airbrushed. Does Wright ever employ non-computer methods?

"Nope, that was done with a steady hand and a mouse. All on computer, I'm afraid. I often feel like I'm cheating, but if I can achieve a desired effect on computer in a shorter time, then so be it. It's an effect I've admired and learned from several underground rock-n-roll poster artists in the States."

Eventually, the music proclaimed in Make Some Noise magazine will become standard for elevators, and newer, even noisier music—and dirtier logos—will emerge.

45

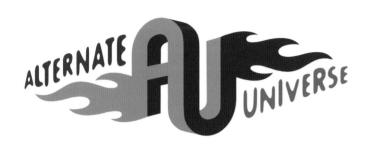

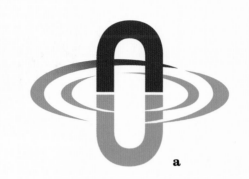

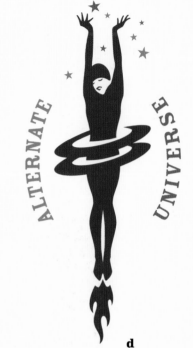

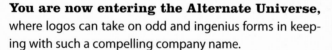

a

b

c

d

Jon Wippich / Karen Wippich
Designers

Dotzero Design
Design Studio

Alternate Universe
Client

You are now entering the Alternate Universe, where logos can take on odd and ingenius forms in keeping with such a compelling company name.

Alternate Universe organizes fan conventions around shows like *Star Trek* and *Buffy the Vampire Slayer*. The two female partners started as fans themselves and later ran a charity auction for a fan-run convention. They saw examples of mismanagement and price gouging in some conventions, so they decided to start a nonprofit, not only to run charity auctions but also to run fan conventions with the profits going to charities.

Designer Jon Wippich says, "The clients were open to something fun and different. The first Alternate alternate [**a**] was going for sort of an Alice-through-the-looking-glass, matter/antimatter, mirror-image sort of effect. The *A*

and *U* were almost the same shape. All the *A* needed was a little part of the wave ring to become the cross bar. So many sci-fi shows have done that type of thing—like have an opposite version of everyone in the cast, or something.

"The next two versions [**b**, **c**] were playing with dimensions where the side of one letter forms part of the other letter. It has a bit of an M. C. Escher look to it. Again, I liked that the two letters had such similar shapes. The *A* just seems to naturally flow over into the *U*. The girl version [**d**] is like a rocket through space passing through other dimensions signified by the rings."

Well, personally, I like [**d**] best, but the winning logo was an alternate version of [**b**], with a bit more spark. "Adding the flames," Wippich says, "gave it some action and evoked the carnival atmosphere of some of the conventions."

46

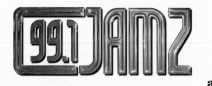

a

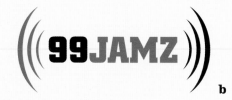

b

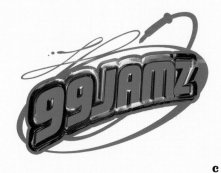

c

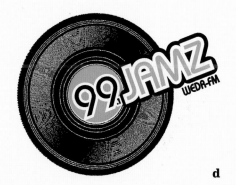

d

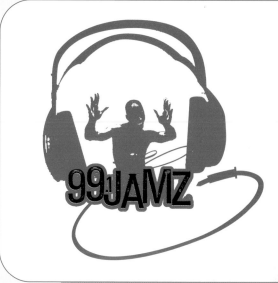

Fritz Colinet
Designer

Retna Media Inc.
Design Studio

99.1 JAMZ
Client

"My approach is to think of the target audience. You market to the audience. The Miami, Florida, radio station 99JAMZ had expanded their programming to include R&B and classic soul, but they wanted to hold onto their base, the younger, hip-hop crowd. So they wanted an identity that was kind of new and hip with more of a 'today' vibe," explains designer Fritz Colinet.

"So after thinking about what would most appeal to my audience, I started to make sketches, still thinking about the product and trying to incorporate those ideas into the end result."

Colinet presented five finished versions to the client, The first was a 1970s "solid gold" Photoshop treatment [a]. "I went down a retro path and updated it with a bit of bling (there's an overused word!)," he says. "I also wanted some-thing very simple [b], with no distractions, that in one shot would say everything, almost in shorthand.

"The blue and red version [c] was an attempt to bring in the musical connection from one place and plug it into 99JAMZ. In Miami, with Art Deco and retro being 'in,' the record idea [d] was meant to introduce the new, more con-temporary R&B, without alienating the base clientele."

As sometimes happens, the final chosen logo may actu-ally be the best of the batch.

"It has an 'it's all good' vibe," Colinet says. "I wanted it to feel like there was a connection between all the elements. For the kid, I sketched several ideal silhouettes then did a photo search for something comparable. I found a good one, but it wasn't quite right, so I sort of redrew it; I didn't want the face to have too distinct features. "

47

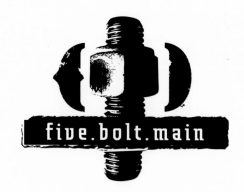

five.bolt.main

FIVE BOLT MAIN

five.bolt.main

five.bol.main

Blake Howard
Designer
Matchstic
Design Studio
Rock Ridge Music
Client

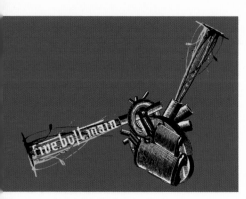

Cool collage and crazy colors
distinguish this T-shirt design that
any motorhead would relate to.

48

This is a logo for a heavy metal band whose name, I was told, comes from the extra bolt added to the engines of muscle cars to give them more horsepower. Wow, I always wondered what that extra bolt was for!

According to Blake Howard (no relation to Shemp or Moe Howard), "At first we went straight for the obvious: add some sort of cool-looking bolt in there, and slap some cool type on it and stick a fork in it, 'cause we are done!

"Or so we thought. It was too cliché; we weren't thinking deep enough into this one, the client told us.

"We then thought, 'What if it's not the bolt or engine we focus on, but if it's something that says 'muscle car,' without being so literal?' But how do we say muscle car without literally having a picture of a muscle car? The lightbulbs started going off. What if it's a logo that looks like a muscle car em-

blem? And that turned out to be just the push over the cliché speed bump we needed.

"We researched and studied old Mustangs, Corvettes, Chargers, El Caminos, and Dodge Neons. We noticed a lot of those emblem types have a subtle mark involved in the letterforms. They all had to be clear and easily legible so people could notice what kind of car just blew past them in a puff of gravel and smoke.

"We applied our research to the current set of letters we were working with. Then we noticed the *T* and the *B* both jutted out and demanded some sort of treatment to be done to them. That's when we flared them out give them a balanced wing-like appearance.

So how did the job turn out? "Client loved it," says Howard, "and we all ran off into the sunset rejoicing."

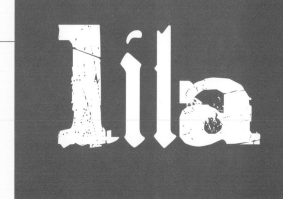

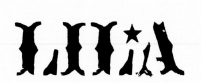 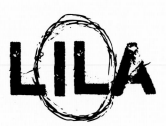 (L)*LILA

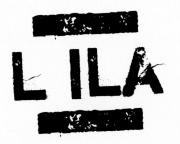 LILA

Blake Howard
Designer

Matchstic
Design Studio

Rock Ridge Music
Client

Imagine Barbra Streisand with a logo like this. Everybody'd think she was sick. But nowadays the look perfectly falls in line with the current hip musical aesthetic, which is precisely anti-Streisand.

Designer Blake Howard explains how it all came together. "This process for us was all about experimentation. Lila's music is very experimental—lots of synthesizers, bongos, and other weird sounds combined.

"For this job, we took off our shoes. It was important to be barefooted as we immersed ourselves in the music, hoping the earth connection would inspire us. We were also drinking absinthe, and maybe that helped. We decided that this mark should focus on the letterforms. It's such a short name that it was hard to make it work on its own without the crutch of an additional mark or other graphic elements.

"The music is bold yet subtle in places. I started playing with different typefaces, spacing, and arrangements. I seemed to go into a swoon. I think I left my body temporarily. That's when it came to me to add one small thing, some minute soft detail to juxtapose with the strong, bold type I was working with.

"I was really pleased with the version that has the egg shape illustration behind the type. I loved the combination of two treatments—one bold and rough and the other soft and delicate. And I ate scrambled eggs that morning."

In the end, the client selected the lowercase version in which a different typeface is used for each letter. Well, at least if Lila is ever kidnapped—heaven forbid, knock on wood—the kidnappers can save time by using her logo as part of the ransom note.

Rian Hughes
Designer
Device
Design Studio
DC Comics
Client

This logo was for a line of comics called DC Focus, where an indie flavor was called for. In the brief given to Hughes, Touch™ was described as being the story of an unethical showman who could give people superpowers by touching them. Then he'd pit his "heroes" against one another as entertainment.

According to Hughes, "We talked about a Las Vegas look and another concept was Victorian woodblock capitals—like an old billboard that would promote a prizefight, with some grittiness added. I did the gothic forms to emphasize the backstreet brawling; like gang tattoos or spray painted signs, somewhere between graffiti and old signage."

I asked Hughes if he first does pencil roughs. "When you show clients a pencil sketch," he says, "they think it's going to look like that. Nowadays it's useful that clients see a high degree of finish. Often there are no preliminary thumbnails at all. A lot of what I draw I see in my mental eye quite clearly. Drawing on computer doesn't lend itself to sketching."

Hughes is also a vivid colorist, one who expertly varies his palette to suit the mood of a piece. He says, "What I love about the computer is finally we can tweak colors easily. When I was using colored markers, my options were more restricted. In general with logos—ongoing titles especially, my colors are just for suggestion, since the art director will change them, depending on the cover art."

And he is no less a chameleon when it comes to working in different styles, as all of his examples show. "It's like being an actor and playing different parts," Hughes says. "You put on your hard-core modernist head, for example, and you go off in that direction for awhile."

Rian Hughes
Designer

Device
Design Studio

DC Comics
Client

With a background as a comic artist, Rian Hughes is often asked to do comic book logos. In this case, the client asked for something, "a bit *Superfly*; sort of a gangster comic: guns and gals; a noir comic. The cover of the first issue owed a bit of a debt to the *Superfly* aesthetic. But I'm not a big fan of slavishly copying something," says Hughes.

"I absorb visual ideas day to day. For example, as I passed a flea market recently, I saw numerous examples of 1980s-style record sleeves that I'll undoubtedly feed back into over the next month—whether I want to or not. Most designers are sponges who pick up stuff in their environment."

Surprisingly, none of the 100 Bullets logos were used. Another version [not shown] was drawn by the comic artist himself, who may understandably have preferred his own logo, in spite of the relative merits of Hughes' version.

So, moving right along, I asked the prolific Hughes what he likes best in all this. "The joy for me is in the doing," he says. "I love speaking with other designers; it's all about the fun they have following the process. I don't like 'servicing clients' needs' or 'fulfilling market expectations.' But I think that the honest designers will generally admit they design because they love type and love color and can get great enjoyment out of just a nicely designed bit of typography.

"Where designers and comic artists peak and stop progressing artistically is when they start recycling the language they've internalized. They become distilled versions of themselves. Often that's due to clients who want you to keeping doing what you did, but in some degree it's laziness on the designer's part in resting on his laurels."

If that happens to me, I'll pump 100 bullets into myself!

Rian Hughes
Designer
Device
Design Studio
DC Comics
Client

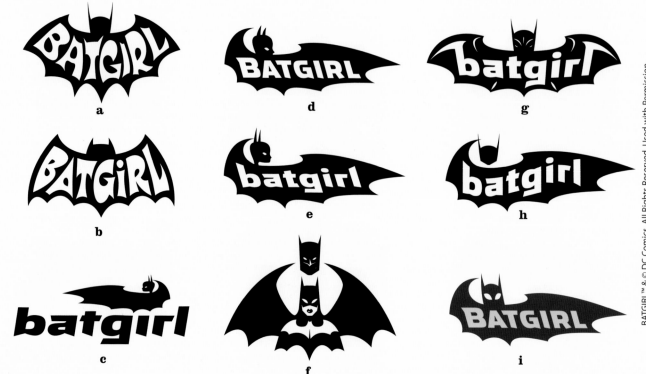

a

d

g

b

e

h

c

f

i

Hughes trembled as his trained eyes fixed upon the cheesy, old-fashioned Batgirl™ logo, "which, though cool," he told his client, grimacingly, "is quite badly drawn."

Repairing to his secret underground design cave, Hughes' face twisted into an ironic smirk as he envisioned a new logo so diabolically dynamic, it would surely strike fear into the hearts of clients who take longer than thirty days to pay.

As his keen mind flipped back to his early attempts at the Batgirl logo, based on the 1960s original, Hughes mused, "I'd been summoned by Curtis King, DC's art director, to see if I could update the original. But the old lettering was very … idiosyncratic, and as I tried to produce something more modern [**a**], it became apparent that the results were too retro [**b**] and lacked drama. Version [**c**] would never see the light of day … or night, but the bat-shaped silhouette would remain. The heads on these [**d**, **e**] were considered too elegant. This new Batgirl is meaner and tougher .

"Two other versions [**f**, **g**] were intriguing but said to be too far-out. In a few versions [**e**, **h**], the heads were too high, so they were lowered to make the character more menacing and aggressive, and the logo to sit better on the cover."

The never ending battle for truth, justice and hip logos was indeed nearing an end.

Darkly, Hughes told us, "Finally, the head was redesigned to resemble the shape of Batgirl's mask [**i**], and the uppercase replaced the lowercase that was considered too 'feminine.' (Hmm … Is lowercase inherently feminine?) The outline/shadow was also added for the final."

Now the story behind this identity is no longer a secret.

Fritz Colinet
Designer

Jim White
Creative Director

Retna Media Inc.
Design Studio

Kentucky Derby Festival
Client

The Kentucky Derby Festival is the largest celebration in Kentucky—it's like one giant party! Kentucky has been a center of horse breeding and racing since the 1700s. The Kentucky Derby officially began in 1875. So when Fritz Colinet was asked to redesign the logo for this very historic event, the client stressed that the heritage of the brand was all-important.

Colinet says, "My goal was to totally revamp the logo, yet partake of the historic value contained in the former logo. I started sketching, and after producing lots of sketched type treatments, winged horses, globes and icons, I chose the ones that seemed most creative and best, strategically.

"The Festival logo was to be used on everything from small souvenir items to huge billboards, so I wanted the design to stay simple and impactful. I sketched out a few con-cepts, walking a fine line between maintaining the heritage of the brand and evolving the identity. The positioning of the event was extremely important. The chosen tagline was 'The Greatest Celebration on Earth.' How's that for a chal-lenge! I certainly attempted to reflect that in the logo.

"For many brands, staying in the race means staying new, so an updated image is essential. That's why, with every mark I do, I strive to create an icon that resonates emotion-ally with the target audience.

"For the final, I used colors that would compliment the excitement of this historic event. Often I face the dilemma of wanting to show too many versions. But, I showed the client only a few and came away with a winner."

The client agreed that Colinet had captured the elusive balance between old and new that they were looking for.

53

a

b

c

d

e

Jaimie Muehlhausen
Brand Director/Designer

Mark Sgarbossa
Illustrator

Tony Hawk, Inc.
Client

If you've never fallen off a skateboard, you may not be aware that the name Tony Hawk is considered one of the top five most recognizable in the world of sports. Hawk's Boom Boom HuckJam is an annual tour of major sports arenas around the country, featuring such events as skateboarding, BMX bicycling and freestyle moto-cross.

"Tony's is *the* name in Xtreme sports," says Jaimie Muehlhausen, brand director of Tony Hawk, Inc. that creates licensing materials featuring the Hawk name, "so we wanted a logo that reflected that and went with the distressed look, and that begins with grunge fonts. We took pieces and parts from some letters to build the frames around the letters."

I asked if grunge fonts are all there is to Xtreme graphics.

"Well, what a lot of people miss when they come into it," Muehlhausen says, "is that it all gets down to basic design.

They think they have to provide all this wackiness in the design, so they do all these crazy things trying to create a look. But the sports themselves are the thing that's exciting and that provide the imagery. So my theory is to stay out of the way and provide tasteful design around it. People tend to look to action sports graphics for what's fresh and new."

And Muehlhausen does indeed keep it fresh. The 2003 HuckJam logo [**a**] was updated in 2005 [**b**], with the addition of action graphics by Mark Sgarbossa, and then again, with the Hawk name more prominent for European merchandising [**c**]. When the tour spawned a reality TV show, the logo got another facelift [**d**] that was eventually changed to [**e**].

Most recently, the HuckJam Ramp Ragers 2006 tour logo has taken yet another design turn. Just imagine how the 2007 designs will be ramped up!

a

b

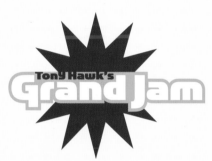

c

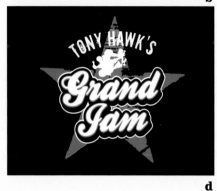

d

Jaimie Muelhausen
Brand Director/Designer

Tony Hawk, Inc.
Client

The Grand Jam is an offshoot of the Boom Boom HuckJam, but on a smaller scale. Since it costs hundreds of thousands of dollars to put on a HuckJam show, the Grand Jam is a smaller—shall we say, more intimate—and less expensive version to stage. But attendees know they'll still see a great, big show.

So house designer Jaimie Muehlhausen sat down to create a Grand Jam logo. Judged purely from a design standpoint, the work he came up with—even the color combinations—looks great. However, there were those inevitable pesky marketing considerations that needed to be taken into account.

According to Muehlhausen, "The first version of the Grand Jam logo [a] was put together in a hurry, and it got used on one poster before we decided it was inconsistent with the image we wanted to project, not to mention too busy.

"The redo, which was the red one [b], was a bit too designy and not very readable, so it too was scrapped. We simplified it and did some events and merchandise with this next version [c], but ultimately decided Tony's name wasn't big enough, so we went to the drawing board once again and the logo with the pink star [d] became the basis of the final logo version."

The final logo's colors were based on Tony Hawk's American Wasteland video game—the fourth biggest-selling franchise in video game history.

With all that success, I wondered how Hawk is as a boss.

"Tony is amazingly great to work with, and is also literally one of the nicest people and easy to work with all the time. He also contributes a lot of good ideas," Muehlhausen says.

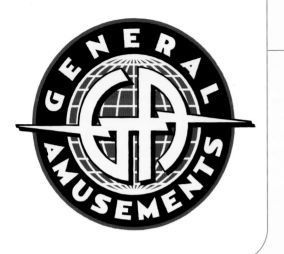

Michael Doret
Designer
General Amusements
Client

Doret uses Prismacolor pencils to indicate color schemes.

56

General Amusements was a digital entertainment start-up that went under in the "dot bomb" era. But before that, they asked designer Michael Doret for "something reminiscent of an amusement park; something that had warmth and was not too technical looking." They came to the right man—each of Doret's roughs is an absolute gem.

"I wanted to do something that was fun," Doret says, "with a reference to classic amusement parks and arcade games. But as is usually the case, the clients picked the least interesting one of all. Sometimes I think I should pull the ones out that I don't like, but you never know what will fly. The final selection is usually out of our hands."

How many roughs does Doret usually provide? "I think clients expect to see tons of things these days because a lot of designers will often present dozens of versions that are just slight iterations of the same fonts. So I usually tell them I'll give them five, and if I can get away with it, I'll do fewer. The first one or two are usually the best ones I do, and after that, I'm usually just spinning my wheels. I prefer to do pencil roughs, and I like drawing by hand with a graphite pencil—it's only one step away from a turkey quill."

How does Doret manufacture his ideas? "Sometimes I lie in bed—in the nude—and just think. Sometimes I just start looking through old books, but most of the time the idea comes straight out of my head. But, say I wanted to use a robot, I may just go looking for robot images as reference."

Historically, it's unusual to find logos with the complexity for which Doret is known. "I'm basically refiltering that stuff, but with a modern twist to it," he says. "I doubt I could even do an absolutely accurate vintage piece."

a b

Brian Zick
Designer

Murphy FX
Client

Logo jobs can often come from unexpected sources. "Dan Murphy is a friend whom I lived next door to in 1962," Brian Zick explains. "His mother is Paula Murphy, a legendary drag racer. So it's not so surprising Dan formed a special FX company; he was around nitro fuel his whole life.

"I started this logo sort of from scratch. Actually, Dan suggested some ideas that I included to assuage the request. For instance, the exploding letters [a], seemed a little too obvious to me. My favorite logo had the explosion emerging from the *M* [b]. I was most intrigued by the follow-through from the spiky style of the explosion to the spiky letters.

"The process is basically one of word association. I just tried to think of visuals to match the subject matter of special effects. In effect, you draw upon a library of familiar symbols, such as flames, sticks of dynamite, the classic old-fashioned bomb and fireworks, because they communicate."

Since Zick's initial fame came from his work in illustration, I asked if he considered logo design to be a related talent.

"In both cases it's all about, 'how do I solve this problem?'" Zick replied. "I'll start by scribbling ideas for illustrations and it's the same process, although logos require more idea sketches. Why? Because an illustration is more complex, I try to work it out more fully when presenting the client sketch, because I don't want to do it twice! Whereas with a logo, the nature of the elements is much more limited. And, I think clients naturally expect to see more of a range."

Is it just as exciting to do a simple logo as a complex illustration? "Yeah, whatever," Zick says. "A good piece of work is a good piece of work."

Rian Hughes
Designer

Device
Design Studio

Tokyo Project
Client

Rian Hughes presented me with so many versions of this logo for Tokyo Project, a record label, that I asked whether they were done to satisfy the client, or was he working out the problem in his own mind?

"Mostly I'm working out the idea in my head," Hughes said. "I'll go through several concepts and then cull the best for presentation to the client, who may only see one or two designs out of twenty or thirty. If I find myself submitting, say, over a dozen, it's usually because the focus has been lost or I'm unsure of what works best."

Does the budget suggest how many variations Hughes will present for a given job?

"Sure. Larger budgets allow time for more varied explorations. However, it's sometimes the case that a great solution presents itself early on or even straight off the bat, and

submitting further ideas only serves to undermine that. I try to submit no more than three to six ideas for the first round; sometimes I'll submit only one. However, some jobs historically have ballooned to several rounds of designs and upwards of 80+ logos. This is generally due to client prevarication and a changing or ill-defined brief. It can also be due to input from multiple sources—marketing, in-house design departments, etc.—all of whom have to offer suggestions and must be indulged."

Hughes employs many computer tricks to slant, twist, color and drop-shadow his logos. Are these variations just a way of getting more versions to show the client?

"Not for padding, no," he says. "For certain logos, I use them to impart an appropriate dynamic that flat-on type lacks. I always use these tricks sparingly and always within

the appropriate conceptual context; in other words, to enhance the idea behind the logo. Don't confuse an effect with a good idea."

Does Hughes reject versions he personally doesn't like, or for that matter, does he always know what he likes? Or is it a matter of what the client likes that identifies the winner?

"Personally," Hughes says, "I feel that a conceptually rigorous design—that is, one with a sound idea behind it—will often dictate the way it should look. Idea precedes appearance. Clients have to understand both aspects of a design to make a good judgement.

"However, I reject the designs that I feel are inappropriate or ugly, and those designs that I'd be disappointed if the client chose. Often there are several equally good, but quite different solutions to a design problem. I'll always explain the pros and cons of each submission. However, I'll sometimes get to the point with a client where I really have no idea what criteria they're using to distinguish good from bad, which is why I always include a rationale and a recommendation with the design. If the client isn't visual at all, they sometimes feel more comfortable with words. It's best to explain why a design is appropriate, not just show and expect them to appreciate the beauty of it."

After all his work for Tokyo Project, the end result was not one, but a series of related logos. The basic logo in red, white, and black follows a vertical lozenge design, like traditional Japanese lettering, but updated.

The logo is adaptable to various musical genres, such as Tokyo Project Extreme and Beach using different, but related color schemes, patterns and graphics.

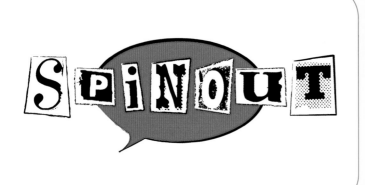

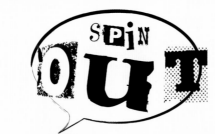

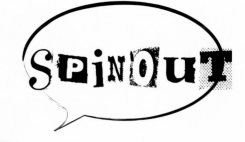

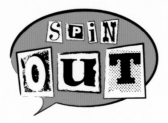

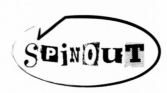

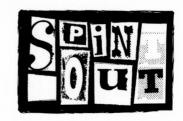

Marie-Joe Raidy
Designer
Spinout
Client

When this coffee shop in Beirut, Lebanon, sought a logo designer, they looked no further than Marie-Joe Raidy, well known for her bold and provocative designs. For years she's been plastering the walls of Beirut with stickers and posters in what's become a mushrooming movement for social change.

Raidy says, "Aside from selling food and drink, Spinout's intent is to promote comic artists, providing a place to show their work and display their messages. In Beirut, comics are considered a lowly part of publishing. But comics speak in a voice that is direct, raw and honest. The medium has always offered a space for those who 'spin out' fresh ideas.

"The Spinout logo's comic bubble echoes this spontaneity. The cutout letters suggest creating, experimenting and playing freely with no limits, and without fear. "

Yet the practical aspects of design have not escaped Raidy's attention. "In the real world, being a good designer is not only about creating good visuals, it's also about being able to convince the client that your concept is what they should go for. You have to know how to read your client, speak a language they can comprehend, and try to find a middle ground between what you believe is a good design and what they are capable of accepting.

"First of all, I always listen to what they have to say. My favorite kind of client is one who acknowledges the fact that I am the designer and trusts that. The more a client trusts you, the better work a designer can deliver."

Raidy's ultimate goal? "I would love to change the world with my design one day … make people weep from sadness and joy both at once, with one visual."

Filip Blažek
Designer
Designiq
Design Studio
Český Rozhlas
Client

Clients often fail to tune in to our wavelength, and their directives may at times result in disappointment, as when Filip Blažek tried to please himself—*and* his client.

As Blažek explains it, "Recently, the Czech Radio, a broadcasting company, established three new digital radio stations. They held a competition to design a new logo for two of them and we were asked to join. We won the second one for the D-dur station that plays only classical music. It is broadcast in digital form only, and it can be heard on the Internet in many streaming formats; for free, of course.

"The task wasn't easy. We had to accept several demands of the client, including use of 'official' colors and a rectangular shape. Also, the new logotype had to fit together well with the logotypes of a dozen other radio stations of the Czech Radio system.

"I started working with several modern faces to create a contemporary typographic logo. I liked the simple style, but I soon learned that the client and I did not see eye-to-eye. Then I started to twiddle with a tilde wave motif to express the continuous stream of music. The tilde also referenced an existing logotype of another of the clients' stations.

"I was quite satisfied with the tilde with gradient applied to contemporary Antiqua, although I was not sure the client would approve this. Therefore, I tried a nice handwritten script with a very old-fashioned *d*. This was the logotype chosen by the client's jury. I am a little bit disappointed they selected this logotype as I preferred the one with Antiqua. But I am glad they accepted the *d* and the gradient. I had to fight hard against their demands to 'normalize' the logotype."

61

Ben Couvillion
Designer

John Homs
Creative Director

J H I
Design Studio

IQ TV
Client

Sometimes, all the careful planning in the world won't prevent a logo presentation from going sour. "We were approached by an independent consultant who interviewed us—there was another company that was up for it, but we got the job—probably it was my dog Gilbert that impressed him," says J H I creative director John Homs.

"We were thrilled to work on this project for IQ TV because it was a unique company: web-based, rich media content for the web. And I thought that the group of ideas our project designer Ben Couvillion came up with were tremendously good identities in themselves. But it ended up descending into mediocrity, primarily because there were too many people involved and no consensus on direction. Finally, the top guy said 'I'm ending the process.'"

"The consultant had written a 'branding brief' that we used as a jump-off document. That was helpful because generally, before we start to work, we begin gathering a lot of information. These are technical and aesthetic considerations to be defined that we use as a benchmark for design. We've often found that clients don't really understand creative services. So we try to put their minds at ease that we're smart people with their best interests at heart. We understand and articulate the business issues first, which seems to give clients a level of comfort. By then we've established that we'll also be able to deliver a meaningful identity."

"If you don't set clear expectations at the beginning, at the end there may be disappointment. Clients have to be in a buying mood; even though we start out without a clear idea of what we'll deliver, the client has to feel, 'Yeah, I want

that,' in the end. In the first meeting with a client, there's typically a whirlwind of confusion and contradictory directives. And so my job is to listen closely and say, 'What I'm hearing is this…' We have a questionnaire that we use, but I would never ask a client to fill out a form; I fill it out myself later based on what I heard in the meeting.

"The interesting thing was that we were asked to work directly with the in-house creative team, and we went down a path that the president didn't like, and it seemed to degenerate from there. That's why we ended up with so many iterations of the logo. The lesson may have been that by not working directly with the decision maker, we were, in effect, wasting everybody's time."

But doesn't identity design always contain an element of shooting in the dark? "No, it's never shooting in the dark.

It's just the opposite. In this business you lose money with poor project management, so you really need to understand your client very thoroughly before you get started."

"It's the words and thoughts between the lines that we listen carefully for. People generally have an emotional relationship with design and art, and as we're listening, we keep attempting to put it into words both for them and ourselves. For example, what does it mean when they say 'bolder and more masculine, yet still elegant.' After all, we're in the business of solving communication problems. If they could design their own communications, they wouldn't need us.

"Ultimately, if a company's sales force is hitting the streets and they're not excited about the presentation materials they've got in their hands, they can't sell very effectively and that means we haven't done our job."

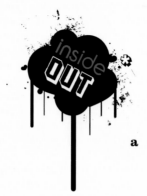

Nick Hollomon / Blake Howard
Designers

Blake Howard
Art Director

Matchstic
Design Studio

North Point Community Church
Client

An invitation whose design beautifully integrates the logo style and colors.

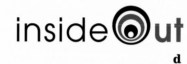

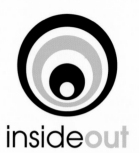

a

b

c

d

e

f

g

"This project was a process of getting down to what the client really wanted," admits Blake Howard of the design studio, Matchstic. At first, we thought this mark for a church youth group could be a little more risky, with a young, punk, and indie rock demographic, but we slowly realized this was not the client's intended audience.

The idea behind the name is about planting a message inside and letting it grow and expand from the "inside out."

"Our first concepts revolved around the idea of a paint can [**a**]," says Howard. "We liked the idea of the spray paint coming from the small can and then spreading out into the air. After the first round of comps, we realized they were looking for something cleaner. So we decided to make it look like the spray paint was being sprayed through a stencil [**b**] with the negative space making the *o*.

"After another client meeting, we realized they really wanted clean, but couldn't quite express it. So, to my dismay, we nixed the spray paint concept and decided to play with solid forms that were more concise, clear, and clean.

"We came up with a couple of circle type marks [**c**, **d**, **e**], but they were too cliché. Then we tried using the type to communicate the idea through intertwining letterforms [**f**], letting it broadcast up from the top of the *d*.

"Eventually we hit on the idea of a series of circles expanding outward [**g** and final logo]. It was clean and full of clarity but still had motion and energy.

While the [**a**] and [**b**] selections are cool, they don't necessarily express "inside-out." But by pushing ahead, the designers arrived at a great solution that not only is not a compromise, but is even nicer than their original pet idea.

Leslie Cabarga
Designer

Doug Freeman
Creative Director

Lorac Productions
Client

Lorac Productions, headed by popular film critic Richard Schickel, had outgrown its old logo design, but still they did not want a complete departure from the original. According to Lorac Vice President Doug Freeman, "Our increasing awareness of logo issues—and that people whose aesthetic ideas we respect were ragging on our graphics—led us to make a change.

"Part of it was pragmatic: we were almost out of the old stationery. Much of the movie material we deal with comes from classic films of the 1930s, and we wanted that sort of association with the Art Deco era. The new logo gives a sense of forward movement and motion, and we are dealing in moving images here."

When I was called in to redo Lorac's logo, I was none too fond of what they had (naturally), but I liked the leap-ing eland (a large African antelope) featured in the logo—though theirs looked more Dr. Seuss than Deco. I immediately envisioned it as an Art Deco sculpture and started making complex, shaded designs. The client, however, wanted something simpler that would be suitable for a wide variety of uses.

We found a compromise, however. I gave them their iconic logo, yet they couldn't resist also ordering a stamped metal foil Art Deco version (sidebar) made from my earlier, more extravagant comps.

"I had saved a foil stamped seal from an insurance company that had a real old-school appeal to it," Freeman says. "I was glad for the opportunity to do that for Lorac. It was a real vanity endeavor, yet I'm super proud of it. It makes a great impression stuck on our video and DVD cases."

The logo in its foil seal incarnation, manufactured by Fossler® embossed foil seals, www.fossler.com.

Marcos Minini
Designer

Master Promo
Design Studio

Curitiba Music Workshop
Client

a

b

c

d

e

f

Have you noticed the return of the curlicue? Designers of today, however, don't usually possess the free-hand chops of even the grossest of engrossers or the gravest of engravers of the nineteenth century, when flourishes flourished. So today's flourishes are mostly grungy—though most certainly attractive because they seem fresh and new, just as in the examples above, by Marcos Minini.

"The Curitiba Music Workshop takes place every January, gathering musicians from all over the world to play and learn erudite and popular Brazilian music," Minini says. "This year electronic music was included on the program, and our briefing was to create an identity that would be compatible with all the varieties of music to be featured.

"In the first studies [**a**, **b**, **c**], I tried to find a harmony between the letters *O* and *M* or *O*, *M* and *C* to be able to pass on the idea of harmony in the musical sense, but the results were confused and lacked a unique, central symbol, especially [**d**], in which I first tried out the flourishes.

"The design of the flourished *M* started with the font Mutlu Ornamental, but I felt the letter *M* was too narrow and too complex. So I redesigned it to merge with a sans serif *M* for a more proportional symbol [**e**, **f**].

"The chosen logo has the shape of a letter *M* combining classic and modern characteristics at the same time, together with a musical staff. The use of bold colors leads to the possibility of vibrant publicity materials."

For the final logotype, the vertical line dividing the name in two has a special purpose. "This makes it possible to use the logo for the coming years' events," says Minini, "and then I'll only need to change the roman numerals!"

FESTIVAL DE DANÇA DE JOINVILLE

FESTIVAL DE DANÇA DE JOINVILLE

Festival de Dança de Joinville

FESTIVAL DE DANÇA DE JOINVILLE

FESTIVAL DE DANÇA DE JOINVILLE

Marcos Minini
Designer
Master Promo
Design Studio
TIM
Client

The problem: to inject a logo with the spirit of the dance itself. The solution: to let the dance—or the dancer—become the logo.

For the past four years, the Brazilian media company TIM has sponsored the Festival of Dance in Joinville, the largest event for dance students in Latin America, held in Joinville, a most important industrial center in the state of Santa Catarina in Brazil. The intention of the Festival's visual identity program is to attract participants and attendees between fourteen and twenty-five years old.

"For this year's festival," designer Marcos Minini says, "the briefing request was to incorporate the energy and movement of dance into the visual identity.

"In my earliest studies, I tried to use typography to convey this feeling, but I missed the human element. The results were quite common and without the necessary energy. It was when I decided to incorporate a photographic element to the logo that it started to come together for me. I knew that use of photography wouldn't be a problem since all of the production would be printed in offset or digital printing.

"I found some photos of dancers and tried a polarized effect that was quite dramatic and effective, but I was still not quite satisfied.

"Then I happened to be looking through a stock photo catalogue and I found this picture of a dancer whose body formed an *X*, as in *XX*, the Roman numeral sign for *20*. It was just what I needed to get the logo done, and the client agreed. Accident can be a great ally when you pay attention to it."

67

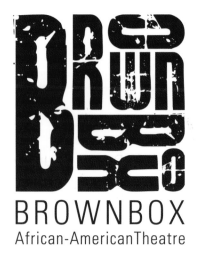

BROWNBOX
African-AmericanTheatre

Light Habersetzer
Designer

Sara Pickering
Art Director

Design Elements, Inc.
Design Studio

Brown Box Theatre
Client

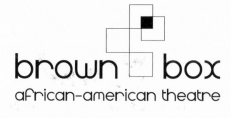

Brown Box Theater is a company whose mission is the creation, development and production of African American theater. Brown Box considers itself part of the Afro-American-inspired, cultural renaissance that is taking place in the Pacific Northwest.

African-American theatre, as described by the client, has a dual origin. First came the indigenous theatre, consisting of folk tales and songs along with music and dance. These forms of expression were, of course, African in origin and became transformed by the American environment. As the civil rights movement gained momentum, it fostered what eventually became African-American theatre of today.

"In our discussions with the client," designer Light Habersetzer says, "we came away with the following words as guidelines: Afro-minimalism, contemporary, earthy, clean,

deconstructed, creative, simple, and Afro-centric. The rich history inspired us to create imagery that represented the important role of African ideals in American theatre.

"When we hit on the concept of using the letters as objects: simple, graphical elements, it helped to create the clean and bold feel the client was after. As the idea was developed even further, each letter began to represent 'links in a chain,' bringing with it the connotation of black history and cultural iconography."

The final design is a parenthetical allusion to black history; sort of a logo-as-time-capsule. The distressed type is reminiscent of the old wood type used in the minstrel posters of the 1800s, and newspaper ads announcing slave auctions. The individual letters mounted on wood blocks lend themselves marvelously to this constructivist arrangement.

a

b

c

d

e

f

Mark Fox
Designer

BlackDog
Design Studio

TV Land
Client

There seem to be no accidentals in the Fox network of logo concepts, no purely decorative conceits. Each of Mark Fox's logo concepts for TV Land, a cable television station devoted to the celebration of vintage network programming, was accompanied by a well-reasoned rationale. Here are the portions of the descriptions the client received.

About [**a**] Fox wrote, "There is a Chinese ideogram—a squared spiral—which signifies 'return' or 'come back.' By incorporating a spiral with a TV, we can suggest the idea of TV Land as a place where classic shows are revisited.

"This logo [**b**] plays with a variety of ideas: the TV screen as window; the horizon as a signifier for 'land'; in other words, TV Land has an alternative world view.

"In this logo version, your TV screen is the map [**c**] by which you find your way through TV Land.

"The addition of the 'and' sign (&) to your initials creates a rebus [**d**] for TV Land: TVL&. Besides spelling 'Land' in code form, the ampersand functions independently to suggest that the TV Land experience continually offers more: & retromercials, & all your favorite shows, & lotsa laffs, etc.

"Here is an eye [**e**] with the musical notation for 'reprise' or 'a repeated performance.' In essence, this symbol says 'watch and watch again.'

"I couldn't resist: A TVL monogram [**f**] that makes a TV. The *V* creates 'rabbit ears,' while the *L* is the highlight on the screen."

In the end, the client, rejecting his carefully-concocted, graphically stunning rebuses, asked Fox to just rework their original logo. Perhaps this was the most sensible solution. A basic advertising axiom is "simple is best."

69

Raúl Santos
Designer
700GRAMOS
Design Studio
Grooove Discotheque
Client

It's incredible what some designers will do to obtain logo accounts: "I own 700GRAMOS, a design studio in Madrid," Raúl Santos says, "and we offer tons of candy to our clients every time they come. But truly, someone gets to know someone who has already hired us, and if he likes what he sees, we are in. We do some on- and off-line promos, but there's no doubt that a job well done speaks for itself and gets the word spread."

Suspecting there was more to the story, I probed, "Why do you hate logos? Is it because of your mother? Admit it!"

"My mother taught me that you have to eat all different foods. If I refused to eat the soup at lunch, she would serve it again for dinner. Some design jobs are interesting, and some are simply boring, but they are all necessary. And how I love 'puchero' soup now!"

These logo comps, I noted, are all completely different.

"That's the whole point about creativity: you don't know where the hell it's hidden, but somehow ideas come when you need them. It's good, though, to keep the process a secret so we can get paid by those who can't find it. As to the variety of approaches, it's just a method of work. When a design doesn't have what it takes, I put it aside and start again. New blank sheet of paper, new idea."

So, just what is the dirty little secret behind this logo?

"Time to tell the truth," Santos admits. "Actually, this disco never opened its doors. Someone I knew asked me to assist him with the name and graphic design … He didn't have much money so he offered this agreement: free drinks in the place for life. I only learned his whole operation had turned to smoke when I had already finished the logo."

Paul Howalt
Designer

Sally Crewe
Creative Director

Tactix Creative, Inc.
Design Studio

Public Hi-Fi
Client

"Digital is a dirty word, and if the machinery doesn't hum, pop or hiss, it probably will never see the inside of Public Hi-Fi, an Austin, Texas-based recording studio owned and managed by Jim Eno. Everything there is amplified, filtered and recorded on vintage analog equipment." Thus Paul Howalt described the work of his client.

Public Hi-Fi wanted a logo design that was reminiscent of the 1950s and 1960s, when the machinery that they use was created. They also wanted to use the limited spot color and vernacular design of those times.

Says Howalt, "I've done a *ton* of this sort of work in the past. To be honest, I went to my old logo files first (Shhh!) and recycled a few things to use as starting points, and then began to embellish the basic typographic formats.

"The client wanted iconic visuals of things indicative of that industry, and specifically analog equipment. Being a musician myself, I have a lot of that old equipment still lying around in my garage collecting dust. I studied the tubes, circuitry, laminates, switches, dials, lights and cords. The richest stuff to draw upon was found on the old amps.

"The actual final logo came from a study based upon the baked enamel metal labeling on one of my old Fender tube amplifiers. It wasn't my absolute favorite direction, but it sure fit in well with the client's studio.

"Although the logo was for Jim, it was commissioned for him as a birthday present by his friend and associate Sally Crewe, a singer from London. Wish I had friends like that! The two of them were great to work with, and if I do say so, I think I was the perfect match for the project."

Yes, thanks to Howalt's high fidelity to vintage design.

We now step into the provocative area of retail and service industry logos. If you thought the last chapter was something else, well—hold onto your hats (because management is not responsible for your personal belongings)! We've got identity marks for restaurants, consultants, healthcare providers, and many more. They range from the sublime (Kopsa Otte) to the meticulous (Charles Luck Stone Center), and from disturbing (Silent Screams) to relaxing (Cheeky Tea). We also go from heartwarming (Willowglen Nursery) to heartburning (Efrain's Taqueria). The stories behind the logos are so thought-provoking you'll end up begging for more!

RETAIL & SERVICE

AAA LANDLORD
services

Paul Howalt
Designer

Paul Howalt / Cam Stewart
Creative Directors

Tactix Creative
Design Studio

AAA Landlord Services
Client

Sharp-looking collateral materials show off the AAA logo to great effect.

"First comes the concept: it directs the project. Sometimes clients come to you with a beer coaster and ask you to copy this artwork they found in a bar last night. I try to marry the concept of what is right for the project with what the client thinks he wants," Paul Howalt says.

"Not every single concept can be deep, though it is our responsibility to try to create that. Sometimes the client is not interested in concept, though, and he ends up with something weak conceptually, yet hopefully still beautiful."

AAA Landlord Services, offering such things as property management and tenant screening, seems to have gained a logo that is both conceptually strong as well as beautiful.

Howalt says, "They were concerned that they would end up looking too stuffy, like a law office. They wanted to push things, style-wise, to be more current; something that would live on, that people would see and be challenged to accept visually and that wouldn't get stale too quickly."

For initial ideas, Howalt says, "I go straight to some of the books containing collections of logos and dig around there, but if I take any ideas from those, it's more just style cues rather than specifics. For example, if I were doing a skull, I'd never rip one off verbatim. I'd take flairs and cues and hints, but I'm always conscious of not looking too much like anyone else's work. When you look beyond your own creative horizons, it pushes you down the road. If you don't do that, you're operating in a vacuum."

AAA is a logo success story. The company has expanded and will soon be going national. And Howalt says, "The materials we produced along with the logo helped propel that. And they keep referring new clients!"

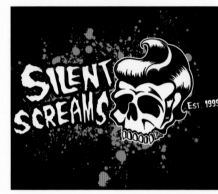

Andrew Wright
Designer

Breath of Fresh Air
Design Studio

Silent Screams
Client

"This was a logo design that just worked out right from the beginning," South African designer Andrew Wright says. "The company Silent Screams deals with sales and distribution of underground music, clothing and accessories. The client wanted something that would represent her taste in music and psychobilly style (imagine Elvis in a B-grade horror movie).

"So, drawing a skull with an Elvis quiff-type hairstyle just seemed to be the right option. After illustrating the skull with pen and fixing it up on the PC, all that was left was the general layout of the logo. The client was quite happy with one from the first designs I gave her (the skull with banner) and accepted it. But after a few days, I came up with the pink blood splats logo and had to give her that one too. She was blown away and thrilled."

I asked if clients with tattoos, multiple piercings and fuchsia mohawks are different to work for than other clients.

"Mmmm, good question," Wright replied. "I'd be tempted to say yes, but that could possibly be a biased opinion. At the end of the day, the client knows what they like and don't like and will not take the logo till they are 100% happy with it, whether they have tattoos or not.

"It is my job to create a logo that best describes and depicts what that company does and is about. I think if anything I might come up with a logo faster for a 'tattooed, pierced and fuschia mohawk' client simply because I live that culture and understand it better than say someone who owns an accounting firm. It is my job to use my visual skills to create a logo or design for a client that will work best for them—in other words, bring in more money for them."

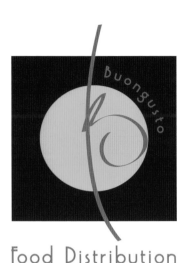

Patsy Balacchi
Designer

Yantra Design Group
Design Studio

Buongusto Food Distribution
Client

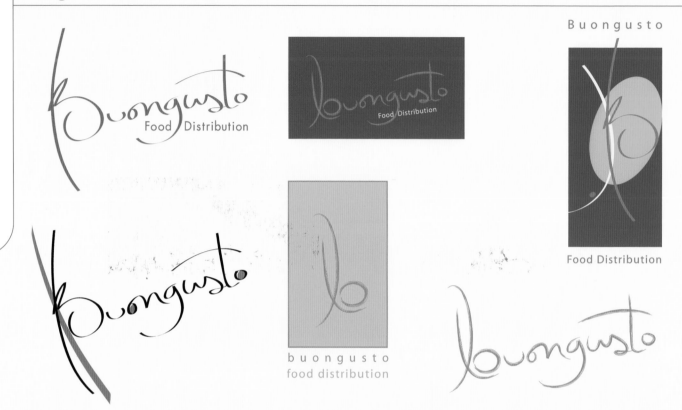

Creating a logo that both signifies good taste and also is in good taste is what Patsy Balacchi attempted and has accomplished with her design for a purveyor of Italian gourmet foods.

"Buongusto" translates as "good taste." The client envisioned his company logo to be contemporary, yet sophisticated and wished it to stand out from the obvious, or typical Italian-American red-white-and-green thematic scheme.

"I presented a couple of logo concepts that were rejected because they seemed too trendy. Buongusto wanted a logo that would withstand 'the test of time.'

"Given this guideline, I thought that calligraphy would help convey this idea of permanent elegance, and this happened to be the easiest part of the project. I wrote the word in pencil, and it seemed to just flow onto the paper. I then used the calligraphy brush tool in Illustrator and drew the letters, trying various stroke weights for each of them.

"For the color palette, I convinced the client to at least use red for the company name, but a challenge arose when I tried to incorporate another color. Black gave the logo an Asian feel. I decided to use blue as a background color with a yellow-orange sphere to represent the sun and sky. Blue was approved when I reminded the client of the famous 'azzurro' uniforms of the Italian national soccer team.

"The client decided to use the tri-color logo for signage and promotional materials but used Buongusto in red alone for his executive stationery."

It's been five years since the company launched, and Balacchi says its logo is still considered one of the strongest corporate identities in the South Florida food industry.

a

b

c

d

e

f

Krista Cojocar
Designer
Infinity Sports & Entertainment
Client

"Building a client base begins with networking skills, and you move on from there," Krista Cojocar explains. "This logo was for my brother-in-law, a lawyer who is developing a clientele in sports management.

"First, we discussed the initial idea, and I suggested some logo concepts. Next I created some sketches he liked, and then I went to the computer to 'bring them to life.'"

Describing her process, Cojocar says, "I have some design books that I look at for inspiration, but if something comes into my mind initially, I sketch that out first. Then I start choosing color combinations according to the particular industry and client, even taking into consideration if the client is male or female."

"My initial idea in designing this logo was to incorporate an infinity symbol, but the client and I immediately decided to avoid such an obvious solution. Instead I attempted to create a suggestion of the symbol without being so literal. "The idea of a limitless bridge came to mind [**a**] and that morphed into the double wave [**b**], which was like a partial infinity symbol. Then I tried the wave as an *S* for 'Sports' [**c**] which became the elongated *f* in Infinity [**d**].

"I then hit on the idea of interlocking rings [**e**, **f**] which also seemed to convey 'infinity.'

As is so often the case after being presented with a number of comps, the client was torn between two different logos, and the decision was made to combine elements, adding the rings symbol from [**e**] to the elongated *f* logo [**d**].

"This, I felt, created a nice balance in the final logo," Cojocar says. "It's sometimes interesting how a client has a different way of seeing things that can enhance the final work."

77

Chris Parks
Designer

Up Design Bureau
Design Studio

Coffees Dezvous
Client

a

b

c

d

e

Chris Parks wasn't content merely to provide pretty pictures—something he does exceedingly well, actually—for Coffees Dezvous, a client that was developing a 'mobile espresso service' catering to corporate office parks by bringing premium coffee drinks to those desiring an alternative to the 'brown stuff' down the hall.

"The clients came to me with a lot of coffee logo reference from trade shows they had been to," Parks says. "It was typical stuff: coffee cups, steamy swirls and other fairly expected imagery. Since nowadays, great coffee is ubiquitous, I opted to emphasize the service, convenience and user experience in my designs, rather than the product itself.

"But the client still pushed for the more literal imagery and it wasn't until I pointed out to them that their name itself—Coffees Dezvous, meaning a 'rendezvous with the customer'—was speaking to the service and delivery aspects, that I began to win them over on ditching the hackneyed visuals in favor of a type treatment [**a, b**]. I admit I gave into them a bit by sneaking in a coffee cup or latte glass with those darn swirls they wanted [**c**]. I even resorted to elevating a roasted coffee bean to grandeur [**d, e**].

"When I came up with a concept involving a mythological metaphor—Pegasus swooping in to deliver a treat—I thought it was a long shot. But the clients surprised me by choosing that option. And I managed to incorporate the steamy swirls by integrating them into the symbol, rather than having them hovering over the expected coffee cup."

We've all faced the challenge of trying to steer a client versus acquiescing to their wishes—for better or worse. Chris Parks' efforts resulted in a great job for client and designer!

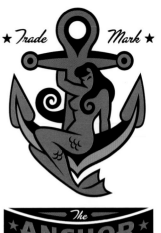

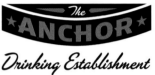

ANCHOR

"El Ancla"
— THE ANCHOR —

Chris Parks
Designer

Up Design Bureau
Design Studio

The Anchor
Client

'Sin central' is what the locals call a trio of shops owned by Schane Gross, one of the few female tattoo artists in Kansas. Located in the middle of the newly restored Old Town district, Schane's tattoo and body piercing parlors occupy two of her shops. In spite of the city fathers' wish to cleanse Old Town of Schane's dens of iniquity, this canny entrepreneur not only stayed put, but decided to fill her third storefront with a new bar and restaurant.

Designer Chris Parks explains, "Schane asked me to develop an identity for her new business that would be fun, memorable, and 'in their face,' yet more 'polished' to capture the type of patron who would normally steer clear of anything hot rod or tattoo-related, and to keep up with the newer, surrounding shops in the district.

"I took my inspiration from the visual language of skate boards, alternative art, video games, tattoo flash, and comic books. The name itself, 'The Anchor,' modestly references tattoo lore, pulling from vintage, nautical, and early 'Sailor Jerry' tattoo flash. Also big with Schane's group is the alternative art movement, which embraces graffiti and re-interpreted Tiki, Polynesian art and pop culture.

"Because of the nautical nature of the name and the popularity of Polynesian-pop imagery, the Tiki option developed as a close second to the final selection, which is a provocative feminine symbol: an amalgam of ideas dear to the tattoo, hot rod, vintage nautical crowd—and Schane Gross' own aesthetic."

Ironically, despite the initial chip on the owner's shoulder, the Anchor has become a successful watering hole serving all walks of life—those with and those without ink.

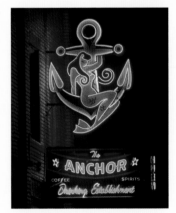

With neon like this, it's no wonder the joint is jumpin'.

79

Roland Murillo
Designer
Murillo Design
Design Studio
Atlas Culinary Adventures
Client

Having resurrected a ready-made logo solution for Atlas Culinary Adventures, a sort of travel agency that sends clients to remote locations offering unique dining experiences, Roland Murillo had a dilemma. Now, he realized, he'd have to come up with further concepts—equally brilliant—just in case the client didn't go with his first one.

Murillo explains, "I keep a sketchbook, and you know how sometimes when you're doing one job, other unrelated ideas come up? So, one day I happened to draw this chef on a flying fork in my sketchbook. And, I knew that eventually a company would call me up and say 'we have a catering service …' and then I'd be ready! So, that actually happened three or four times, but I couldn't sell this idea to any of them.

"When the Atlas job came in, I just thought 'Hey, if this isn't the logo for you, I don't know what is!' And they were like, "Well, we'll consider it, but can you show us some other options, and I was like, 'OK, fine.' (They wanted me to work for it.) So I came up with other ideas, but the problem was I wanted a series of icons that were just as strong as my chef on a flying fork in case they didn't pick it, 'cause there's always the possibility they'll pick the design you hate.

"So despite a group of strong alternates, every time I sat down with the client, I held my favorite closer to them and eventually they agreed or just got tired of my pushing it."

And indeed, Murillo's rejected options are just as conceptually clever as the chef on a flying fork the client chose. Dig it: he's got a train whose plume is a chef's hat, peripatetic silverware, a global platter, flying Atlas letters with a puff of smoke that is also a chef hat, and a globe with a bite taken out of it. All of them masterpieces (for a future client)!

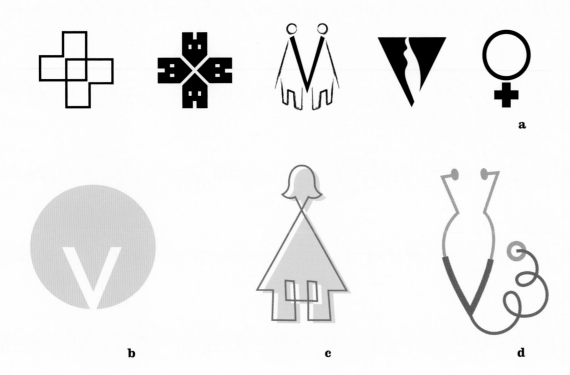

a

b c d

VILLAGE CROSSING
WOMEN'S HEALTH

Roland Murillo
Designer
Murillo Design
Design Studio
Village Crossing
Client

I've heard that genius is the ability to combine two or more existing concepts into something new and unique. "That's when you get one of those *eureka!* moments." Roland Murillo says. "It's grueling, but when you do find something, it's a nice feeling." Murillo must feel nice a lot.

The doctors at Village Crossing, a women's health clinic in Boerne, Texas, wanted "a village, a river, a woman, a tree, a kid playing in the back yard," Murillo says. "And I told them, 'That's a mural, not a logo.' I did do some of their other ideas [top row, **a**], but they eventually opened up to mine.

"They wouldn't go for the *V* vagina design at all [**b**]. They appreciated the concept, but it was too provocative. The houses in Boerne have steep-roofed, German-influenced architecture, so I tried to do the idea of a village and a woman in one [**c**] where the roof becomes a skirt. They liked it but again thought it was too hip for them. The stethoscope [**d**] was pretty nice, and it's so obvious you can't believe someone hasn't done it before—or maybe they have—but I couldn't pass it by.

"The final logo that the doctors picked had more of an elegant, high-end look, and there were subtleties in it, such as the crossing of the lines—like 'village crossing'—that also formed the woman's figure. That's what I like most about it.

"Whenever I do a design for somebody, I want to feel that I achieved something unique or different. It may take someone a moment to notice the lines are crossing—like the arrow in the FedEx logo that nobody ever sees until someone points it out—and then it adds a dimension to the experience and to the identity. That's important to me, it's craft."

And it's also genius, like I said.

81

Mike Samuel
Designer

Michael Samuel Graphics
Design Studio

Michael C. Fox
Client

Typically, a fox hunt begins in the drawing room, where red-coated guys without anything better to do gather to toast the fox's doom. Designer Michael Samuel's fox hunt also began in a drawing room, of sorts.

"I began," he says, "by creating images of foxes (which, as it turns out, are incredibly difficult to draw). To complicate things, I was aware that fox images are frequently used in logos for items like mountain bikes and video games, and since this job was for men's suits, I wanted to present the fox in a style that would avoid product confusion.

"I started out working with pastoral scenes and full body foxes when I came upon the idea of the french horn. It is classic, old fashioned, and definitely removes it from the teenage/action sports realm. At this point, I replaced the *O*—probably the most replaceable letter—with a fox head.

"I then realized that by utilizing the fox head and the horn, I could combine elements to have my cake and eat it too. From there, the job boiled down to just refining the image in various ways, like by replacing one fox head with a more sophisticated fox drawing.

"For the color scheme, I chose pool table/drawing room green, gold for the horn, and a foxy 'red' as the basic colors. In the final logo, I went with black type and matched the fox to the type to simplify the mark and force the horn to sit back, so the fox would stand out as the key element."

The final logo is designed to look like a clothing label. For the subtext, Samuel used the sans serif font Minion, following his personal rule: "Complex logo/simple type." Observing his process above, I note that Samuel's early attempts bite, but then he works it through until he makes the kill!

a b c

d e f g

Michael Samuel
Designer
Michael Samuel Graphics
Design Studio
Capri Coffee
Client

Inspiration sometimes strikes the first time out or it may take a trip to the Isle of Capri and back again before we achieve a design worthy of getting steamed up over.

In Michael Samuel's case, even his first designs show an expert orchestration of type, graphics, line weights and color, but he pressed on until he had come up with a concept that was … good to the last drop.

"Because this was a food establishment," Samuel says, "I wanted a logo that had an integrated type and symbol, something that could be used for packaging as well as napkins and signage.

"I started by trying to evoke glorious visions of travel and the Isle of Capri with a Colombian Coffee triangle and some Prudential Rock of Gibraltar thrown in for good measure [**a**, **b**, and **c**].

"During my research, I saw a coffee scoop which I thought was highly evocative. I began by replacing the *A* with the scoop [**d**] and proceeded to try dropping the scoop out of it [**e**]. I was also working on replacing the *O* with a coffee cup [**f**], but I was never too happy with the floating coffee bean idea, even though the slogan was 'A Bean Above.'

"When, finally, the steam rose out of that cup [**g**] and into the *A,* the top of my head nearly came off. This all took place between 9 PM and 2 AM when I came up with this idea.

"The client never actually saw the other sketches. I believed in this design so completely that I sold this idea strongly above the others. The client's marketing person later suggested a little less quirky lettering, which I thought was an excellent idea."

That's what happens when you let your mind percolate.

83

"Some clients are keenly aware of what they like and dislike," Karen Charatan says, "and that can be a good thing … I think! In this case, I really just ended up rendering the logo for Cheeky Tea according to the client's own concept that was drawn from various elements that they liked in my preliminary sketches."

Cheeky Tea is a web catalog and mail order company for many exotic varieties of tea that are introduced and sold through house parties, à la Tupperware.

"When they first contacted me," Charatan says, "my time was quite limited, so I suggested some fonts they could purchase. But they waited several months for me to work with them because they really wanted my hand lettering.

"The preliminary concept sketches [shown on this page] are a little rougher than I would normally show a client,

a b c

Karen Charatan
Designer
Cheeky Tea
Client

because I think of it sort of as showing up half-dressed.

Unlike some letterers, Charatan is not averse to employing appropriate fonts in some of her designs.

"When I'm doing a lettering-based design," she says, "quite often the first thing I do is look at a variety of fonts to see if someone has already discovered some inspiring letterforms. However, I usually prefer to use my own lettering, because I like to create a hybrid of illustration and text. I find that more expressive hand lettering can simplify the concept, creating less need for a pictorial element. Letters have arms and legs and seem quite anthropomorphic, so they seem to be adaptable to things like handles and spouts!

"This sketch [**a**] is one that inspired the final version, with parts of letters performing functions. The *e* forms steam from a teacup and the handle is an unexpected turn of the *y* descender. Ascenders may become steam, but it's not too often that you see a lower case *e* with an ascender!

"At this point, the client suggested the lettering within a tea pot and I made the sketch [**b**], that was refined into [**c**].

"At the eleventh hour, after having gone through dozens of versions, I needed objective eyes and I shared my sketches with Ray Cruz, who is a great lettering artist. His friendly critique was very helpful. He pointed out many small things that still needed attention—things I couldn't believe I'd overlooked. For example, adding a curly ball on the end of the *T*, as well as refining the ball shape on the *a*, helped to unify things. Probably lots more could have been tweaked, but it was time to send it to press."

In the end, Charatan says, "Though the concept was not mine, the goal was achieved: the client was quite pleased."

Filip Blažek
Designer

Designiq
Design Studio

Vizus Ltd.
Client

Belmond is a medium-sized company based in Prague offering messenger and transport services, among other things. Parent company Vizus Ltd. approached Filip Blažek to create a simple, contemporary logotype, and the client's initial specs were quite to his liking.

"I was given absolute freedom in choosing the design, colors and type," Blažek says. "I was limited only by certain usage specifics: the logotype had to work on business cards as well as on pick-up trucks and vans. They didn't give any hint, any closer specification of what they wanted. The only thing they knew was they wanted to get rid of their old homemade logotype.

"I started playing with stylized wings. To be honest, I recycled the wings from a rejected logotype of another transport company. Usually I can't reuse ideas created for

a different context, but in this case they were perfect.

"Although I spent a lot of time finding a good combination of the wing and the text, I was not satisfied with the results. I suddenly realized that Belmond is not an air transport company; the logotype should 'stay on ground!'

"A few days before the deadline, I started experimenting with triangles. And the idea of overlapping shapes came very quickly to my mind. The symbol itself could be used on cars in very large sizes (and now I think it looks really great when I happen to spot their car on the streets of Prague).

"I've created two versions of the logotype, vertical and horizontal, to allow better placement of it on different vehicles. Meanwhile, the company expanded into other business fields, and I used the same style to create a 'sister' logotype for flower delivery and caravan rentals."

Todd Rosenthal
Designer

Todd Rosenthal Design
Design Studio

Shu Katahira Translation
Client

Generally speaking, bare feet and gritted teeth do not make the best logo graphics. Nor do gaping eyeballs and dog paws. But, as Todd Rosenthal found, you never know what might occur when you allow yourself free reign of a sketchpad in search of a novel idea.

Rosenthal says, "I have always spent a lot of time drawing, which is what initially brought me into design and illustration in the first place. This Japanese-style logo was for Shu Katahira Translation, my wife's business. She teaches Japanese and also does professional document and simultaneous translation. At the time, I was taking a Japanese class and really immersing myself in the language. She wanted an identity, and I was happy to oblige.

"I have always been a big fan of anime since I was kid. That, and traditional American comics influenced me greatly when I was growing up. I always appreciated the simple, clean elegance of Japanese design.

"The sketches I put on paper just seemed right and worked. So I went from paper to final rapidly—just one of those times I was in the zone and the right environment."

The unusual final logo is a comic book "speech balloon" for two speakers, with an ellipses apparently bridging the translation gap between them. Or it's a magical forest creature with two legs and three eyes—you be the judge.

"When I was creating this logo," Rosenthal says, "I wanted to not only create an interesting logo but a familiar 'feeling' character for Shu's Japanese and American clients alike. I came up with something that was exactly what I imagined it could be: fun, simple, and distinctive. And the 'client' was very pleased."

Above, another fascinating Rosenthal logo created for Katahira, but this time to promote her as a sculptor.

87

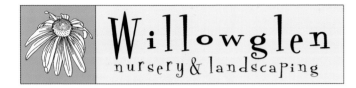

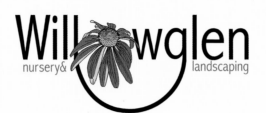

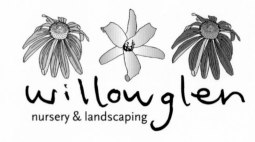

Michaelle Boetger
Designer
Willowglen Nursery
Client

We often work for clients for whom we feel no affinity. So Michaelle Boetger was delighted to nurse this logo along for a client whose product deeply moved her.

"Willowglen Nursery first contacted me about designing a postcard for a summer garden event they were putting on, and upon completion of that project, thought it was time to explore having a new logo designed," Boetger says.

"Willowglen's brochures, advertisements and web site all had different designs, and they felt it was time for a consistent identity. I met with the clients in their perennial gardens, nestled in a corner just off the beaten path. The gardens themselves are an inspiration.

"When a job is first proposed, I almost always have an initial idea in my head, and then I move on from there. My research involves not only learning more about the customer and their business, but making lists of colors and shapes, and sketching any ideas that come to mind. As designers, I think we sometimes forget about this important step, assuming the computer is going to somehow magically assist us.

"While in the client's garden, I took digital photos of flowers, thinking it would be appropriate to incorporate them into the logo. They sell a lot of heirloom and custom plants, so it was important to show these specifically and not use some readily available stock photos or clip art. I traced my flower photos in Illustrator and used them in some of the logos. I chose colors that would keep the logo simple.

"For a few of these versions I used lettering that I'd written out and scanned into the computer. I liked the resulting organic feel, somewhat like the peacefulness you feel when visiting the gardens at Willowglen Nursery & Landscaping."

Jeremy Bohner
Designer

Tim Ellis
President/Creative Director

Inertia Graphics
Design Studio

Efrain's Taqueria
Client

a

b

c

A painter gathers his paints, brushes, canvas, and other materials to begin work. Jeremy Bohner, designer for Inertia Graphics, described how he gathered some and created other materials he'd need for this job, a logo for a Mexican restaurant.

"We have a huge database of fonts," Bohner says, "and once I start designing and brainstorming ideas, I'll type in the name of the company we're working for and try it out with up to three thousand fonts [**a**].

"Then, I sketch out icons and images, scan them and bring the images into Illustrator, where they can vary quite a bit from the sketches I drew, and can take me in different directions. So by amassing my font choices and creating a bank of graphic elements—like the hot peppers and sombreros for Efrain's [**b**]—I've got something to start playing with. Once I'm designing, I'll pull in the fonts and see which ones look best and see how I can incorporate symbols and graphics.

"Sometimes, the font may even suggest the style that the drawing can take. That's one trick I often employ: to actually try to get an idea from the font. For example, if the strokes are distressed, you can incorporate that into the image.

"They say you really don't have to be able to draw to be a designer, but it's very helpful to be able to generate your own images. Not everything will always end up on the computer, but the basis gets me started in various directions.

"For this job, we tried to throw out and hit on many different design approaches [**c**] and see what the client was going to grab."

And I'd say the best final choice was made. It's a classic!

Joel Kreutzer
Designer

Clint Runge
Creative Director

Archrival
Agency

Kopsa Otte
Client

Kreutzer found inspiration in the ubiquitous and mystical "Big Brother" image above.

90

It is said that there's no accounting for taste. In his highly tasteful logo design for Kopsa Otte, a unique accounting firm focused on the salon and beauty spa market, designer Joel Kreutzer contradicts that old saying.

"In developing the identity," Kreutzer says, "we had to understand Kopsa's target market, which is predominantly-female salon owners who are stylish and image conscious. The objective of the identity was not to emulate the beauty market, but to establish Kopsa Otte as a leading financial advisor with expertise in this area.

"Thus, it was important to create a balance between beauty and the accounting profession. This allowed us to approach the branding process from many different directions, drawing on unique aspects of both markets.

"Our identity process usually begins with sketches and computer-generated roughs. Once a direction is solidified, we'll proceed mainly on the computer. When developing concepts, we believe that it's important to know and understand the client's needs before moving too far in a certain direction. Having a better idea of a client's limitations allows you to know when to be more conservative or where you can break the boundaries."

The final logo employs an intriguingly abstract icon based on the pyramid/eye from the dollar bill about which Kreutzer says, "As a company whose focus is largely 'youth branding,' or targeting younger customers, we see a growing trend toward abstraction, which we attribute to a necessity for constant reinvention of icons. The general public has become savvier to iconography in the last two decades, and people are experiencing symbols every day in their lives."

Roland Murillo
Designer

James Howe
Art Director

Thompson Agency
Design Studio

TDoT
Client

Sometimes, logo design is just connecting the dots, as was the case with Roland Murillo's design for The Texas Department of Transportation, a job that he did through the Thompson Agency in San Antonio.

"Connect the Dots was the name of the program," Murillo explains. "It was to be used internally in the TDoT, by the people who manage the highway systems. The idea was to brand an audit system that enables these officers, called 'Texdots,' to better communicate with each other instead of each working independently. They wanted something conceptual, but not so much so that a driver or layman couldn't understand. And that's about as much as they told me.

"It makes it easy for me when the client can be really descriptive about what they want, so I ask a lot of questions, because you never know when some phrase will open up

a treasure trove of ideas and imagery. Here in San Antonio, I'm known as the logo guy, so they basically said, 'Whatever you come up with is good.'

"Immediately, a lot of obvious images—highways, vehicles, connecting dots—came to mind, and I worked with those. But I always take the attitude that my first fifty ideas are almost always just regurgitating things I've already seen. When I finally run out of ideas, I'll step away from the project, and then when I come back later, the only things left are going to be new ground."

For Murillo, the challenge comes in combining two existing elements and putting them into a new context, as in the final logo (where truck tires are also connected dots).

"To me design is communication and problem-solving. I don't know if I could stand just doing pretty marks," he says.

91

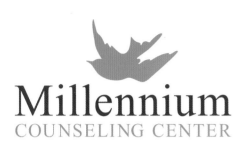

Millennium
COUNSELING CENTER

Claudia Renzi
Designer

Millennium Counseling Center
Client

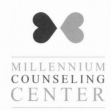

MILLENNIUM
COUNSELING
CENTER

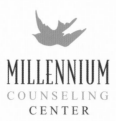

MILLENNIUM
COUNSELING
CENTER

MILLENNIUM
COUNSELING CENTER

millennium
COUNSELING CENTER

Millennium
COUNSELING CENTER

MILLENNIUM
COUNSELING
CENTER

Millennium
COUNSELING CENTER

MILLENNIUM
COUNSELING CENTER

MILLENNIUM
COUNSELING CENTER

Being able to convey in imagery and typography the meaning of what a company is all about is an elusive task. Some designers sacrifice that goal for style alone, simply applying the latest design trends to their own jobs.

Not so Claudia Renzi, the designer of this logo for Millennium Counseling Center, an organization that offers counseling and intervention services, treating all forms of addictions including chemical dependency, sex addiction, eating disorders, depression and more.

As she describes it, Renzi allows the needs of each new logo assignment to redefine her own design style.

"When I read the MCC Mission Statement, right away I thought of freedom, along with love, hope and rebirth—qualities that I wanted to express through my logo. Even though it is an organization whose clients came mostly from referrals, I felt it was important for MCC to have a professional identity system that communicated their services and how they could positively affect people's lives."

Renzi sees color choices as integral to a company's identity. "I chose light blue and gray because I wanted the logo to feel elegant, timeless, smart and at the same time soft, trustworthy and relaxing. I wanted the colors to help make patients feel relaxed, comfortable and secure.

"I prefer to use two colors that are of similar intensity. For example, both are either dark or of a medium value. It's important that logos work in black and white before you start researching colors. I've also learned to always show the client Pantone color chips, since as we designers know, colors look very different on the computer screen than in color outputs."

Successful
S E L F ✳ C A R E

Successful Self~Care

Successful
selfCare

Successful
S E L F ~ C A R E

Claudia Renzi
Designer
Successful Self Care
Client

Successful
selfCare

Successful
S E L F ~ C A R E

S U C C E S S F U L

self-C A R E

SUCCESSFUL
S E L F ✳ care

Successful
selfCare

Successful **self**Care

In logo design, one good job can lead to another. Ann Foster, the director and creator of Millennium Counseling Center (previous page) referred Claudia Renzi to Nancy Smith, owner of Successful Self Care, an alternative medical clinic in Chicago.

Renzi says, "When I spoke to Nancy for the first time, she wanted her logo to express strength and that she was highly professional, though not highly expensive. She also explained that her success depended on convincing her patients that their recuperation depended on their own willingness to change their lives for the better. That is why she called her business *Self Care.*

"I started working on ideas that reflected rebirth and personal growth. I played with a sunburst representing radiant health, and then drew a heart in two parts. When I drew an-other heart out of leaves, that's when I came up with the idea of using leaves to represent growth and care and the dot representing the self or individual. And this idea was chosen as the final logo."

"I started to use colors with earthy tones (warmth) for this logo to connect with the earth-like shapes (leaves) that formed it. Nancy, however, felt a strong connection to aqua and wanted that color to be part of her logo. After some exploration, I found that gray offset the aqua best. I tried using the different shades of aqua to soften the logo and emphasize the feeling of care provided by Nancy, and the honest, open transparency a patient must bring to Self Care in order for the therapy to heal them."

Will another potential client one day admire Renzi's logo and inquire about its designer? Undoubtedly!

Paul Howalt
Designer

Cabell Harris
Creative Director

Tactix Creative, Inc.
Design Studio

Charles Luck Stone Center
Client

As luck would have it, all of the wonderful work on this logo by Paul Howalt for Charles Luck Stone Center, a company that sells quarried stone veneers, went unappreciated. I wanted to find out why, so I asked Howalt what kind of "briefs" or ideas he was given.

"They asked for something timeless," he said, "and yet something that would reference the company's long history. They wanted simplicity, yet wanted a distinct personality. They wanted to indicate the product, but dress it in the upscale luxury of Rodeo Drive.

"When faced with a tangle of contradictory mandates, I usually scrap them all and do what I feel is conceptually correct for the company. So I gave them a slew of logos that I thought solved some customer perception issues. I explored strong visual formats and gave them looks ranging from ultra modern to Victorian back to early colonial.

"To be honest, the folks I worked with are a very diplomatic bunch, very articulate and kind. The main problem with the process is that the project went about twelve rounds before the president of the company was ever brought in.

"By round five, I felt beat up creatively and had given up on selling a solution that I knew would give them a big visual presence. In the end, I was just rendering prescribed typographic solutions in order to move on with other work. I can't bear to look at the final solution, which ended up being as 'vanilla' as it gets. They're happy with it, but it is, hands down, one of the biggest logo design nightmares that I've ever been through."

At last report, Howalt's joined a "twelve-round" program to end his client codependency, and has sworn off veneers.

a

b

e

c

d

C·R·3
media

f

**Christina Maynard, Giulia Cala,
Rick Sato**
Designers

Rick Sato
Creative Director

Ricksticks Inc.
Design Studio

CR3 Media
Client

When putting a human face on logo design fails, well then, you try something else. CR3 Media, a consumer electronics business providing sales and distribution facilitation between manufacturers and small retail stores, wanted to convey the "people-centered" focus of their business.

"The client told us they wanted the 'CR3' portion of the company name rendered to simulate a human face" says Rick Sato, head guy at Ricksticks, Inc., "and he even drew his idea out for us [**a**]. Though initially hesitant, we took our own stab at the "CR3" face concept [**b**], but after viewing the results, the client decided to move away from the idea, and we commenced developing original concepts based on our discovery questionnaire and research of the industry.

"Some of these concepts attempted to incorporate "CR3" as part of the graphic element [**c**, **d**], while others made use of typical industry iconography [**e**]. Since the company founder is a musician, we felt his nostalgic taste in music and his client-centric business style might lend itself to a more metaphorical approach to the logo [**f**].

"This latter idea struck a chord! The version the client chose was suggestive of an eardrum/shell, with sound waves emanating from it. We felt the image 'invited one to listen in.' We next selected a rounded text face similar in line weight to the shell graphic, and with some judicious tweaking created a harmony between text and image.

"For color, we were intent on using subtle, muted tones, but the client was unmoved. So we presented crimson and charcoal (the client's call) and got approved immediately."

The moral to the story is that when it comes time to face the music, you sometimes have to do an about face.

Mirek Janczur
Designer

Mirekulous Graphics
Design Studio

Union Square Pilates
Client

Many logo designers attempt to inundate their clients with choices in various styles, just to be sure they've covered all the bases. Mirek Janczur presented just three designs to his client, all elegant variations on a theme.

As Janczur describes his work. "The Union Square Pilates logo is typography—AvantGarde arranged in a Bauhaus setting. It was a real pleasure to work only with type for a change. It almost felt like writing a poem.

"I decided to work with the concept of square and union: Which part should be a typeface? I wanted a font that was easy and quick and had a New York state of mind. The rest was just experimentation, chewing on the same idea, over and over, to boil the solution down to a few variables."

Janczur's research phase involved asking the usual questions to assure the successful outcome of his logo—not only visually, but from a marketing standpoint: "What is the target market? New York City. The client's competition? Huge."

Janczur also asked himself, "How many body/health/therapy logos use a humanlike shape? To answer this I engaged in an 180º thinking process. My decision: No humanoid icon in my logo!"

To my mind, Janczur has succeeded wonderfully in his task, creating a precision logo that lends a breath of fresh air (rather than of sweaty exercise equipment) to our expectation of this Pilates studio located near New York City's gentrified Union Square.

In the first of the three comps, above left, I like the Jackson 5ive-style use of a square in place of the letter *Q*, which to me, totally reads. The final logo's circular motif evokes a Greek fret while also reiterating the client's location.

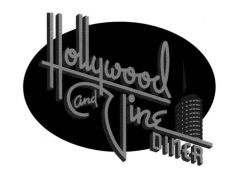

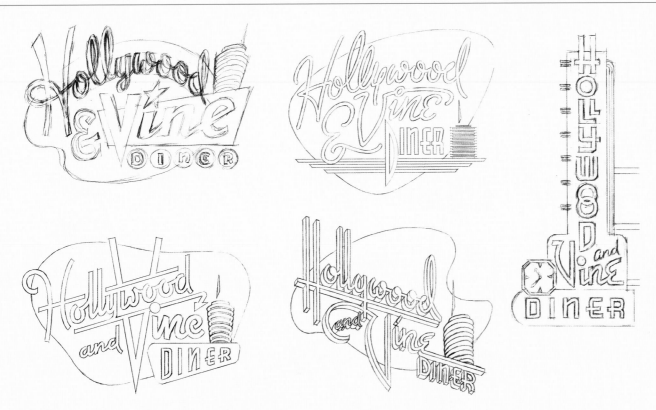

Michael Doret
Designer

Rod Dyer
Creative Director

Rod Dyer International
Agency

Hollywood and Vine
Client

"For some strange reason, the original client for the Hollywood and Vine Diner wanted an image of the Capitol tower [a Hollywood landmark] in this logo just because it was up the street," Michael Doret says.

"The place is designed sort of dark and clubby, with Art Deco interiors, and they wanted that kind of look for the logo. My sketches were influenced by retro diner signs because I wanted to show the client how the actual signage could look. I figured it was a chance to see my work become a 3-dimensional object; why not have the logo design become the sign? But they ended up going in another direction for the sign that had no bearing upon the logo. I can never figure out why these decisions—which seem so obvious to *me*—often seem to go wrong."

But, I asked Doret, isn't it typical for clients to reject our best ideas and choose our worst? "Actually," he says, "there have been many times when they'll ask for a change and later, I have to admit it's better than it would have been."

I asked Doret, who is known for creating illustrations with lavish lettering, how a logo assignment differs from an illustration or a magazine cover. "An illustration involves telling a story. With a logo, I'm trying to communicate in much simpler terms what the client's company is all about."

And his greatest excitement about the work? "When I get to do a good design that's appreciated and I get paid for it. That's the best of all possible worlds."

"I ended up with two different finished logos [see both, right] because a few years after I did it, the Diner was bought by people who wanted to eliminate the Capitol tower and the word 'Diner' from the logo."

trade mark

Vespa

wichita

Chris Parks
Designer

Up Design Bureau
Design Studio

Vespa Wichita
Client

Scooter Planet

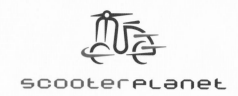

scooterplanet

★ TRADE MARK ★
SCOOTER PLANET

scooter planet

estb. 2000

scooterplanet

a

trade mark

Vespa

wichita

Once upon a time there was a little logo that morphed, mid-stream, into another. It seems that Chris Parks was hired to design an identity for a new scooter boutique, but the client was undecided as to which direction to take his new venture: Should he start a scooter shop with a mix of new and vintage Italian scooters, or open an official dealership with Vespa, the cool, Italian motor scooter maker.

Parks says, "I was asked to develop two identities: Scooter Planet, for my client's vintage scooter direction, and another logo to switch to, for a Vespa shop, in the event he was awarded his dealership license.

"The Scooter Planet direction was easy. The name itself suggested fun and playful imagery. Referencing the great visuals from the 1960s, when the mod-scooter movement was at its height, was helpful in understanding the built-

in equity of the scooter mystique. The final design for the short-lived Scooter Planet logo was a scooter silhouette with a planetary ring around the front tire [a]."

Approaching the logo for the Vespa dealership was trickier, Parks found. Now, focusing only on the Vespa brand and brand new scooters, the identity had to let go of its vintage visuals. "Our only restriction from Vespa," Parks says, "was to incorporate their famous logo. In the end, because the client had gotten so attached to his Scooter Planet logo, he asked me if there was a way to somehow incorporate it."

Our tale has a happy ending: Parks was able to swap-out the Saturn-ringed planet tire for the "target tire" image [final logo in red-outlined box] and come up with a Vespa scooter silhouette. And don't the side view mirrors sort of look like alien antenna springing from a single eye?

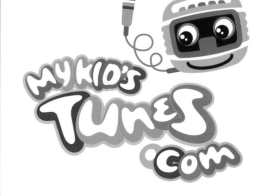

a

Tyson Mangelsdorf
Designer
Tyson Mangelsdorf Illustration
Design Studio
My Kid's Media
Client

"The client asked me to get into the head of a child for this logo for *My Kid's Tunes,* a music retailer specializing in digital music and audio books for children," Tyson Mangelsdorf says, "but I also felt it was important to keep it hip, professional, and appealing to adults, such as parents who purchase music for their children, and financial investors.

"I began by reviewing other logos in the children's market. Then I started working with the words of the logo with various fonts to see if anything stood out. In the end, I want my logos to function, in a sense, as the definitive period that finishes every message from the company it serves.

"This project truly inspired me, so I kept running with ideas and ended up producing forty logo explorations that I thought were worthy of presentation.

"At first, I'm only concerned with structure and shape, so I work in blue, a holdover from my blue pencil days, before computers). From there I try various arrangements and color schemes. It became clear that one of the color comps was the standout [a], so I went ahead and explored it further to get every possible refinement worked out."

I asked Mangelsdorf if he himself created all the images.

"It's usually faster and easier for me to draw something, rather than look for the perfect clip art," he replied. "Mainly, since I'm getting paid to come up with something original, I wouldn't feel good about taking someone else's royalty-free art and incorporating it.

"This job worked out well. I focused on the client's vision of the marketplace, and he relied on my design expertise, so we were able to collaborate on a solid design that effectively represents *My Kid's Tunes* in the national marketplace."

CENTRAL
LOUNGE·RESTAURANT
SUNSET STRIP

Rod Dyer
Designer / Creative Director

Rod Dyer International
Design Studio

Central
Client

100

When the first idea is the best, do you keep going?
"The ideas and solutions come a lot easier when you've been doing this awhile," says Rod Dyer. "I've always been able, right off the bat, to solve a graphic design problem. I can take the name and almost immediately visualize something that works for the concept."

This was the case when two experienced restaurateurs approached Rod Dyer to design the identity for a central gathering spot on West Hollywood's famous Sunset Strip.

Dyer says, "I immediately envisioned a spiraling C, that eventually became the final logo. But instead of quitting there, I got to the point of trying to include a map of the Sunset Strip and soon realized it had become too convoluted.

"Interestingly, the clients zeroed in on the very mark that was my favorite. I find that with most stuff I do, you kind of know the one that's really working, but sometimes you have to guide the client toward making that decision. As a rule, the first design I'll show the client is the one that's my favorite. So that logo is their first impression.

"We normally present designs mounted on large foam-core boards, but lately we've been doing it by email, though I don't really like that. When you're there, you can really sell something. I will always fight for the mark that I think is best. I'll explain to them the reasons behind it. It's my reputation on the line, and I have to be proud of the end result.

I asked Dyer how it feels to stand at the bar of this hip Sunset Strip hangout, chatting up some hot babe, with the logo you've designed overhead, etched huge in granite.

"Well, you can brag to her that you designed the logo," Dyer says, laughing, "but she'll never believe you."

DRIVING ORGANIZATIONAL CHANGE

a

b

c

d

e

f

Sarah Gries
Designer

Snap Creative
Design Studio

TLC Consulting
Client

Some logos provoke subliminal comprehension of their deeper meanings. This was the result when Snap Creative was hired to design an identity for a corporate consulting company owned by two women who pride themselves on their creative approach to business consulting.

Sarah Gries says, "Having ascertained the personal tastes of the client, we set to work on the initial concepts. All of our first attempts involved combining the two Cs in ways that would not compromise legibility.

"A flower to replace the *o* in consulting was an obvious feminine touch [**a**], but a lack of legibility and an *overly* feminine feeling caused the client to reject this concept. The straightforward, blue logotype [**b**] was simply too straightforward and corporate for the client.

"The stylized leaf mark [**c**] was suggested by the organic process embodied in the client's working style. Rays emit from the leaf and break the boundary of the circle. Next, a 'group effort' or 'team-building' concept manifested in the mosaic tiles logo [**d**], but it was not unique enough.

"To portray the process whereby clarity is achieved through consultation with the customers, we showed a dotted line becoming solid while moving through a box [**e**]. A variation on this idea used three intersecting circles [**f**].

"In the logo ultimately chosen, a crescent moon *O* indicates the mutability of consulting services offered—similar to the phases of the moon. A surrounding box counters the offset weight distribution of the type above. The colors purple and sage suggest warmth and approachableness."

Overall, the client was reportedly very pleased with all the progress seen throughout each stage of the process.

Various (see text)
Designers

LogoWorks
Design Studio

Blue Canoe
Client

blue canoe a

b

c

BLUE CANOE d

e

f

Design by committee is all in a day's work for Logoworks, the largest web-based provider of affordable logo design on the planet. LogoWorks draws from a network of some two-hundred designers worldwide plus twenty-five in-house staff artists who independently work on customers' designs. It's a highly-efficient, low-cost logo-creation system that makes some freelance designers cringe.

"Logoworks efficiently targets small business owners that otherwise couldn't afford professional graphic design," said Rob Kirby, Creative Director at Logoworks. "When a customer comes to us, they fill out a creative brief and any of our designers can sign on to accept the job. They have three days to come up with their initial concepts. The customer chooses an initial concept and moves forward with that design until he ends up with a logo they are happy with."

A typical case is LogoWorks' design for Blue Canoe, a canoe rental and tour company. The logos above were created by Curt Jenson [**a**], Tyler Lynch [**b**], Val Tiatia [**c**], Nate Perry [**d**], Adam Heaton [**e**], and Bartosz Golebiowski [**f**].

"The customer chose the initial concept by Bartosz Golebiowski, but wasn't happy with the rendition of the canoe itself," said Kirby. "Bartosz took the customer through two rounds of revisions, but the client still felt the piece wasn't quite right. Then several other designers submitted designs during three more rounds of revisions. Val Tiatia's variation led to the final piece."

Though Logoworks' business model may upset some designers, I cannot fault their enterprise. They've carved a valid niche, and their work is of competitive quality. The rest of us will simply have to paddle just a little bit harder.

a

b

Geoff Akins and Jeff Parker
Designers

Geoff Akins and Jeff Parker
Creative Directors

Akins Parker Creative
Design Studio

South Bay Custom Cycles
Client

A fifty-year-old client realizes that the money he's made as a successful businessman has not brought satisfaction. His solution? Start building choppers, grow the hair long, and pierce an ear or two.

And then hire partners Geoff Akins and Jeff Parker to make you a great logo. They'd already done a lot of work for another firm, West Coast Choppers, and were familiar with the motorcycle culture.

Parker says, "We asked ourselves, 'How do we connect these bikes to an audience that has a keen sense of authenticity?' Our solution was to play up the old-school character of the product in the vintage forms of the logos to stay true to the product and the customers.

"We referenced lots of the post-Vietnam War, hand-painted biker logos with their odd and imperfect shapes. While they had to fit with an existing visual language in this community, our idea was that these logos should feel like they came from the same garage as the bikes that were taped off and painted pretty well—but don't look *too* close.

"The colors came from the biker culture and the research that we did. The old school bikers are like 'Easy Rider' ex-military guys, so the black and burgundy and the silver-blue colors really had their start in squadron patches from Vietnam.

"Our favorite of the options we presented is the ambigram [a]. It was motivated by how the logo would look painted on bikes and how it would spin if it went on the wheel. We thought wouldn't it be cool if it was oriented both ways. You can see that also in the vertical design [b]."

AkinsParker's final logo perfectly captures the genre; you can just see it streaking past you on the highway.

103

Chapter 4

This book is not merely a collection of excellent logos, it's also a fascinating view into how different types of companies seek to portray themselves through their brand identities. For example, both Writers Guild of America and the green investment firm Hope Equity need stability, but the latter also needs warmth. Luxury dwellings, such as Ocean Club, Agave, and Mosaic Homes, require a tricky mix of warmth, plus exclusivity. On the other hand, the Wattis Institute for Contemporary Arts and real estate firm eEmerge need to evoke both substance and hipness. Read on to discover how designers work to provide our clients with logos of appropriate and compelling ambience.

BUSINESS&
ORGANIZATIONS

888 SAN MATEO

Ty Mattson
Designer

Lance Huante
Creative Director

p11 creative / Mattson Creative
Design Studio

Centex Homes
Client

I don't know if these designs would work for an address like 888 Shoreline Drive in Chicago, but to me, the warm color palette of these fifties-style logos beautifully evokes the mood of a crisply sunny California address.

And I'm embarrassed to admit that at first I saw the graphics as abstract. Only now, as I sit at my computer in velvet smoking jacket and Italian loafers, puffing on a Bidi, do I realize—and it hit me like a ton of stucco—that each of these designs encodes the building address.

Maybe the designer, Ty Mattson, has something to reveal about the work that might enable us to emulate his talent.

"Interesting project," Mattson says. "Unlike corporate IDs, identities for real estate projects can move very quickly with very little client input. The only information we had on this was the name (which was also the address), the product type: urban loft condos, and the target market, which was 25–35. So, with that as a launch point, I just jumped in and started having fun with the numbers.

"I think this was my first logo project that involved numerals, let alone the most symmetrically interesting one. Add in the repetition of three 8s in a row, and it became a really fun game of abstraction.

"The six simple circles creating three 8s was my first idea—super minimal. From there, I moved to the concept of the circles and squares becoming sophisticated patterns. Another idea was the hard-edged rectangle 8s, which work as numerals as well as kind of portraying urban, multi-level living. When I skewed the angles, it added the 'fun' element and just worked."

I'm impressed. Even if you never get the 888, it's good!

Ty Mattson
Designer

Ty Mattson
Creative Director

Mattson Creative
Design Studio

Centex Homes
Client

Agaves are succulent plants of a large botanical genus of the same name. Chiefly Mexican, they occur also in the southern and western United States. The plants have a large rosette of thick fleshy leaves generally ending in a sharp point and with a spiny margin (thanks, Wikipedia). And the best part, as designer Ty Mattson found, is that the plant shape makes for a nifty abstraction.

Agave is also the name of a neighborhood community with Spanish-style homes targeted to young families. According to designer Ty Mattson, "The client wanted to communicate 'fun, vitality and celebration of life.' Agave is very suburban—and the name suggested an organic solution with a Spanish twist, so I think the style reflects that. It's still fun, but softer and more traditional.

"I started on this project by researching the name. I looked at a lot of photos of agave plants and found one that was taken from directly above, creating this beautiful, almost geometric pattern. This became the inspiration for the final mark."

But notice that aside from somewhat similar desert color palettes, Mattson's agave designs seem almost to have come from a different hand than the one that designed the harder-edged 888 logos on the opposite page. Maybe this is the difference between a design targeting suburban young families as opposed to yuppies.

As Mattson describes it, "Bright, warm colors and interesting positive/negative space communicate the energy and vitality, and the typeface blends perfectly: the round figures and sharp points complement the symbol and communicate a hip, Spanish vibe."

107

ENOC Challenge

Mariam bin Natoof
Designer

Emirates National Oil Company
Client

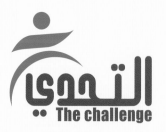

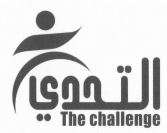

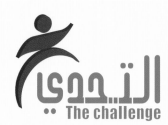

I was fascinated by this particular submission from the Middle East. The designer, Mariam bin Natoof, was asked by the Emirates National Oil Company (ENOC) to design a logo for an educational program they were sponsoring to train young students. I asked Natoof how she got started on this project.

"The client suggested the word 'challenge' to describe their concept of what the program was all about. So I brainstormed the problem. I thought of things like hands, fire, the world, and the human figure. Then after awhile I came up with the idea of using colors and shapes from the ENOC logo which, combined, look like a human figure stepping forward to meet the 'challenge.'

"The balloons you see in the earlier versions (and later discarded) were intended to represent the world and its challenges, and suggest that the ENOC course would prepare the student to face them."

I was curious about Arabic typography. Bin Natoof told me that there are far fewer Arabic fonts available, perhaps only 300, as compared to the thousands available to English-speaking people. She said she wanted to use a big, bold font to represent the idea of "challenge."

I was also struck by the colors she used, ones I thought unlikely to be found very often in American logo design. As it turns out, Natoof explained, these colors are fundamental to the Arab world and are typically found in the flags of various Arab nations.

So I guess you could say Natoof spends her Arabian nights sweating the details just like the rest of us. It's clear that design is design, the world over.

DELACRÈME

Delacrème

de la
CRÈME

delacrème

DELACRÈME

Delacrème

DE LACRÈME

delacrème

delacrème

Raúl Santos
Designer

700 Gramos
Design Studio

Gamadiez Recursos Humanos
Client

Delacrème is not a new, flavored coffee drink. It's a division of the Spanish human resources company Gamadiez, a high level headhunter for high level employers, such as Armani, Gaultier and Cartier. This division is especially dedicated to the biggest and most exclusive clients.

Designer Raúl Santos explains, "The name we came up with for the brand tried to give response to this exclusiveness and distinction. My first attempt was to highlight the accent, which helps to remind us that this is French. But I soon realized the typography should have its own personality and so moved on to a more handmade script.

"Eventually I ended up with a set of irregular, painter-like strokes which contributed to the sense of craftwork and dedication this brand deserved. The client loved it at first sight and didn't ask for any changes."

Did Santos draw the scripts? "I took fonts and then made changes to them until I got the appearance I believed it needed. I use a Wacom for custom lettering, but in this case I didn't need it (as they were fonts)."

Why are certain letters in orange? "I wanted to create an element that shined from long distances. Orange is perfect to accomplish this job. I found the *M* had more 'visual personality' than the rest so I made it orange, but there's no double meaning in this decision. Just visual."

When asked what he strives for in his logos, Santos says, "First of all, beauty: something capable enough to catch everyone's attention at first sight. And then you dream about the possibility of doing a great job and turning your offspring into a worldwide icon. I guess it's all about being proud of what came out of you."

109

WRITERS GUILD
OF AMERICA,
WEST, INC.

Rod Dyer
Designer / Creative Director

Rod Dyer International
Design Studio

Writers Guild of America, West, Inc.
Client

writers guild of america, west, inc.

WRITERS GUILD OF AMERICA, WEST, INC.

WRITERS GUILD OF AMERICA, WEST, INC.

110

All my essays open with an intriguing statement to draw the reader in—such as this one, about Rod Dyer's design of the Writers Guild of America, West, logo. Some background about the company is then provided. For example, located in Los Angeles, the WGA, West, is largely concerned with bettering the lot of screenwriters.

I then introduce the sensitive protagonist: designer Rod Dyer, who'll be pitted against the usual Simon LeGree of a client, and therein—we hope—lies some sort of a plot.

I then quote Dyer, who tells me, "Leslie, these WGA logos were inspired by your book, *A Treasury of German Graphics*. That whole collection was about designers creating with a quill pen, so for me, there was a logical jump to screenwriting." (Well, now the plot takes an unexpected twist!)

"I wanted something very graphic, that would reduce well," Dyer continues. "Something traditional as well as cool.

"With the advent of computers, everybody and his sister can design, and clients expect to see multiple versions—not like Paul Rand who'd go in with one logo and say, 'That's it.' But for me, it's always been you distill the company down to some image that reflects in an interesting way their pure and simple essence, and you put that across ... in a second."

At this point, a story should introduce what writers call the "complication." Dyer provides it: "I walked into a huge boardroom meeting with twenty writers—all very heady people who don't really understand graphics—and no one could agree on anything. It became all about ego, not logo."

But every complication must lead to the dénouement, and here it is: Eventually, the main guy put his foot down and a thrilling logo was chosen. The end.

Andrea Hoffmann / Ivan Angelic
Designers

Andrea Hoffmann
Creative Director

Hoffman Angelic Design
Agency

Philips Oral Healthcare Professional Group
Client

There ought to be a word like "onomatopoeia" (that refers to words derived from sounds like "buzz" or "crash") to describe logos that visually imitate the definitions of the words comprising them.

If so, such a word would apply well to Hoffman Angelic's logo for Emerging Trends in Oral Care. With a few master strokes, each of the comps they created, along with the final logo, manage to emerge not just as elegant and trendy but as beautifully composed with regard to tonal balance and the blending of art, lettering and type.

Creative Director Andrea Hoffmann tells us, "We had just designed a very well-received package for the Seattle Study Club Symposium that over time garnered us quite a few new clients. Eventually, it came to the attention of Philips Oral Healthcare, and they decided that they want-ed us to design the logo for their upcoming symposium.

"With the following spartan but clearly-defined guidelines, we went to work: The visual idea of 'fluidity' should be explored in preliminary designs. The main title, 'Emerging Trends' should stand out over the subtitle, 'in Oral Care.' The logo should have a 'hi-end' and 'new science' look. Of course, this took some research in pharmaceutical journals for us to determine what the client meant by 'new science.'

"So in our designs, we sought to depict fluidity with lettering in some cases and in others with flowing imagery. We tried to stay away from the typical 'scientific' symbolism and instead created just clean logos, while at the same time trying to capture the concept of 'emerging.'"

The final logo looks as fresh and clean as teeth after a hygienist's cleaning, though the comps are strong, too.

Mark Fox
Designer

BlackDog
Design Studio

CCA
Client

Of his logo for the California College of the Arts (where he's taught for many years), Mark Fox said, "This was a bit difficult because I didn't want to embarrass myself. I knew that the students would be rather brutal if they didn't care for the final logo.

"I was trying to create something that was both historical as well as current. I ended up using Paul Renner's *a* from his original design of Futura. I love the classicism of it, yet it also looks modern. It's created a consistent identity, especially the lowercase *a* which embodies CCA's spirit of experimentation, and this was the logo the client chose."

Mark Fox, who by elegant example has shown us what good logos look like, also spoke of bad ones. "A logo is bad when it's a cliché that we've all seen before. Or, from a form and function standpoint, it doesn't work at various sizes or is not designed for print; or to work in one color. First rule is creating something unique and memorable because you're creating an identity, so you must be distinct from somebody else, otherwise you fail. Poorly conceived, poorly executed, bad use of typography: that's a bad logo."

So far, comments from students on Fox's CCA logo have not been too brutal. And what else has teaching taught Mark Fox? "It's been a tremendous privilege to teach and work with the students," he says. "It forces me to think about design and to articulate in ways that I never have.

"Students continually challenge you and ask why. You can't so much as voice an opinion without being questioned by the students. And sometimes I'm wrong and that's helped me as well. It's taught me a lot about considering design on a deeper level."

C C A C W A T T I S I N S T I T U T E
FOR C O N T E M P O R A R Y A R T S **a**

 b

C C A C W A T T I S I N S T I T U T E
FOR C O N T E M P O R A R Y A R T S

c

C C A C W A T T I S I N S T I T U T E
FOR C O N T E M P O R A R Y A R T S

d

vv ɑ ʟ ʟ ı ꓛ

CCA Wattis Institute
for Contemporary Arts

Mark Fox
Designer

BlackDog
Design Studio

CCA Wattis Institute
Client

To be contemporary, just cut the top off the title. But there may be more to it than that. Designer Mark Fox explains, "In filling out my initial job questionnaire, Ralph Rugoff, Director of the CCA Wattis Institute, wrote: 'We are showing art that's thoughtful, provocative, moving and amusing, and that provokes curiosity and wonder. Art that … allows room for moments of discovery by the viewer.'

"This part of Ralph's statement intrigued me," Fox says, "and it became the basis of most of the identity concepts I created for the Institute. Art is particularly adept at making the familiar unfamiliar. By using an *M, E,* and *3* as *W*s [column **a**], I thought I could similarly make the familiar strange.

"The question mark [**b**] addresses the challenging (and puzzling) nature of the art shown by the Wattis: what? how? why? I did the 'wi' monogram (Wattis Institute) [**c**] in a script to suggest the individual and idiosyncratic nature of the work shown at the Wattis. And there's also a highly stylized *w* [**d**], which mirrors the process by which viewers of art often need to 'connect the dots' to understand a work.

"When I got the idea to crop the type in the final logo, it was another effort to render the familiar unfamiliar. At what point does the legible become illegible? At what point does something cease being itself and become something else? This point of tension is interesting conceptually and visually, and it memorably symbolizes the Wattis and its mission."

The chosen logotype explores the edge between suggestion and depiction and, in the process, creates an opportunity for that "moment of discovery." It does indeed draw our attention, causing us to ask the question, "What th—?"

But most importantly, the Wattis mark is memorable.

113

a

Andrea Hoffmann / Ivan Angelic
Designers

Ivan Angelic
Hand-Letterer / Illustrator

Electra Design Group
Agency

Wakefield Property Partnership
Client

When the project for Wakefield Beach came up for Hoffmann-Angelic Design, there was no doubt that a hand-lettered logo was going to be the ideal approach.

"This was a new development project that was located right on an island beachfront," Andrea Hoffmann explains. "The target was an affluent crowd. The client envisioned elegant type for this, and since the homes were quite contemporary, they didn't want to go the historical route. There was mention of playing to the 'senses,' the idea that you could 'hear' waves, 'feel' sand and breezes, 'smell' the air, and that time would stand still in this airy retreat.

"The graceful brush lettering we created seemed to have 'breezes' blowing through it, like the wind off the ocean. We also created custom designed type [a] so the client would have type that was uniquely theirs. And it also provided a stronger, more stable base to offset some of the softer symbols.

"After looking at photos of the location and beach scenes, we presented soft, restful colors that we saw in the water and sky and in the mauve sunsets. These colors would also work well on the white background that the logo was to be displayed against on the brochure.

"All the comps contain clean and calm symbols that speak of relaxation—such as the Adirondack chair, the shell and starfish—and help conjure the feeling of the sand under your feet."

The final logo chosen by the client is breezy with an almost nautical feel. The designers say that the three flowing brush stokes, colored green, blue and tan, represent the wind, the trees and the sand.

Andrea Hoffmann / Ivan Angelic
Designers

Andrea Hoffmann
Illustrator

Ivan Angelic
Hand-Letterer

Andrea Hoffmann
Creative Director

Hoffmann Angelic Design
Design Studio

Food & Service Resource Group
Client

Cook Studio Food Services is a social enterprise in British Columbia whose mission it is to create jobs and build skills for the long-term unemployed and youth at risk. They themselves describe Cook Studio Food Services as "a successful model of government-supported training for the unemployed that leads directly to employment created by partnership with industry [to aid in the] revitalization of Vancouver's Downtown East side."

Andrea Hoffmann describes the genesis of their logo design: "When this organization expanded into catering, they needed a logo that wasn't just the type and clip art they'd been using. They wanted something 'upscale, foodie, now, loose, trendy and friendly' to appeal to the kind of clientele that they were competing for in the catering business.

"Since Cook Studio designs innovative and creative menus for individuals, we used loose lettering to add a feeling of artistry. The artistic feel also echoes the word 'Studio' in their name. We rendered most of the designs loosely to create that specified 'trendy-friendly' feel, and included some food references as well. However, we also presented a logo that we felt added an important 'people aspect' of the project, and that one—the little chef running—was the one they chose.

"Well, when we doodled the chef in our thumbnails, we didn't think we'd be using it as a final. So when that logo was chosen, we naturally tried to redraw the little chef *much better*. But try as we might, it always lost some energy in the redrawing. So in the end, we simply scanned the chef into Photoshop as a greatly enlarged version, touched it up carefully, and—voila! Here's our happy little chef."

eemerge

e emerge

Dave Fletcher
Designer

theMechanism, llc.
Design Studio

eEmerge
Client

eemerge

eEmerge is a real estate firm in New York City specializing in short-term leases for start-up companies with high growth expectations.

"eEmerge was our first client," Dave Fletcher, Founding Partner and Creative Director of theMechanism, llc., explains. "It was a barter arrangement—that's actually how we started our company. We redesigned their logo and web site, and they provided us with office space. I couldn't imagine a better business deal. The dot com bubble had just burst, everyone was scrambling, and we were able to have a base in New York City.

"The client had chosen the name 'eEmerge' because someone else had already secured the URL 'emerge.com.' That was the first problem I tried to solve. It was important to separate out the name—so it was recognizable as a word—

from the first *e*, which could also live on its own as an icon.

"Since we were dealing with real estate, I wanted to express the idea of momentum and growth, and of young companies being able to grow out of their space. eEmerge was, in a sense, incubating companies until they could go out on their own. In our logo designs, we showed the *e* floating to the top, expanding outwards, or breaking out of the enclosed space: fairly literal imagery.

And how has theMechanism, llc., fared in the competitive atmosphere of Manhattan and London design firms? "We get jobs by doing extremely good work for our clients," Fletcher says. "The best thing for an agency like ours is word of mouth, and we've never really had to advertise. If you have clients that are happy with your work, they are your best form of advertising."

SBS

REAL ESTATE

MANAGEMENT COMPANY

Claudia Renzi
Designer

Gretchen Norman
Creative Director

Norman Inc.
Design Studio

SBS
Client

How many ways are there to say "real estate?" This is the crux of the problem we designers face every time we attempt to graphically distill the essence of a certain kind of company for whom we are designing a logo.

"The way I approached this logo was by looking at other real estate logos and trying to do something completely different from the norm," Claudia Renzi says. "I knew the client wanted something elegant containing just the letters *SBS*, but Creative Director Gretchen Norman recommended that a small description of the business should accompany the logo, so we added the words *Real Estate Management Company*, which defined the company.

"Most of the time I do sketches of my logo ideas, and then when I have some I like, I go to my computer. I will usually try to do some typographical, some abstract, some sym-

bolic, and then a combination of these different approaches. When I have the symbol down, I try to find the font that would complement the symbol. I don't ever do it the other way around because I believe that the symbol alone should give you an idea of what the business is about.

"Metaphors are also great. A logo should contain an element of the unexpected. I also kept in mind that they wanted a logo that looked corporate, so we presented more conservative logos on the second round. Again, the logo the client picked was not my favorite, but they were happy, which is important when they're the ones paying for the work. In the end, my final design, though selected, wasn't used by the client."

Yes, this happens to all of us. I call it "getting paid for practicing." And, if *another* company named "SBS" ever calls …

117

Leslie Cabarga
Designer

Frank Godwin
Creative Director

Goodthink Consultants, Inc.
Client

You've heard of the fabled elephant graveyards where aged pachyderms go to die? Somewhere, perhaps, there's a dot bomb logo graveyard for logos like this one for Goodthink, an IT consultant that didn't make the cut.

It could be that thinking good thoughts is just not the trend these days, or it could be that my logo design was the final nail in the coffin that sealed the company's doom. Do you ever think about that? What if it really is our fault?

Company owners obsess over their logos, nitpicking and fine-tooth-combing them to assure that every detail is perfect (though there's really no measure of what constitutes "perfection" in art). But what if—despite all our diligent efforts—some essential detail has been overlooked? What if, on account of the logo you designed, thousands of people are thrown out of work and lose their pensions?

What if it's Enron times two, not because of shady management and questionable accounting this time, but because you chose to use some lousy script lettering for the logo!

You may find this idea funny, but if your client thinks it's so imperative that he fuss over every dot and squiggle in your logo, then wouldn't the absence of such scrutiny spell certain doom for the success of his company?

So I asked Fred Smedly, former CEO of Goodthink, about this, but he didn't get my irony. "I think our chief mistake in this whole process," he said, "was settling too soon and not looking at another one hundred or so more logo comps. I still lie awake nights wondering, 'Was the *G* too large in relation to the other letters? What if we had just eliminated those two spirals? What if the baseline hadn't undulated? Was that shade of dark blue too dark … ?'"

a

Leslie Cabarga
Designer

Eric Davis
Creative Director

Institute of the American Musical
Client

I like to think that I'm so good I can nail a logo in one shot. Sometimes it happens. But sometimes not. My first logo for the Institute of the American Musical [a] was one such logo that I presented to the client full of confidence that they would immediately want to rush over and kiss me. No such luck. And I still don't get it.

Historians Miles Kreuger and Eric Davis, who run this phenomenal research center containing thousands upon thousands of still photographs, books, music sheets, recordings, playbills and other memorabilia relating to the musical theatre, are really partial to what I call the 'tween years from 1910 through 1925.

And that's precisely the style in which I designed this logo. The 'tween years came after the Victorian era and just prior to the auspicious debut of Art Deco in 1925. It's the Craftsman era, when design lines became blocky and more geometrical in contrast to the Victorian curlicues, but were still warmer and less severe than Art Deco. My clients got the distinction, but they still didn't like it. So I had to do another version—still sort of 'tweeny, but more contemporary. And this time they liked it!

Institute director Kreuger, who rejects modern definitions, had this to say about my logo, "I wouldn't call it a logo; it's lettering. A logo is an abstract design symbol for something. To me, a logo is the round thing they use for AT&T. As for the lettering, I love the lettering because it suggests early twentieth century. That's why we approved it."

And a canny move it's been, too. I understand the expectation of increased revenue has gone up by 56 percent since the new logo—or lettering—was implemented.

119

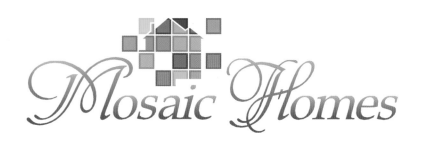

a

b

c

d

e

f

Mosaic Homes builds custom luxury homes. For Trish Schaefer, designer of the company's logo, the meticulous detail and old world craftsmanship suggested by mosaic tilework seemed a perfect way to express quality home construction.

As Schaefer tells us, "I started searching online for Middle Eastern, Mediterranean and also currently trendy tile styles. I then created a sort of composite tile design in a vector program using colors found here in the Southwest as well as the Middle East [**a**].

"Although I liked the tile I drew, it just wouldn't work. Too busy [**b** and **c**]. So I started playing with tile squares in non-specific patterns [**d** and **e**]. Good, but still not 'Wow!' Finally, I combined a house outline with the random colored tiles, and then I liked it better [**f**].

"I played with the colors of the tiles until I felt I'd achieved an impressionistic look of sky, sun and earth. Next, I used gradients to make the type look like wrought iron or copper, which are two very desirable building elements.

"I showed the client two fonts, one frilly and the other a Book Antigua Italic. They felt that the script was too scripty and the other, the italic, was too plain. So I mixed them together by using only the initial letters from the script, and it was the perfect solution. The tiled house, however, is really the focal point of the logo and will be used in different situations with and without the type."

The final printed logo was embossed and copper foil stamped, a lavish printing job befitting the luxury home builder. Eventually, the company plans to recreate the logo in actual tile and copper for the office. Sweet!

Trish Schaefer
Designer

Polaris Construction
Client

a

b

Trish Schaefer
Designer
Tidan USA
Client

NOGA Properties, LLC

c

Here's an otherworldly design where two visions—the client's and the designer's—though apparently conflicting, appear to have converged synchronistically.

Noga is a property management company whose name comes from the Hebrew word for the planet Venus.

"When given the assignment to design this logo," Trish Schaefer says, "my client showed me a logo that he'd found with a 'swoosh' going through one of the letters. He adored this idea and asked me to incorporate it into his logo, but I thought I'd try some other approaches as well.

"I went online and found some pictures of Venus transiting the sun [**a**]. I also found the word 'noga' written in Hebrew. From these, I picked my color palette and fonts.

"My early attempts played off the calligraphic style of the Hebrew [**b**], but my client didn't care for them, so I did more versions and some that incorporated that swoosh.

"Originally, I wanted the swoosh to bleed off the business card [**c**], but I decided I preferred the arc turned around, which led to the final logo: Venus is symbolized as the *o* in dark red with the sun, to be printed in gold foil, stamped behind it. It became a subtle representation of the transit of Venus across the sun. The font for Noga has a sort of hand-done look, only not too crinkly, to contrast with the glossy paper it would be printed on. The client and his partners have been very happy with the logo."

Looking at Schaefer's final logo, I see Venus transiting the sun, as in her original idea, yet I also see the swoosh through the letter *O* as in the client's wish. Two apparently conflicting concepts that somehow merged into one. Coincidence or an intelligent designer? You be the judge.

121

A-TOWN

Ty Mattson
Designer

Ty Mattson
Creative Director

Mattson Creative
Design Studio

Kovach Marketing /
Lennar Corporation
Client

One of many mock-ups created to sell the concept by giving the client a feel for the final logo in use.

It's all in the presentation and the conviction behind it, as Ty Mattson found when his all-stops-pulled-out proposal resulted in the selling of the concept he himself most believed in.

"This is one of those great projects that you wish all your other projects were like," says Mattson. "Amazing collaborations with everyone involved: myself, the fantastic marketing team, and the client—everyone had great respect for what everyone else was bringing to the table.

"The identity had to work for both luxury and affordable housing and have the energy to represent a distinctive retail environment. Once we understood the client's vision, we were charged with developing a name for the project. Of those we presented, the client green-lighted the name 'A-Town,' and we then set about designing the identity.

"You know how sometimes you create multiple concepts where there are multiple solutions, any of which would work fine? Well in this case, once I executed what would become the final mark, I was immediately convinced that it was the only concept that was appropriate.

"To make the case for this logo, I showed a wide range of photographic mock-ups that demonstrated how the mark would work on signage, monuments, hats, shopping bags, buses … even coffee cups. (Find them at www.mattsoncreative.com). We showed all of these in the initial logo presentation because of our conviction that the logo we were recommending really captured and communicated the client's vision. And the client agreed."

Client tastes may seem mercurial, but Mattson's story suggests that belief in our own "product" can be infectious.

Ty Mattson
Designer

Lance Huante
Creative Director

p11 creative & Mattson Creative
Design Studio

CIM Group, Inc.
Client

It's great when the name of the project suggests very clear imagery, and when the client allows the designer to fully utilize such possibilities and have fun with them.

"The art direction was '1930s/Daily Planet (as in Superman)' for this urban project," Ty Mattson says. "The development is located within an historic downtown district and the client wanted to reflect the building's authentic heritage with a new, fun and hip vibe."

So Mattson started, naturally, by researching trademarks and typefaces from the 1920s and 1930s, looking at iconography and style from that era. What he arrived at was a set of presentation comps that reproduce a 1930s Art Deco sensibility in style and color. But not perfectly. Instead, he created an updated version of the period style that functions well for his modern client, evoking all the grandeur and pomposity of period architectural design … sans cockroaches.

Says Mattson, "Depicting actual globes was an obvious first step. And I had a lot of fun creating the Atlas sketches, which have a lot of personality.

"In the end, the client selected a more refined concept where the actual representation of the globe is secondary to the type. It's a simpler solution, but I think it's more sophisticated and bold, while still evoking a distinct time period."

Having visited Manhattan's famous Art Deco icon, the Chrysler Building, I was especially impressed with the angular ziggurat designs on the elevator doors, done in inlaid exotic wood veneers. This memory came back to me as I looked at Mattson's designs, which surely must be an indication that his research into period design was not in vain.

Jon Wippich / Karen Wippich
Designers

Dotzero Design
Design Studio

Green Tags
Client

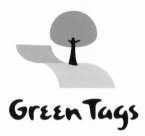

The moment I laid eyes on the Green Tags logo I was wild about it. Maybe it was the colors or the informal brush script type, or maybe I'm just a tree-hugger at heart.

Green Tags is a program of the Bonneville Environmental Foundation, a small nonprofit that helps conscious consumers to support green energy-producing companies.

Designer Jon Wippich says, "The complex mission of this company wasn't an easy one to illustrate, but few really are. It seems that so many businesses are too nebulous to get a handle on immediately. 'Environmentally-conscious' was the main impression this client wanted to convey. As we worked on it, it became clear that we could get the general idea across with just a simple leaf image.

"We created a number of icons involving tag and leaf shapes. Then we presented them with different fonts to see which the client preferred. It came down to an integration of tag, leaf and type. The effect was light, lively, and active."

Karen Wippich is Dotzero Design's resident color expert. Her sumptuous palette of leafy greens contributed mightily to the Green Tags logo's success. When she and husband Jon design logos, Karen will often take over work on files at the color stage. She says, "I'm hyperaware of color combinations everywhere. I'll look to interior designs, or I'll recall colors that I saw on a TV ad. Then, I start pushing them around until they look right. Color makes or breaks a design."

And at the end of the day, Green Tags was more than just another job well done! Karen Wippich says, "We've done a lot of environmental and nonprofit logos. The issues they address can make our job feel more rewarding. And they are often the most appreciative of the work."

a

b

c

Wendy Stamberger
Designer

The Stamberger Company
Design Studio

Hope Equity
Client

By nature, most designers become chameleons to adapt ourselves to the requirements of any job. For Hope Equity—an online community allowing people to invest in the countries, organizations and social issues that matter most to them—Wendy Stamberger has seemingly taken on a 1950s persona. Her high-concept, high-contrast logos all have an appealing retro feeling to them.

About her client, Stamberger says, "Hope Equity goes to places like Africa and South America to teach people how to use the land to its fullest capacity so they can sustain themselves. But for their logo, it was all about financial, and they didn't want anything too earthy looking. They're targeting a younger, more urban and affluent audience; sort of the Starbucks crowd.

"I wanted to give the identity a look that I myself would trust, if investing my own money, yet not something that looked traditional, like a typical banking foundation.

"I did the feather and fish [a] to represent the animals, and the fishing rod represents the philosophy of teaching people to fish, rather than just giving them a fish. The grey mask [b] is two different people, one is behind the other, helping. The clients were really happy with what they saw, but they wanted it really simple, so, for example, the feather and fork was too hand-drawn for them. They still wanted it strong, like a banking concern. They liked the leaves [c], and in the end, we simplified it to indicate 'earth-friendly' and 'sustainable' without being too specific."

The clients are delighted with the final logo's warm/cool color combo that appeals to a modern urban aesthetic while still somehow retaining a cool, 1950s pedigree.

125

HOUSE OF RUTH
MARYLAND

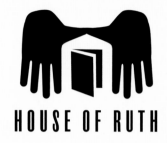

HOUSE OF RUTH

a

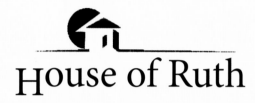

Ⓗouse of Ruth

b

Michelle Suazo / Kara Brook
Designers

Michelle Suazo
Creative Director

Brook Group, LTD
Design Studio

House of Ruth
Client

House
of Ruth

c

HOUSE OF RUTH

d

It might be said that anybody can trace a hand or draw a rudimentary house or book, without it necessarily being indicative of great talent. However, the artistic juxtaposition of typography and simple visual elements I see when I look at Michelle Suazo's logo comps for House of Ruth tell me that there is a talented hand at work.

These are excellent examples of good judgment in the use of tonal color, proportion, composition, juxtaposition and arrangement of type, including letter spacing. For example in [**a**], the bold condensed font echoes the spaces in the fingers, creating a harmony between the two.

In [**b**], both the font and the illustration have matching thick/thin aspects. These are the sorts of qualities that are not easy to teach or even to define. We designers need to have the capacity to recognize them—and later emulate them—in the graphic design we observe around us.

These designs are not just decorative. The images also inject meaning into this mark for House of Ruth, an organization that is one of the nation's leading advocates for victims of domestic violence, helping thousands of battered women and their children find safety and security.

Suazo explains, "One way we expressed this 'safe haven' was the open book [**c**], referring to the origin of the organization's name from Biblical references, that also forms a welcoming entry to a house.

"Our goal for the final House of Ruth brand mark was to show a progression from chaos to stability. The scribbled line concept—resulting from a collaboration with Kara Brook—which develops into a home with an open door [**d** and final logo], signals welcome to all of those in need."

a

b

c

Michelle Suazo
Designer

Michelle Suazo
Creative Director

Brook Group, LTD
Design Studio

Soulful Golf
Client

Michelle Suazo is obsessed—with design, that is. "Sometimes years later, I'll notice that the integrity of a mark has strayed, and I'll call my client to offer suggestions," Suazo says.

Luckily, the obsession to rid the world of poor design is shared by her boss, Kara Brook, owner of Brook Group, who does a lot of work with organizations. Her reaction when she met the founders of Soulful Golf was, "Hey, you guys need help."

Soulful Golf is a national organization dedicated to increasing the presence of golfers of color on the world's top golf courses. They needed a logo that instilled a more professional image.

The first step involved a questionnaire. Suazo says, "We sit down with all our clients and ask them such things as, 'What are your image attributes? How do you want customers to think of you?' Often, going into the process, clients don't even know what they want. Eventually, you get everyone to agree to your accepted terms. So later, nobody will say, 'I don't like green.'"

Green *was* cool, however, though apparently not orange and blue, as in Suazo's first soulful design [**a**], about which she says, "That was meant to be playful and to show a bit of diversity in the different colors. And it visually tied in the topic, so right away you saw 'golf.' But when it came down to it, they wanted something more simplified. The goal of the mark was to convey the excitement and action of golf and success in an easy to identify mark. The next design [**b**] went too far in a conservative direction—not enough playfulness."

As for the final mark [**c** and boxed], Suazo says, "The clients are very happy, and their organization continues to expand. But I noticed they print it in a different green every time, so I'm like, oh my gosh! I feel that it's my obligation—or maybe my obsession—to ensure that the mark is well-handled in perpetuity."

800north8th
city homes

Lance Huante
Designer

Lance Huante
Creative Director

p11 creative
Agency

800 North 8th
Client

a

b

c

d

Did you at once notice the "800" made of leaves in preliminary logo version [a], for a condominium community in an upscale area of Northern California, or did it take you a moment? The next logo [b] is just windows and a door, but I like it anyway.

Now look at [c]. At first, I imagined it as a baguette, endive and cucumber sticking out of a shopping bag—obviously items from local gourmet stores—before I realized it too was an "800." If the attempt at integrating the 800 as a graphic had been too forced, as many such attempts are, it wouldn't be so wonderful, but instead its inclusion is a seamless and attractive attribute to the nameplates.

Lastly, did you think [d] was just some stylized foliage behind trees and a bench in what must be the idyllic setting of this condominium? No, the foliage is yet another "800."

As for the final mark—a total departure from the leafy comps—designer Lance Huante says, "It was meant to reinforce the novelty of the numerical property name. We wanted it to look almost sculptural, with flow, presence and depth. We wanted to be able to see it animating in the property web site. It's got a neutral color palette that fits the urban industrial look we aspired to, making it fairly timeless."

p11 creative had been told that the design should be hip without being overdone. It had to emulate the clean architectural lines of the property. And it had to stand out amidst a bustling retail and residential downtown area.

But how did you get from leafy to lean? I asked. "Well," says Huante, "our client is a big believer in 'less is more,' so we simplified the final logo to accommodate his preference. When a client has a good idea, we listen."

a

b

c

d

e

Lance Huante
Designer

Lance Huante
Creative Director

p11 creative
Agency

Ocean Club
Client

Sometimes logo design begins in weird places, like Microsoft Word. When p11 creative was called in to rebrand a newly renovated apartment complex called "The Village," they decided a more sophisticated name was in order. So bundled with the logo design, they ended up naming the product, too. The client selected "Ocean Club" to emphasize the exclusivity of the beachfront location.

According to p11 creative's Leigh White, "After visiting the property, two things inspired us: the waterfront location and the beautiful landscaping. Mind you, the colors could easily have gone the way of the 1980s *Miami Vice* teal and pink nightmare palette, but for Redondo Beach, California, we chose a more natural color array.

"This logo [**a**] has windswept boat sails, but the condo residents are hip professionals so the idea was too nautical.

"The client said this icon logo [**b**] was too 'new wave.' We thought this one was simple and beautiful [**c**]. It had the texture of tile, and a feeling of water but it needed more of the green of the gorgeous sprawling landscaping.

"This was sort of an obvious idea [**d**], but it looked like a cruise line offering. Now if Isaac from the *Love Boat* TV show was in the Ocean Club sales office mixing fresh margaritas, this would've made sense. But no such luck.

"Almost there [**e**]. The key was taking those curvy shapes and adding motion. Making them more wave-like, more like feathers of seagulls in the sky. Playing with them. And making them embrace the word 'club' to show a relationship."

The final version has it all: motion, elegance, beautiful colors reflecting land and water, and a clean, lowercase modern sans serif font keeping the design airy and light.

a

b

c

d

e

f

"The National Quality Center provides quality improvement technical assistance to Ryan White CARE Act grantees across the United States, building capacity to improve the quality of HIV/AIDS care and services." So this agency describes itself. Put more simply, its mission is to benefit those with AIDS. And like any other organization, they needed a compelling logo.

Enter designer Felix Sockwell, who describes his process leading to the final NQC logo. "This first direction [**a**] was 'repurposed' from a previous job. I usually don't show such work, but you never know what someone else is going to see. The continuous-line figures did actually foreshadow the final logo.

"Here is another approach [**b**]. It's pretty terrible. It was an idea though and something I had to work through. The next thing I tried was kind of a weird ribboned-hand as helper [**c**].

"Now, these bold-style figures [**d**] have a strong, solid feel, but they seem a bit too easy. Basically, this direction didn't knock anyone's socks off.

"This series of faces [**e**] is also a bit off. When art director Stefan Sagmeister

g

h

Felix Sockwell
Designer

Felix Sockwell, Matthias Ernstberger
Illustrators

Stefan Sagmeister
Art Director

Sagmeister, INC
Agency

AIDS National Quality Center
Client

and I sat down initially, he was thinking something along the lines of a face made of ribbon. I liked the idea too, but the more it evolved the more it became apparent that there was a gender issue: how could we choose between a male face and a female one? That proved tough.

"I actually quite liked this idea [**f**], a composite photograph of one ribbon taken several ways, ending in the red AIDS symbol. The problem came in its application: it wouldn't reduce well on the web.

"This grouping [**g**] is a set of marks unified by a red-ribboned initial Q. It includes the logo-mark NQC, a signage suggestion and three accompanying icons. It is grounded in a nice aesthetic, but something still seemed to be missing. Perhaps it was just slightly boring.

"The idea that we finally settled on was an image I had drawn long ago [**h**]. It's a simple gesture that communicates two people taking care of one another. The final selection, composed of the red ribbon, slightly resembles a G clef, but hey—it still works! Our plan was to photograph it but we ran into a production issue, so we just went with this version drawn in Illustrator with gradients. I'm really pleased with it.

"It was great working with Matthias Ernstberger and Stefan Sagmeister on such a meaningful job. One thing that resonated with me was Stefan saying 'Felix, we only show one!' as I opened my sketchbook. Now, rarely do I only show one design, but I found this to be an incredibly empowering mindset. Sure enough, he presented only one. And one was all it took."

Thanks Felix, for that comprehensive tour of your logo!

131

Andrea Hoffmann / Ivan Angelic
Designers

Ivan Angelic
Hand-Letterer

Andrea Hoffmann
Creative Director

Electra Design Group
Agency

Brio
Client

a

The preliminary comps leading to this final logo show great individuality and uniqueness in terms of the letterforms. It makes me wonder, where did the designers get such a variety of great ideas?

Well, it turns out Hoffmann and Angelic were given some decent direction by their client: "We were told that the meaning of Brio was 'the quality of being active or spirited or alive and vigorous.' As the target market for this condominium project was to be mainly young singles and couples in their twenties and thirties, the look was described as needing to be 'fresh, hip and fun' with a cheerful and entertaining attitude.

"The client also said they wanted to see a logo with the Vespa motorcycle look, to go along with the 1950s kitschy style that is popular right now, but we had misgiv-

ings about that right away. Even though we showed one in a 'Vespa' script [a], we felt it was too close and warned them that such a 'tribute' might be an infringement. Luckily, they didn't even like that approach once they saw it next to the other ideas we presented—it is often surprising how you can talk a client out of his own idea simply by bringing it to visual life and standing it up next to your own better designs.

"With all the development projects being built lately, it is important that each one makes a memorable statement. The designed script lettering the client chose is a perfect approach for these projects as the desired image can be communicated entirely by the lettering."

The final Brio logo is indeed unique—there's not another logo like it in the world. It's a handmade work of art.

a

b

c

d

e

f

g

h

Michael Samuel
Designer

Michael Samuel Graphics
Design Studio

Hickey Turner Capital
Client

"It's easier when the client knows what he wants," Michael Samuel says. "Not that he'll always get it! This client had a strong bias in favor of a griffin [**a**, **b**]. Since Hickey Turner Capital is a company that 'helps Chinese companies go public in the U.S.', it didn't sound like such a bad idea.

"The client then decided that a lion would be stronger and asked me to match the style of an old pin he had in his collection [**c**]. Still searching for that elusive symbol of power, we next tried a dragon [**d**] as a stronger image and moved to a square for additional solidity.

"When a client asks for something so specific yet continues to be unsatisfied, that's my signal to take over the design process. I began to explore other design options that seemed relevant to investment firms [**e**].

"The client never actually saw this first rendition of the *H-T* blend [**f**], but I was looking for something specific to his business name, and I have to admit that Raymond Loewy's International Harvester logo wasn't far from my mind. To add a little visual sophistication, I outlined the letters [**g**]. At this point, I began to get that shivery feeling which indicates that I'm onto something major.

"At 2 AM I got out of bed and sent an email to the client with this sketch [**h**], telling him the problem was solved. For the final, I added a center line in imitation of Chinese lattice screens. After showing it to his associates and receiving a unanimous response (and taking a few days to mourn the passing of his dragon idea), the client agreed."

The symbol is visually striking as well as imposing. To look at it is to automatically assume you are dealing with a multi-national corporation. Yes, it's all in the visuals!

133

The physician is admonished to "heal thyself."
Hey, have you ever tried giving yourself a proctological exam? Fortunately, designers who must design their own logos face an easier task—though to hear them whine about it, only slightly. In this section we hear from Eisbrenner, Buzzbizz, Drobac and Ricksticks about their self-design tribulations. We will also find out how firms like Klose Associates, Big Leap, Timber Signs and Gabriel Gely, that are designers themselves of one sort or another, have circumvented the issue by hiring other designers to create their logos. But enough talk. Turn the page and see.

ADVERTISING
&DESIGN

Eisbrenner

P U B L I C R E L A T I O N S

Nathan Rowe / Steve Salhaney
Designers

Nathan Rowe
Creative Director

Eisbrenner Public Relations
Design Studio

Eisbrenner Public Relations
Client

When a company seeks to update its own image, there's nothing like having the solution right at its fingertips. Thus it was that *Eisbrenner Public Relations*, a full service public relations and marketing communications company specializing in valuable media, supplier, OEM, aftermarket and association relationships within the automotive and technology industries, looked no further than its own design department for the new identity they sought.

As graphic designer Nathan Rowe explains, "Our company's logo was dated and no longer represented the culture and capabilities of the firm. Our task was to develop a logo that better represented the firm's brand identity.

"To help distinguish the logo from other font-based solutions, we incorporated the orange dot above the *i* as an iconic element. The orange dot also served as an aid in the pronunciation of the company name (*Eyes*-bren-ner). In addition, we chose the color orange to represent the creative side of the firm, and the blue represented the strategic, professional side.

"We've gotten a great response to the new logo. We feel it successfully represents the company's philosophy and corporate culture—creative, strategic, technical—while still retaining a recognition factor for the firm's target audiences.

"A useful aspect of the Eisbrenner Public Relations logo is its flexibility. The firm has adapted this basic layout to develop logos for each of its practice areas: Eisbrenner Design Group, Eisbrenner Events Group and Eisbrenner Message Coaching[SM]. You can tell each of these logos is a part of Eisbrenner Public Relations."

a

Willette Youkey
Chris Bjerken
Designers

Buzzbizz Studios
Design Studio

Buzzbizz Studios
Client

She lay in bed, wearing only a flimsy negligée, in that dreamy, half-awake/half-conscious state, when inspiration struck. And brother, did it ever!

As Willette Youkey later told the tabloids, "Been working late on a redesign of the company logo—Buzzbizz Studios, a full media production house encompassing audio/visual production, graphic and web design, printing and CD/DVD duplication. Knew the logo had to be something eye-catching and still represent our slogan: 'Be seen. Be heard.'

"But with every sketch I made, success mocked me. Felt like just another washed-up designer who chokes when design gets personal—when it's for *your own company*. I even had Chris Bjerken give it a try [a], but no dice.

"2:00 AM. I lay there, somewhere between consciousness and sleep. Lady Luck finally arrived in a burst of inspiration.

'Go back to the basics of being seen and being heard—just the eyes and ears, ma'am,' she whispered.

"The logo sprang to life, and the rest was a piece of cake. The final logo consists of an eye with 'sound waves' emanating from its brow. The shape is clean and maintains our original cobalt blue and silver color scheme—blue for creativity and intuitiveness; silver for hi-tech.

"Lastly, the font. Flirted with dozens and none suited me better than Oblivious. I like my fonts like my men: high-tech, masculine and … oblivious. It looked good in contrast to my more feminine (logo) curves.

"Case closed. Partners happy. The new logo stands out from a distance and has several options: It can be used as logo, name, and slogan; logo and name; or just the logo."

And that's all she wrote.

In the rush to open, the first logo was thrown together to identify the original three services the studio offered.

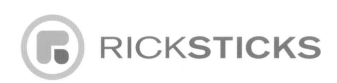

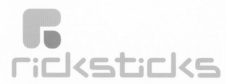

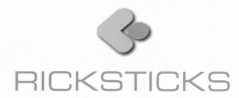

Jeff Dingwell, Rick Sato
Designers

Rick Sato
Creative Director

Ricksticks Inc.
Design Studio

Ricksticks Inc.
Client

Rebranding a design firm can be a daunting task for those involved. So much so that many will choose to outsource the project to gain objectivity and perspective.

Ricksticks Inc. is a graphic design and communications firm servicing the Toronto area. The Ricksticks identity remained on the shelf for many years before business growth made a solid branding program a necessity.

So, how hard could it be? "We were in the business of designing logos," Rick Sato says. "Yet incredibly, the task proved to be difficult enough to produce sleepless nights. Our problem was not a lack of ideas. The difficulty was in discerning the proper tone and deciding upon the unified voice of the firm. The Ricksticks name was a remnant of a completely different business model; one more focused around the talents of a single individual, myself, and the new identity needed to reflect the service offerings of a team of creatives.

"After much hard work and soul-searching, a solid concept began to develop. The concept emerged from a shape which could be described as an *R* or a fluid droplet or an arrow. However, execution was still problematic, so we decided to go outside the firm for help.

"We e-mailed the raw elements of the logo to peers and confidantes with hopes of new insight. One designer, Jeff Dingwell, suggested new elements: a rounded square and a secondary shade of grey. We morphed the rounded square into a circle, stretched and kerned up the name and the new logo was born."

By the very selection of a bold and tasteful final design, the firm has "positioned" itself as upper level, an effect that, in my opinion, earlier versions would not have achieved.

GABRIEL GELY

DESIGN GROUP

gabriel gely
design group

gabriel.gely

DESIGN GROUP

GABRIEL GELY

design group

gabriel.gely

DESIGN GROUP

GABRIEL**GELY**

DESIGN GROUP

Christina Maynard, Rick Sato
Designers

Rick Sato
Creative Director

Ricksticks Inc.
Design Studio

Gabriel Gely Design Group
Client

Many designers feel that we can design anything, but it is often wise to know your limits and, when necessary, call in the specialists. As did Gabriel Gely Design Group, an audio/video design and installation company specializing in custom home theatres and automated commercial spaces.

The firm asked Ricksticks, Inc., to create an identity for them. The final logo would need to appeal to a high end, sophisticated market, both residential and commercial. An extensive client interview revealed a great deal of interest in making use of a Möbius strip within the logo. They also liked the idea of the triangle as an appealing geometric shape.

Ricksticks designers Rick Sato and Christine Maynard felt that, while the Möbius strip was an important idea that needed to be explored, they wanted to look for ways to make the shape work in two dimensions. So additional concepts were also developed based on ideas derived from using Ricksticks' client discovery questionnaire.

"For example," Sato explains, "we chose to make use of the double *G*s within the company name by emphasizing the letter and identifying visual themes that would be a good fit within the industry."

Having once worked with the client before, Ricksticks had some insight into the style and tone that would best meet their tastes, so the initial response to their concepts was positive. The Möbius idea was forgotten in favor of the final version—a *G* rotated and morphed into a power button icon.

I think the rotated *G* is brilliant, while the Möbius strip image has been overused. The final choice of type speaks as eloquently about the company as the mark itself.

139

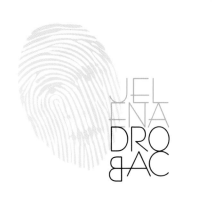

Jelena Drobac
Designer
Jelena Drobac
Client

a

b

c

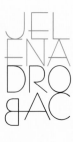

d

e

f

A fun manifestation
of the Drobac logo in
a self-promotional ad.

140

Jelena Drobac says, "Designing a visual identity, logo, symbol, pictogram, or whatever you may call it, is an interesting game, but complex. It has to look good and eye-catching, easy to read and understand, has to have meaning and relevance, look good both in small and large dimensions, and not least of all, be memorable."

And as many of us have found, that task is even more difficult when it is your own logo design with which you will be represented as a designer who designs visual identities.

Here's how Drobac describes her own quest for a personal visual identity: "I started with the most common approach—just combining letters [**a** and **b**]. Then I tried adding an idea from heraldry to it—keeping the letter *D* as a letter, the shield and letter *J* could be turned into a foot, an ancient heraldic symbol of strength [**c**]. Also, it reminded me of dance, play, elegance, wit. I still think it's a great idea, but some people asked me if I was in the shoe or shoe design business.

"Next I tried a little play with letters [**d**]. My name is divided from my surname by color. To add a little bit of spice, I turned the *B* around and connected it with *A*.

"Some of the old masters of painting and sculpture used their fingertip to sign their work. I tried that here [**e**], but there was something missing, so I incorporated my facial features [**f**] to just vaguely resemble me, but not too much. I wanted my thumb print to remain the central focus."

In her final version, the thumbprint-portrait has been relegated to the background, like a real fingerprint. To the fore is the logotype. And the message according to Drobac is: "This is me adding a personal touch to every project."

Jelena Drobac
Designer
Multipano
Client

What would we do without client parameters? If a client said, "Go and design a logo—oh, anything will do," would we be like the painter facing the terror of a blank canvas? So thank goodness, when we're assigned a logo job, there are parameters, briefings, expectations—a company name and its purpose to expound—and these provide us something to work with, placing us, right from the start, at least several squares ahead of the fine artist, with only his own neuroses to mine for ideas, toward completing the assignment at hand.

For example, when Jelena Drobac was given this job to create the identity for Multipano, a Belgrade-based outdoor advertising company, she first had to wrack her visual memory to find associations.

"The company name consists of two words, multi and pano—literally 'board' or 'billboard,'" Drobac explains.

"I decided to play with the words and all my concepts were based on variations on this theme of a multitude of boards."

Drobac's initial attempts met with the usual client responses, such as, "It looks like it's a building construction company," and "It`s too similar to a Japanese Tobacco Industry logo." (There's always some bright executive whose desire to have an opinion heard and his ego acknowledged overrides his desire to look objectively at the work.)

Drobac's favorite became the final design. (It's so nice when that happens!) The logo features three billboards in perspective forming the letter *M*. The perspective view is enhanced by gradations of color. The typography consisted of regular letters and small caps to keep it more dynamic and to show the creative side of the company.

MARKETING AND
COMMUNICATIONS

Noah Bell
Designer

Sara Pickering
Art Director

Design Elements, Inc.
Design Studio

Big Leap Creative
Client

I wouldn't necessarily look to Sandpoint, Idaho, if I needed the services of a PR marketing firm. But if I didn't, I'd miss Big Leap Creative, a full-service PR marketing firm, based, indeed, in Sandpoint, Idaho. Big Leap develops and implements marketing strategies, and assists their clients in "leaping" over the various business hurdles. Their specialty services include PR, marketing and copy writing.

"In need of a re-brand, Big Leap Creative asked if we could design their logo, and do so in a big hurry," Design Elements' Noah Bell says. "We had just two weeks. With a conference scheduled in a month's time, they needed a finished logo for placement on various collateral and advertising materials. Luckily, BLC came prepared with a suggested color scheme and a clear list of emotive words that they believed best represented their company, included

the following: trustworthy, empowering, confident, spirited, whimsical, uplifting, organic, natural, and edgy.

"Using their descriptors and the suggested color palette, we aimed toward a logo that showed 'confidence' without being too 'whimsical.'

"Some of our attempts, however, looked somewhat like a day care center or a children's retail shop. So we were forced to reevaluate, hoping to find harmony among the descriptors with a more mature statement."

The final choice is a powerful image that was quickly approved. In the end, working on a tight deadline compelled the designer to create efficiently, transferring the client's multi-faceted personality into one compelling idea.

So the next time I need to take a big leap of faith in hiring a PR firm, I might just end up in Sandpoint, Idaho.

CHET FROHLICH

PHOTOGRAPHY

a

chet frohlich PHOTOGRAPHY

c

CHET FROHLICH

PHOTOGRAPHY

b

CHETFROHLICH

Photography

d

CHET
FROH
LICH

PHOTO GRAPHY

e

Chet**Frohlich**

PHOTOGRAPHY

Lance Huante
Designer

Leigh White
Marketing/Concept manager

p11creative
Design Studio

Chet Frohlich Photography
Client

Working for other creative people can impose its own kind of pressure. You feel obligated to outdo yourself to create a logo that goes above and beyond. This was the challenge Lance Huante and crew faced when designing an identity for a fellow industry guy.

"Chet Frohlich is a commercial photographer in Orange County, California," Leigh White of p11creative told us. "He's a very laid back dude and a total beach boy. His clients include designers, creative directors, and marketing managers—basically, us. His logo needed to appeal to this audience yet reflect his independent personality.

"We were inspired by the client's spiked hair for this design [**a**]. We liked the simplicity of the black and red, but felt it was not commercial enough.

"This minimal solution [**b**] was deemed too static. The split type for the name and for the word "photography" made it too hard to identify instantly. Foiled again.

"Every time I have seen him, Chet has a loud Hawaiian shirt on. But our concept [**c**] was too loose for the target audience. The logo still has to maintain credibility and precision. Damn the hypocrisy of business!

"Chet thought the camera icon in this one [**d**] looked like a point-and-shoot and not a professional photographer's camera. (Frickin' photographers and their eye for detail!)

"This solution was based upon a contact sheet [**e**] with the chosen image highlighted in red. But it was too stiff.

Huante's final design in yellow, acid green, and black makes a creative, yet professional statement. The asymmetrical type alignment resolves the company name as well. One can assume Chet Frohlich is very proud.

143

Doreen Kennedy
Designer

Triskill Interior Art & Design
Client

Proving that it really is a small world, after all, Designer Doreen Kennedy, based in Dublin, Ireland, reports that her power breakfast—much like that of any New York designer—consists of "several mugs of Java coffee and toast, or if I'm working away from home, a large cappuccino and poppyseed bagel with cream cheese!"

Kennedy designed this logo for Triskill, a Dublin-based company that creates bespoke (custom-made) artwork for interiors, and exteriors including mosaic and large-scale murals. The year 2005, marked the company's tenth year in business, and they decided it was time for a new look.

As Kennedy describes it, "The company was established by three artists with backgrounds in fine art, and the name developed around the idea of three skilled people: 'tri-skill.' I already had close ties with the company when I was asked to develop the original Triskill logo and I based it around the theme of three people, the triangle shape and three segments. The triangle also suggests strength and, like the pyramids of Egypt, longevity.

"The partners, however, preferred to move away from the symbol of the triangle towards something more typographic, and also to utilize colors that suggested the color schemes found in much of the customized artwork that they create."

Looking at the range of designs above, I would say that the triangle logos are more interesting than the final typographic version. Yet, as many of the logos in this book prove, often the simplest solution is the best. In this case, there is no doubt that Kennedy's final design confers a panache equal to any from Dublin to New York.

a

b

c

d

e

K O A

K L O S E A S S O C I A T E S

Stacey Geller
Designer

American Design Language
Design Studio

Klose Associates
Client

Saying good-bye is never easy. Especially when it's a logo that has provided good service for many years. But eventually, outdated logos must be put out of their misery.

Not without a fight, however.

Stacey Geller tells us about one such experience: "We were hired to redesign the logo for Klose Associates, a firm specializing in designing and producing trade show exhibits. The original logo [sidebar] was created in 1983 by company owner, Raymond Klose, and was due for a redesign.

"We produced three initial directions. The concept behind iteration [a] is that of creating objects through action. This logo is typographically a *K* and an *A*, but conceptually it's a folded piece of paper represented by the dotted line.

"Iteration [b] is based on the concept of how things fit together. This is another typographic solution where the arms of the *K* represent the walls of an exhibit space. The *A* is also a pyramid which is the strongest building structure.

"Iteration [c] forms a dynamic initial *K*. The top half of the box is also an *A*."

With three great-looking logo designs, it should have been smooth sailing at this point for Geller and company. But before making a final decision, the client asked her to explore the idea of modernizing the existing logo [columns **d** and **e**], after which he might be willing to part with it.

"When asked to go back and revisit the original logo, I was open minded about it," Geller says, "but I also hoped it would show the client why they *should* move away from it."

But for Geller's client, "It was a great little exercise in closure. It resolved the question in the client's mind, and he has now fully embraced the new logo."

The client's original logo from 1983.

145

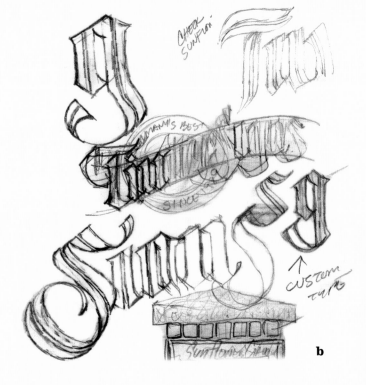

a

b

Gary Anderson
Designer

Bloomington Design
Design Studio

Timber Signs
Client

Gary Anderson hoped he'd finally get a chance to work in the old, classic, hard-edged German style when he was hired to design the logo for Timber Signs, a sign company located in Germany.

"I've been well published in the sign trade magazines," Anderson says, "so this German company saw my work and wanted a logo from me.

"Without really thinking about current graphic style in Germany, I mocked up some old German images [column **a**] to try to decipher where the client wanted to go. But they said they were 'too German.' It turned out they had come to me because they wanted an American style!

"And here's another funny thing. I'd read this word 'form-schneyders' in some book that defined it as "makers of beautiful pictures," so I thought the client would be proud of me

for including this German word, but they had never heard of this word before (don't trust everything you read!).

"So I ended up using my own lettering style based on classic American sign art of the 1910s and 1920s for the job—as I would for any local customer—and when I showed the client the next very rough letterforms [column **b**], they said it was dead-on-the-money where they wanted to go."

I asked Anderson if the final style isn't actually somewhat Germanic/gothic, after all, and he explained some distinctions: "They wanted a custom letter, not a font, and I did it in a somewhat Germanesque style, but the overall look of it is not so rigid. The lettering is placed on a serpentine baseline and it has some swoops and dips that the old style would never have had." Well, though 'formschneyders' doesn't apply, perhaps Gary Andersen's final logo has 'fahrvergnügen.'

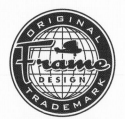

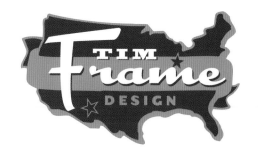

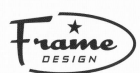

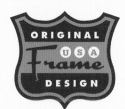

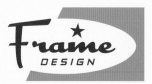
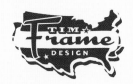
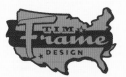

Tim Frame
Designer
Tim Frame Design
Design Studio
Tim Frame Design
Client

Many a client has difficulty discussing his logo with objectivity, so I decided to interview the designer.

How were you chosen to design the logo for Tim Frame?

"Paul Howalt was actually the first choice to design the logo, but ultimately I was hired because my style was more appropriate, and my fee was much lower."

Did Frame turn out to be a good client or a bad client?

"I can honestly say it was like working for myself. He's a really nice guy; he works tirelessly until he's completely satisfied that he's done his best work; and he's very humble, too.

"The client's only up-front requirements were to create a unique logo mark that characterized Tim Frame's work. It was important to incorporate some original typography and utilize icons or graphic illustrations in a style familiar to his work and from which he draws much of his inspiration.

Where did your concepts for this logo come from?

"From a variety of sources, really, but the key element that was designed first was a custom, hand lettered script for the word 'Frame.' The concepts evolved from there and it largely became an exercise in looking at other design elements and graphic treatments that would complement the typography."

What were you trying to convey with the colors?

"Just a unique combination of colors that were familiar by themselves, but much less so as a color combination. Like the goal of the design itself, to utilize a color scheme that could be considered timeless."

In the end was the client pleased?

"Yes, but it's always a challenge when designing a logo for someone who is a designer himself."

147

Chapter 6

http://www.interne

Leslie Cabarga

High tech can mean many different things to different people, so there's no fixed definition of what a high-tech or Internet logo looks like. That's good, because almost none of the logos in this section have icons that look like computer chips. But we do have the whirlpool of Onda, the starbursts of Mission Lights and Aker-Wade, and the cubes of Premier and Cubic Orange. On the other hand, we also have golden leaves for Golden Web, a bouncing ball for PL Studios, and a crown for Luxe Paperie, so go figure. Perhaps the lesson here is that our best designs come from discarding trite and obvious clichés, and besides, computer chips are hard to draw.

HIGH TECH & INTERNET

149

Denise Spirito
Designer

Denise Spirito
Creative Director

p9
Design Studio

Action Talking Product
Client

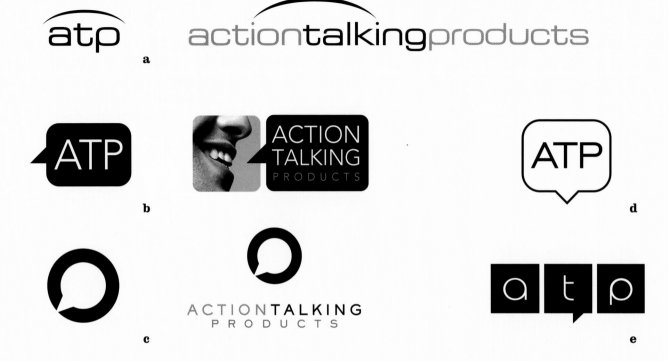

a

b

c

d

e

Here's an interesting study in the use of long and short versions of the same logo for Action Talking Products (ATP). The company develops voice interactive consumer products. Using a unique speech recognition technology, visually impaired users activate and control a device completely hands-free, just by speaking to it.

Denise Spirito of p9 says, "We started to develop logos with the client's key points in mind: Voice Interaction—talking to the product and the product talking to you; Friendliness—ATP did not want a high-tech identity, but rather a consumer-friendly one; Versatility—an identity to be used on collateral, products and packaging, as well as have special market and mass appeal.

"For three of our logo presentations, we created 'long' as well as short, abbreviated versions to provide usage op-

tions. The design with the arch [**a**] allowed us to emphasize the two key words by connecting 'talking' and 'action.' Using an actual image of a person [**b**] helped express a friendly feeling, and the image could also change to promote gender- or age-specific products. A 'talk bubble' [**c**] intersecting a bold, circular shape was another idea we presented.

"The talk bubble became a great symbol to play with, and we also did two designs [**d**, **e**] that were just single marks.

A two-version logo was accepted. The stylized speech-balloon/star design seen in the final logo can also stand alone. I like the bolder line of dots that act as the 'tail' for the balloon as well as to dot the *i*.

By the way, we hope the sequel to this book will be entirely voice-activated, keeping the reading to a minimum so you can spend more time looking at the pictures.

a

b

Denise Spirito
Designer

Denise Spirito
Creative Director

p9
Design Studio

Remote Play, Inc.
Client

"It is p9's rule in developing logos that we always work in black and white. It is the logo in its purest form, and if it cannot work without color, it will never work at all."

Interesting idea, p9, especially since a company's logo finds itself being used in many forms, ranging from the full-blown 4-color version and the debossed brass plate on the front door to the black-and-white version on fax forms. In all cases, the design must be able to stand up and shine.

In this instance, the assignment facing designer Denise Spirito was Remote Play, a company that develops and markets wireless products and networks based on radio frequency identification (RFID) tags to help individuals and organizations keep track of people and valuable assets.

"Remote Play wanted a high-tech identity that clearly represented their wireless products—two remote devices communicating with one another. It was our challenge to find a way to convey this 'remote connection' message within a word mark," explains Spirito.

"Our first design [a] was based on the relationship of two elements. The concept then evolved to creating a connection between two remote points, and the two ascender characters in the company name were used. This approach formed a link between the two words, and the solution also clearly represented two points talking to one another. Version [b] was favored for the choice of font, but a stronger solution was sought as the connecting element.

"The final version uses rings as a dynamic focal point of the word mark, and was chosen as the best solution to the problem of showing connection between two points."

And the Remote Play logo works well in color, too!

151

Alexander Fjelldal (logo)
Vibeke Tjæreberget (pattern)
Designers

Bison Design
Design Studio

Skum AS
Client

ESPEN MICHAEL LARØD

MOBILE: + 47 91 36 33 58 SKUM
PHONE: + 47 22 47 00 90 NEDRE VOLLGATE 9
FAX: + 47 22 47 00 88 0158 OSLO NORWAY
ESPEN@SKUM.NO WWW.SKUM.NO

The Skum logo, shown in use on this business card, is enhanced by the addition of a decorative pattern created by Vibeke Tjæreberget.

Skum, which translates as "foam" in Norwegian, is a small, Oslo based company that develops systems to connect international databases for travel businesses. They asked Bison Design for a logo identity that was young and fresh but also communicated their skills and competence.

"After a brief, initial meeting with the client," Bison partner Alexander Fjelldal says, "we went back to our office and started thinking. All three of us at Bison Design normally begin with long discussions about the job, to get our imaginations working.

"Then we start sketching, making notes, and collecting pictures, colors and typography from magazines and the web. We then paste our ideas and clips on large sheets of paper and hang them on the wall to start sorting the sketches and tidbits, and to make some order of the chaos.

"For the Skum project, we hit on several directions, from comic book lettering and abstract photos of fruit to quirky, retro computer lettering. The solution both we and Skum liked the most is a logo featuring custom lettering accompanied by a complex decorative pattern [seen in the business card at left].

"We looked to Art Deco typography to find inspiration. The color scheme (darkish cyan, orange) adds some vigor and freshness, and the pattern reflects the complexity of their work.

"In general we are very happy with the final logo although I'm not so happy with the contrast in the *m*, but I don't know if it's me becoming blind after staring at the thing for four weeks. As always, we came up with a lot of good ideas that never got to be used."

a

b

d

c

e

Andrew Wright
Designer

Breath of Fresh Air
Design Studio

Cubic Orange
Client

It's amazing the process by which ideas evolve beneath our fingertips as we work. And sometimes it takes putting a pen or pencil into the hand to focus our attention upon the problem and start weaving in the conscious and subconscious mental processes.

For example, an orange becomes a square, then morphs into a cube that finally becomes embedded within a lozenge. This is probably akin to how the wheel was invented: you know, they started with a log, then sliced off a piece ...

Designer Andrew Wright utilized such a process of discovery as he began working on this logo for Cubic Orange, a "growing dot-net company with a young and vibrant staff."

As Wright explains it, "Cubic Orange provided me with a few examples of images and logos that they liked, but basically they gave me an open book to work with. However,

they did request blocks, and possibly something incorporating the number three."

"Starting from the obvious, I included the orange fruit [a] and tried to play with the three leaves to represent a square or cube [b]. At some point the leaves were lost and it worked its way into four cubes [c], and finally a 3-D type cube was created [d]. The next version [e] included the three-sided cube and basically developed into the final logo.

"At the end of the day, the clients were quite happy with the options I presented to them, and luckily they went with one of my favorites. Of the comps, there were a few that I personally didn't like as much as others, but presented them just to see anyway, and they loved most of those too. I normally tend to only give the client the logos I think are the best, so I'm rarely disappointed with the client's choice."

Dave Fletcher,
Anthony Shafto
Designers

theMechanism, llc.
Design Studio

Premier Technology Solutions, Inc.
Client

a

Careful listening, like we learned in school, is often the key to defining a client's innermost desires. So when New York- and London-based design studio theMechanism, llc., went to work on an identity program for Premier Technology Solutions, Inc., a company that implements software solutions, their first step was gathering information.

"Whenever we start an identity piece," Dave Fletcher says, "we sit down with the client and have an interview session. With *Premier*, an interesting idea immediately emerged. The client explained that *Premier* was about putting 'blocks' together and building a structure—a relationship.

"When we started to work on the visuals for the logo, that was the chief idea that we gravitated towards: the idea of the building block. This led us to create an icon with a single block poking outward, like it was the most impor-

tant—or 'premier'—piece within the surrounding structure. We ended up doing a considerable amount of these iconic structures that were not only cool-looking in their three-dimensionality, but they expressed the idea of the one or 'premier' centerpiece poking through.

"Whenever we submit ideas, we always know the one that's 'right'. But you can use designs that may not be exactly right as talking points. For example, we saw the client leaning toward the diamond design [a] with the change in hue, and we used that as a clue.

"In the final logo, I like the way the dot in the *i* and the *p* balanced each other. I sometimes wish we had pushed harder toward the letter *i* representing the number *1*, as seen in some of the comps, but we let it go. There's a fine line between clever and practical."

b

a

MERCUITY

c

Tim Frame
Designer

Jason Hickner
Art Director

Crashshop
Design Studio

Mercuity
Client

"It'd been a typical day—spitballs, trackballs, 'the dog ate my brand identity,' you know, the usual stuff— here at Cedarville University, where I, Tim Frame, work as instructor of graphic design.

"'Yes, you can leave the room, Heather. No, you don't need a hall pass.' But something was bothering me … deep down. And then it hit me: the logo for Mercuity—a web-based ticketing system for venues of all sizes—was due by 9:00 AM Tuesday, and I was stuck for an idea. My mind reeled back to the night before, as I struggled to be merely brilliant and had instead come up with … tripe: a trio of nameplates [**a**] that, while frankly terrific, were still *not good enough*.

"That was just like me, too. I'd been so goldarned concerned with grading my kids' homework assignments, I'd neglected my own *real world* assignment!

"If only there'd been a specific client directive besides to 'explore all the possibilities and to develop concepts that were consistent with the branding strategy.'

"Snapping me out of my maudlin reverie came the voice of Ernie, a freckled, perspiring young designer. 'Gosh, Professor Frame,' he observed, 'the *mercury* sure is on the rise.'

"And that's when it hit me! Of course—mercury: Mercuity! Frenziedly, I sketched Mercury, that little fleet-footed god of internet ticketing, or something like that [**b**]. It was just the inspiration I needed. The rest [**c**, etc.] came easy.

"My client was very pleased. They commented on how many strong concepts I was able to develop in a relatively short period of time."

Yes, Frame aced the gig, but he advises, "Don't wait till the last minute!" As for Ernie, he was made hall monitor.

interactivemedia

Lance Huante
Designer
p11creative
Design Studio
Interactive Media
Client

a

b

c

d

e

Logo design can be a rather touchy subject. Especially when it's for IMN, a manufacturer of plasma touch-screen display directories found in commercial lobbies and retail centers across the country. The task facing p11creative was to communicate the human element (people) interacting with technology (the screens).

Here's how p11creative's Leigh White describes their process: "Our first big idea [**a**] was a person touching a screen. It has a digital memory card feel to it. The horizontal layout of the logo was intended to be panoramic and dramatic.

"The swooping axis design [**b**] was to convey a worldly influence, but the swoop hid the *i* too much. The burgundy loops around the gray angled screen [**c**] were to emphasize interaction, but they looked too much like a big 'X.'

"The blue design [**d**] looked more like an ATM button than

a plasma screen. We had one of those brutally honest talks with ourselves and realized that, so far, we'd struck out.

"Ah, but the fat lady was about to sing! The logo began to take shape with the *i* and *m* intersecting [**e**]. The green was the right color, but we needed to determine the ideal shade. The square corners looked too boxy and Mondrian. We needed a more rounded 'Kostabi' edge.

"We removed the word 'network' in the final logo, which simplified the design. The olive green and black give a nice contrast to the words. The lettering's rounded corners suggest modern, ergonomically-designed technology."

The brilliant part of the final selected logo is the universal way-finding *i*-guy symbol at work at a touch-screen terminal that is also an IMN monogram. And best of all, according to White, "The client loved it."

CONCEPT TECHNOLOGY INC.

Bob Delevante
Designer

Relay Station
Design Studio

Concept Technology, Inc.
Client

Concept Technology sets up computer networks for everything from huge hospitals to small design studios. When they approached designer Bob Delevante, the company had an existing logo, but now needed a more substantial one to reflect their growing image in the marketplace.

"I love sitting down with owners to ask, 'What does your company do? How do you want people to see you? How do you want to be perceived?'" Delevante says. "This client answered, 'We integrate raw technology, but we build things; we're a *concept* company' and in their logo they wanted to integrate this idea.

"Much of logo design is about telling a story—in just this one shot. You're trying to tell people what this company is about, to encapsulate it as much as you can, to distill that image. So you keep picking away at that one little image until it comes down to the core of what the client is trying to communicate."

I asked Delevante how he starts designing a logo.

"First thing I do is take a walk or a ride to think," he said. "Then I sit down with pen and tracing paper and sketch. I'll take the words, or the initials that I've drawn, and cut them up, move them around to try different ideas. The initial sketches may not look like much, but then you take them to computer and refinements begin to emerge."

The final logo for Concept Technologies is a deceptively simple yet clever monogram/icon. "Some people look at it and see a telephone. Others, it takes a moment for them to discover the entwined monogram. It came down to just a way to get the two letters to work off each other and to sort of 'create' each other," Delevante says.

Evo One

Woo
Designer

Ian Myles
Creative Director

Astro Studios
Agency

Ugobe
Client

Script

Biotech

DNA

Genesis

For a company that manufactures kids' toys, Ugobe's logo is not in the least playful. And that is by design. According to the company's website, "Ugobe develops and markets revolutionary robotic technology that transforms inanimate objects into lifelike creatures that exhibit stunning, organic movement and dynamic behaviors."

"They didn't want to be seen as a toy company," Astro Studio's Ian Myles explains, "They wanted to be seen as a biotech company playing with the 'DNA' in toys that are more behavioral, rather than the old-style robotic toys. This is the next generation of toy companies, and they wanted an image that was much more natural and bio-friendly."

I asked about the color bars and thematic labels with the keywords *Script, Biotech, DNA, Genesis,* and *Evo One* that had accompanied each of Astro's comps.

Myles explains, "When a company wants to define itself, they are often searching for qualities that defy a literal description, and sometimes these subliminal keywords, along with color swatches—they're kind of parameters—can help steer the discussion.

"Woo, the project designer, likes to modify fonts in every way he can. The final mark we created was very evolutionary in the way the line weight changes across the word, and the letter shapes also have a progressive and modern look. The word 'Ugobe' is interesting in that you can almost spin it. So we pushed a lot of the letterforms to quite extreme places then had to retreat a bit for legibility's sake."

The derivation of the name "Ugobe" is a *neologism,* a made-up word that is actually a compression of three words: *you-go-be*—which, like their toys, is rather revolutionary.

Woo
Designer / Creative Director
Astro Studios
Agency
Mission Lights
Client

Gosh, it's annoying when I'm piloting my Cessna and I drop my flashlight. But now there's a solution!

Mission Lights has developed Light Glove—essentially a hands-free flashlight—designed for use by general aviation pilots while flying at night. As everybody knows, you can't have lights on in the cockpit because you'll mess up your night vision, and you certainly don't want to fuss with a flashlight you may drop. The Light Glove takes care of that.

For its logo, the company tapped Astro Studios' designer Woo. "I spend a lot of time thinking about the product beforehand, and then I'll start sketching," Woo says. "I'll write down the company name and draw down a bunch of things that are obvious and relevant, like lights and gloves, and then I'll try combining the two. I like to go and do a lot of variations, and from these, you just derive solutions.

"Mission Lights plans to expand into other related areas, such as lights for marine divers, so I didn't want to be too literal with any of my symbols. That's how the abstract approach developed. It became a process of figuring out what I didn't want to do, and then narrowing it down by throwing out literal interpretations, such as the obvious image of a hand with light radiating from it.

"The relationship with the clients wasn't very structured. The design brief wasn't too specific. I would do a bunch of things and make a meeting, and they'd say, 'Well, this is sort of looking in the right direction...' So the process was very casual and organic. We all are happy with the final design."

There is a rumor that Woo now sketches mainly in the dark, illuminating his ruminating exclusively through the use of his own prototype Light Glove.

silverman systems

Todd Rosenthal
Designer
Todd Rosenthal Design
Design Studio
Silverman Systems
Client

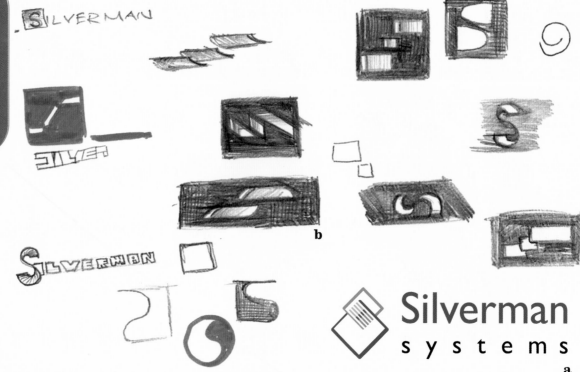

b

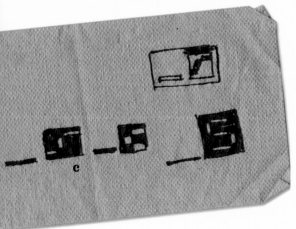

c

The prescient napkin with
its incipient inspiration.

160

Silverman
s y s t e m s

a

According to legend, most great designs begin
as cocktail napkin doodles. Look carefully at exhibit A [sidebar], and witness the truth of this statement.

According to designer Todd Rosenthal, "This job came from someone I had worked with in the past and am still friends with. Silverman Systems specializes in web development and creating custom web solutions/applications.

"The client gave me examples of other logos to show me what he had in mind. I did my best to sway him from doing something that looked similar to other logos. He also said that he wanted something that incorporated an initial *S.*

"The first 'finished' logo I came up with took some time. After several rounds of sketches and comps, we decided on a final logo [**a**]. The client was apparently happy. But I thought I detected that something was not right.

"Alright, I admit I can't stand when my client is not totally fulfilled by what I've designed (the sensitive artist in me). I had surmised this awhile back, but kept pushing my way through this certain design, tweaking and refining it, though all the while the client wasn't really happy with it.

"So, I went back to the drawing board. I recalled the client had once used the term 'High Performance.' My first logo did not convey this. But that term started me thinking in a new direction. Ironically, the sketch [**b**] that led to the final mark seems almost to have been predicted in the early napkin sketch [**c**]. This time around the client and I both were more on target and the final logo [upper left] was born."

Yes, you heard it here first! Thus, we can proudly state that *Secret Life of Logos* gives 47 percent *more* secrets than other logo books on the market. The proof: *We show the napkins!*

a

Dave Fletcher
Designer

Dave Fletcher
Creative Director

theMechanism, llc.
Agency

GoldenWeb.com
Client

A golden opportunity for logo experimentation emerged when theMechanism, llc., a design firm in Manhattan and London, undertook this project, pro bono, for a programmer they worked with who had started her own small company.

As Founding Partner and Creative Director Dave Fletcher tells it: "This was a particularly gratifying design because since it was for a colleague, we were able to have a little bit more fun with it. We experimented with a color palette that may not have worked for our business-type clients. We were able to relax a bit, creatively.

"The client had also given us a good brief, which is always advantageous. She explained that she wanted an organic, or free-flowing feel—something airy and comforting—so a lot of that idea went into choices of typography and color.

It became less about the obvious icons and more about making it abstract. The spinning shapes were emblematic of a web or a sunflower, with everything representing movement. We played with adding programming 'script' to the logo [a], but realized that probably only programmers would get it. The final idea represented growth: partnerships with clients, new relationships and vitality."

I asked Fletcher about the use of abstraction in icon design and he said, "A musician friend said once that every possible combination of notes has been played up to this point, so now everyone's just copying what's been done. I've always taken that idea to heart when it comes to graphic design. I think the ability to create abstract or unexpected shapes allows for a little more pushing of the creative envelope into areas where perhaps one can indeed be original."

161

Sarah Gries
Designer

Angela Neal
Creative Director

Snap Creative
Design Studio

MicroLogic
Client

a

b

The client said he wanted to have a "big guy" look. So the goal set before Snap Creative was to design a high-tech corporate image similar to such technology companies as IBM. MicroLogic's sales emphasis is its customer service and highly-skilled staff. They position themselves as a business partner—saving clients time and money while minimizing disruption. So a high-tech look was appropriate, but with an added human element.

"We began by having three in-house designers create initial comps," Sarah Gries says. "The creative staff then had a critique. Bad ideas were discarded and promising ones were developed. I noted some recurring elements in many of these logos, such as the circle or sphere shapes and the clean lines of sans serif type. Also, many of the chosen comp designs had moving dots or groups of dots or squares. I felt

this had a strong technical association: data moving from one place to another. As I took up work on the MicroLogic logo, I thought about computers and technology in general as mathematical and methodical creatures. This is how the concept of the domino dots [**a**, **b**] came in. The client liked this idea and the simplicity of the mark, but requested some further modification—something was missing.

"By opening up one of the dots and making the mark asymmetrical in the final version, the graphic took on a whole new meaning. Now the dots came to represent open and closed circuits—the essence of all computer technology. An added tag line in gray created a subtle foundation for the main type and helped pull the logo together."

The final logo is somewhat obscure, but its clean, masculine, corporate, and inscrutable visage definitely says "big."

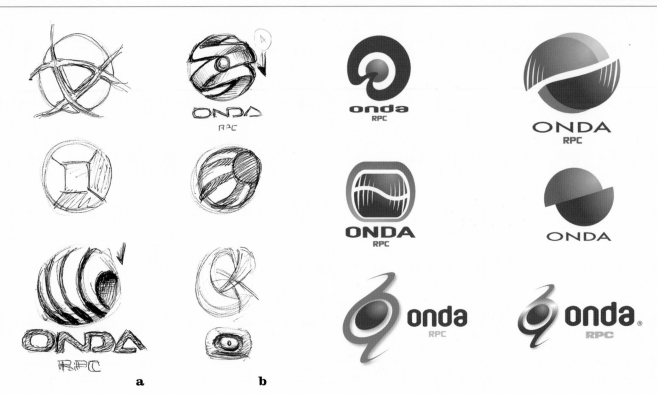

a b

Tobin Dorn
Designer

Isabella Dorn
Art Director

New Level Design
Design Studio

Globo
Client

The Portuguese word "onda" means wave, either radio and transmitter waves or more natural waves, as from the ocean. Onda RPC© is a Brazilian Internet portal. Over the past few years, sales slumped, so designer Tobin Dorn was called in to give the portal a more modern face.

"At lunch one day," Dorn says, "I was brainstorming with Isabela, our art director, and sketching ideas on napkins from the pizza joint [columns **a** and **b**]. While sitting there, we observed many teenagers all dressed in jeans and track suits adorned with various logos. We became inspired by their clothing for the shapes and colors of our logo.

"One project requirement was use of the colors blue and green, but which blue and which green? I began to envision a clean, modern, energetic icon that would say internet, information, Brazil, speed, modern, and young.

"I like to mix elements from nature with man made products. The beautiful mix of lines that are organic go well with clean and precise computer-generated lines. I achieved this with the Onda RPC© logo as the shape formed around the circle feels like a whirlwind or whirlpool. The gradient meets the color requirements and allows us to show the detail of 3-D that can easily be animated for TV spots or intros.

"The final logo solution has an attitude without being cocky. It has movement and energy but isn't out of control. It uses colors that ties it to other affiliated companies of RPC, yet it doesn't look too corporate and boring."

According to Dorn, the entire development process involved three weeks and hundreds of sketches, yet with all the groundwork done and client decisions made, the final icon took just fifteen minutes to execute in Illustrator.

Enterprise
Decision
Engine

Tyson Mangelsdorf
Designer

Tyson Mangelsdorf Illustration
Design Studio

New Century Mortgage Corp.
Client

a

Plugging in to his client's needs helped Tyson Mangelsdorf create a logo that is both a marketing and visual success. In Mangelsdorf's own words:

"A colleague of mine was now managing a team for a national mortgage company called Enterprise Decision Engine (EDE) that used a software 'engine' to make lending decisions. My colleague contacted me to design the logo.

"I knew right away that the EDE acronym would be catchy, not only verbally, but also visually—a D flanked with an E on each side. So I pursued that path.

"As I was working, I realized it would be great if I could work a visual icon into the acronym to integrate another level of meaning (all my favorite logos do that cleverly). So, I started getting literal with the engine idea and realized a power plug could be made with little to no distortion of the lettering—and that's when I knew we had something. The client agreed.

"I offered two single-color versions, since I knew reproduction costs were limited and the scope of media usage was narrow. Green was one of the company's current colors, and the blue I offered is a psychologically safe and 'trustworthy' color. Nobody wants any risk associated with a mortgage product. Blue was chosen for those very reasons.

"The best logos I've done come from working with clients who understand their business and relay that info clearly to me. Too many times there's not enough trust in the working relationship, and the work suffers."

In the logos above, it is fascinating to witness the designer's evolution toward the final version. I just wish the client had chosen the happy face [a].

COMPLETE COMMUNICATION SOLUTIONS

a

COMPLETE COMMUNICATION SOLUTIONS

COMPLETE COMMUNICATION SOLUTIONS

b

COMPLETE COMMUNICATION SOLUTIONS

c

COMPLETE COMMUNICATION SOLUTIONS

d

Nathan Rowe
Designer

Nathan Rowe
Creative Director

Eisbrenner Public Relations
Agency

Transcom
Client

Whether or not the new Transcom logo icon, designed by Nathan Rowe of Eisbrenner Public Relations, will be immediately recognized as spiralling letter *T*s, the explosive visual connotes movement, industry, excitement and the outward expansion of ideas and communication.

Transcom provides complete installation and support of communication hardware and software to businesses in Southeast Michigan—certainly one of those types of businesses that, for a designer, eludes immediate visual associations. Rowe, however, was undaunted.

He explains, "Originally, we tried including visual elements from the industry, such as a telephone, a keypad, a cord, and so on [**a**]. From there we moved on to more abstract concepts, such as a shape formed by rotating the *T* from the company's name. That left the triangular void suggestive of a server or other hardware component in extreme fish-eye perspective [**b**].

"I continued to play with the rotated *T*s, which produced a surprising cube shape [**c**], and by multiplying the number of rotated *T*s, it started to feel like a sunburst, so I took off in that direction [**d**], which felt very powerful.

"The final logo was a combination of the rotated T design [**b**] and a variation on the sunburst [**d**]. To avoid competing with the icon, the title font was kept simple. In an attempt to narrow the client's focus, we limited our presentation to these five concepts."

The approval process took eight months. The client took time to study each design by visualizing the logo in different situations. In the end, such care ensured a well thought-out decision and a dynamic logo.

165

Jill Bell
Designer

Jill Bell Design
Design Studio

Luxe Paperie
Client

"Hi Jill," the client's e-mail begins (this is how so many of us get our work these days; God bless the Internet!), "I looked at your web site and really love your creations!"

Jill Bell, calligrapher, typographer and logo designer extraordinaire, replies: "Love to hear more about your project … please call me and we'll discuss it and I can give you an idea of how much it will cost, time turnaround, etc."

The client, Mary-Kevin Kilkenny, begins to negotiate with Bell. She explains: "The name is luxe paperie. [Kilkenny doesn't bother to capitalize proper nouns; it's very chic, very Internet and very European not to do so.] It will be an online, high-end stationery boutique and eventually a retail storefront in northern california." [Again, no caps, but already, she's got a well-conceived business plan.]

"It should convey a high-end feel," Killkenny continues, "This is why I want it hand-lettered instead of using type. I have envisioned a cute, artsy, girly crown in the logo … but I am not married to that idea." [The client has informed Jill that she is flexible and open

to surprises from the designer. Wow! What a wonderful client.]

So Jill Bell goes to work as she usually does, with brush and pen until she's got a set of lavish sketches, each one displaying its own distinct style and personality.

This time the e-mail to Bell is from me: "Hi Jill," I write (nobody bothers with "Dear Ms. Bell" anymore). "How do you manage to get such diversity in your sketches? Where do the ideas come from?" Bell replies, "Well, it depends on what the client tells me, but I sit down and play until I've got way more than I need, and then I select the ones that are working best. Sometimes it's what the client describes, and sometimes you just have an idea that comes into your mind. Actually, I try *not* to think as I work, but I do have my definite styles and preferences. I also try to do 50 percent of what they ask for and 50 percent of what I think they need."

The logo complete, the story ends happily. "Hi Jill," Kilkenny e-mails, "The lettering is perfect … just as I envisioned! I forwarded your work to a colleague who is also in need of a logo and … "

cleared™

a priva technologies solution

Ida Cheinman
Designers

Kara Brook
Creative Director

Brook Group, LTD
Design Studio

Priva Technologies
Client

What do you perceive when you look at the final logo for Cleared, and at its precursors? What do you assume to be the company's purpose?

Such questions are what we logo designers need to be asking ourselves when we create logo designs. Or rather, the question is, what will *customers* see, feel, and think when they view a logo that we have designed?

In the final Cleared logo, I perceive an old-fashioned key in a lock tumbler. The C-shaped cutaway of the red circle is somewhat obscure as a C, but the resulting odd shape says "high-tech" to me. The red suggests urgency or "stop," yet the friendly, almost cartoony key softens the impression. The bold font suggests strength but it is softened by being gray-colored, which again suggests technology.

The answer to the second question posed above is that Priva Technologies invented a first-of-its-kind authentication technology that enables a wide range of easy-to-use offline/online, wired/wireless identification applications that ensure security, privacy and anonymity.

Now here's what designer Ida Cheinman, for Brook Group, had to say about the qualities she sought to convey in the Cleared logo. "Our challenge was to develop a logo that was in line with the client's primary corporate brand attribute: cutting-edge but approachable. They also listed security, high technology, access, and sophistication—though not stodginess. The use of a skeleton key toned down the otherwise intimidating technology."

This is the alchemy of the designer's craft: transforming impressions through visual nuances that may seem abstract, but which can be applied with an almost scientific touch.

Kamal Patel
Designer

John Homs
Creative Director

J H I
Agency

Aker Wade
Client

I've never been able to pull off such simplicity in my own designs as Richmond, Virginia-based J H I displays in its logo for AkerWade, but I really appreciate it when I see it. And I wanted to find out how they do it.

"I've always been enamored of the super-clean, dynamic graphics of the post-war European aesthetic," J H I principal John Homs admits. "And even the mindset; the ability to tell a story pictographically, yet still with utter simplicity, and I'm always searching for that kind of solution that seems to me so ultimately satisfying."

J H I's vision of simplicity was obviously a good match for AkerWade, a high-tech company that has pioneered a new "fast charging" battery technology for heavy industry.

With potential clients among the top manufacturing concerns the world over, AkerWade needed an identity presence that was commensurate with its clients' expectations: crisp, elegant and confident.

"The bottom line for this company is *power*," John Homs says. "The stylized 'sunburst' represents that critical burst of power when it's needed, and of course, it had to be red. Red plus black is as simple and powerful as it gets. The burst symbol was also designed to serve as an illustrative note when collateral and advertising applications are required."

But, as Homs tells it, "Although they were happy with the logo, we ran into some unhappy times with this client and ultimately thought it best to back away from the relationship. However, twelve months down the road we received a call asking us to discuss future work. I feel that the strength of the identity design was mostly responsible for their desire to reconnect with us. Good work wins out in the end!"

169

THINKSTREAM

Jon Wippich / Karen Wippich
Designers

Dotzero Design
Design Studio

ThinkStream
Client

ThinkStream

a

b

c

ThinkStream

d

e

f

ThinkStream

g

h

ThinkStream

i

On the lam from the prison of mundane ideas, Dotzero Design was clearly thinking "out of the stream" when they created the logo for ThinkStream, a company providing distributed information networking—supplying criminal profiles, for example—to law enforcement agencies.

I wanted "just the facts" in the case, so we put the comps into a line-up for Jon Wippich to identify: "[a] had to do with this bright new idea of handling information. [b] was a way of illustrating the word 'thought.' [c] shows connectivity, organization, efficiency, and a central hub. [d] suggests a stream of data moving horizontally, lining up with the human figure, which together form a *T*.

"[e] was just an interesting way to indicate connectivity between the two letters. [f] was an attempt at literally illustrating the name. [g] was an interesting geometric shape, a cone that becomes defined by the dots of data that surround it. [h] has a human element, but also a technology element. The waves at the base are again a suggestion of stream. [i] is a *T* and an *S* formed of a single meandering line."

The final logo is sharp and dynamic, but to me, any one of these wonderful designs might have sufficed.

"I was surprised, but not disappointed, at the client's final choice," Wippich says. "I thought it might be interpreted as a heavy metal logo, however. Like [i], it is made up of one single line. I didn't want one letter to dominate the other, so I tried to make the mark be seen evenly as a *T* and an *S*."

ThinkStream's amazing technology and Dotzero Design's brilliant concepts prove, more now than ever before, that *crime*—whether merely as incorrigible as shoplifting, or as totally reprehensible as creating ugly logos—*does not pay.*

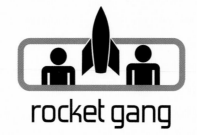

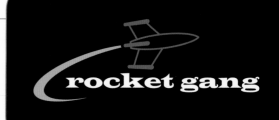

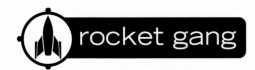

Stephanie Lucas
Designer/Illustrator

Stephanie Lucas Creative
Design Studio

Rocket Gang
Client

Logo design is hardly considered rocket science. Except perhaps when it's for a software development and management consulting firm called Rocket Gang.

Did the designer, Stephanie Lucas, find it challenging to boldly go where no designer had gone before? Not in the least, she informs us. "My client, Pat McDermott, was excellent at communicating and receptive to a range of ideas. This logo assignment was probably one of the most enjoyable experiences I've had.

"Pat and his partners chose the name 'Rocket Gang' to lend some warmth and personality to what might otherwise have been a very dry and technical identity. He took a fun and slightly irreverent approach to naming his company. The 'rocket' was a reference to the popular tongue-in-cheek term, 'It's not rocket science.'

"In the first round, I showed Pat a variety of possibilities. Some included human figures, some were 'campy,' and some more straightforward. To my surprise (and delight) the gang selected one of the campier versions as the final.

"With each new logo design, I get to learn about and become intimately familiar with the personality and purpose of a company—and no two personalities are alike. It's a study in both marketing and psychology disciplines, both analytical and emotional. The logo design solutions are expressions of what you discover in the process. You learn even more about your client when you first present your range of ideas, finding out how bold or conservative they really are willing to be. If everything works as it should, by the end, you often wind up teaching clients something about themselves."

a

b

c

Joe Turner
Designer
PL Studios
Client

Of all the paths designers take to inspiration, Joe Turner decided simply to follow the bouncing ball. Well, considering that the client was involved in animation, the concept wasn't too much of a stretch … or squash.

PL Studios is a company that provides training for 3D programs such as Autodesk Maya and Softimage XSI.

"One of the first things that is always taught in animation classes," Turner says, "is the bouncing ball. That concept—of how the ball appears to elongate as it falls and then squashes upon impact before it bounces off again— was my inspiration for the ball bouncing to rest where the O falls in the word 'Studios.'

"I picked the tall, Art Deco font because it reminded me of the fonts they used in Hollywood during the days of classic animation. I'm not sure if it isn't really an Art Deco 'wannabe' type style, but it suggested the 1930s to me.

"I made at least five different versions of the logo [rows **a** and **b**] before choosing two to show the client [**c**]. They thought the first one looked similar to an existing logo for a local pet store—so that didn't fly! After they pointed this out, I had to agree with them. It's funny how logos get caught in your subconscious.

"I am primarily an illustrator who does logos. My stuff always seem to have a whimsical feeling that, actually, I sometimes wish I could break away from. Fortunately, the client on this project wanted that look, while at the same time to convey a corporate image."

The final logo combines the upright Deco type of the first presented logo with the bouncing ball from the second. The result is, indeed, playfully corporate.

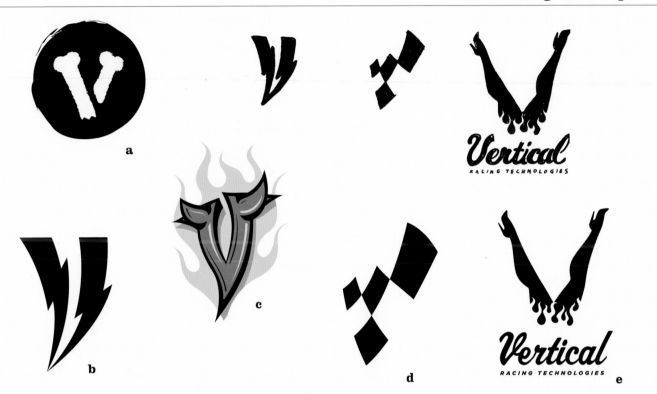

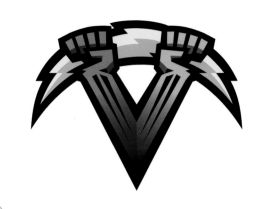

a

b

c

d

e

Roland Murillo
Designer
Murillo Design
Design Studio
Vertical Racing Technologies
Client

"It is called drift racing, where they slide the cars. They customize compact Japanese cars, and it's part of the race to see how far you can slide the car; how far you can go before you must adjust your steering wheel," so explained designer Roland Murillo about this recent phenomenon.

The client, Vertical Racing Technologies—not your typical auto body shop—wanted its brand mark to have a "monster garage" mentality; still maintaining a feeling of high-tech professionalism, yet keeping the image cool.

"What I generally do, " Murillo says, "is to go through a series of questions with clients to interview them and try to get into their head. What Vertical Racing wanted, they said, was to look 'big' but not to appear 'corporate.'

"Most clients tell me they want 'cutting edge,' but this guy was serious. He is adding things like voice-operated seats.

You approach the vehicle and give voice commands to adjust the steering wheel, seats, stereo—we're talking about $30–40,000 worth of modifications.

"The client wanted the brand not to be based on one specific mark, but on a series of images. The idea was that it would constantly be evolving, and in a year's time we'd reinvent the logo and create some new designs.

"I try not to look through books, but just start sketching with a fat Sharpie marker. I try to work at about an inch and a half. The fat tip limits the detail you can get, and my belief is that if the Sharpie can't make it, the design won't hold up under reproduction."

Murillo ended up with not one, but several final logos [**a** through **e**], an idea that many companies would never accept. But then, *they* aren't cutting edge.

173

Media plays an essential role in a free society. And when there is a thriving media, logo designers eat! We need all sorts of media and publishing houses, too, to fit the range of designers' stylistic capabilities. In this chapter, we have publishers like Morgan Road (spiritually oriented), Gotham Books (urbane and sophisticated), University of California Press (scholarly), AuthorHouse (self publishing), and American Roots (Americana). In the realm of magazines, we have НИН from Serbia, *Sunset* from the American West Coast and *Absolute* from the East Coast. There would have been dozens more, but the book ended too soon.

PRINT MEDIA & PUBLISHING

a

b

c

d

e

Mark Fox
Designer

BlackDog
Design Studio

UC Press
Client

In these times, when an e-mail takes no longer to arrive in Kracow than in Kansas, designers often work via e-mail for clients whom we'll never meet.

For that reason, Mark Fox says, "I've learned from years of experience that when you present concepts without accompanying language on the page, it allows other people to throw any remark onto your design like a spitwad, and it will adhere. It's a self defense against people saying stupid things. It also forces me to articulate what the hell I'm doing, and I feel more confident in the work. Clients sense this confidence and that what I'm presenting is not random but well-reasoned."

Excerpting from Fox's comp texts for UC Press, we find "this monogram [**a**] is both typographic and pictorial. The letters form two perpendicular books in an obvious ref-erence to UC Press' historical mission…The form of this monogram is based on classical models, yet is modern in its restraint. This UC monogram [**b**] forms an open eye to suggest creative vision, intellectual curiosity, and the examination of ideas. The eye is also a symbol of light, enlightenment, knowledge. This symbol [**c**] depicts the spread of an open book, marked with a ribbon. The right-hand page, however, is a window into to new ideas and new worlds. This symbol [**d**] references both an open book as well as the ancient Chinese pictograph for fire. Fire has associations with light and passion (zeal). The form of this mark [**e**] also features a strong directional arrow which, in essence, points to the text. Ideas—the text—are the core of UC Press."

The winner contains a book and a ribbon. But if you look carefully, you may also discover a UCP monogram.

a

Mirek Janczur
Designer

Jack Hyndman
Creative Director

Palio Communications
Agency

AuthorHouse
Client

Rebranding a company is often pressure-frought. Especially if you're the new designer on the block. "When I got this project, it was my first week at Palio Communications. I was seated in a heavy-traffic area, with people sneaking up behind my back every minute," Mirek Janczur says.

The back story is that a self-publishing firm that was the largest in the industry realized they had no clear brand positioning in the minds of their customers. In addition, their earlier name had been recently trademarked by another firm. Palio came in and chose the name AuthorHouse from over 400 options.

"We discovered that the essence of the brand was the unique relationship the company had with its authors. It became clear that we needed to position the corporate brand as the author's advocate and emphasize the fulfill-ment of authors' dreams of being published as the firm's highest priority."

But, how do you show this in a logo? "At first, I decided to explore all the possible typographical options, choosing *A* and *H* as my main players. I almost forgot about bringing the "author" into the picture. Of course, my first mistake was to fall in love with my first design [**a**]. When I finally brought the "author" into my mental picture, I was able to adapt my favorite design by turning it into a book."

In the chosen logo, the cover and pages form a house with an author at the core, resembling a bookmark. "I was also able to keep a subtle typographic element in the mark; the negative space forms the letter *A*. The name combines classic and contemporary typography in one complete ex-pression suggesting past and future."

Leslie Cabarga
Designer

Paul Donald
Art Director

Michael Grossman
Creative Director

Sunset
Client

a

Here is the classic Sunset logo on a December 1954 issue.

178

During most of its eighty-year history, *Sunset* magazine used a brush script as its logo that became as much its signature as the Eiffel Tower is to Paris.

Then somewhere along the way, something unfortunate happened: the script logo was abandoned for a modern sans serif. Finally, after ten years or so, *Sunset* came back to its senses and its roots and asked me to supply a script that was reminiscent of the original, yet somehow new and different. Current management felt that the perception of *Sunset* was that it was your parents' magazine, and they wanted to change that.

Why wasn't the original simply restored? "We had long conversations about that," art director Paul Donald explained, "but decided that the original, while classic, wasn't as readable as we wanted, so we said, why not update it

and make it a bit more 'now.' Very few magazines can pull off going with a logo like that. The old logo during its glory days was of a style that has now resurfaced and since we own the rights, and it looked great, we said, 'Why not?'"

I began with pencil sketches and then pulled out a brush (column **a**) to see what the actual strokes of the letters looked like when created with a brush.

Some of my attempts were certainly "now," as the examples above show. Too much so as it turned out, so we went back to a version of the original logo, yet one that improved upon the original's inadequacies, drawing-wise.

Whereas I might have concluded the process earlier, in the end, Donald and team supplied a multitude of pertinent and perspicacious critiques that really served to refine the final logo—and helped make me look good!

НИН

a

7Oдина

b

70 ГОНИНА

c

d

Jelena Drobac
Designer
НИН Magazine
Client

And the winner is…Jelena Drobac, with her logo for НИН (*NIN* in the Latin alphabet), a major political magazine in Serbia that organized a special logo contest to commemorate its seventieth anniversary. The existing НИН magazine logo is shown at [**a**]. To me, Drobac's logo proves how cleverly a designer's mind can work when it's not clogged with American fast food.

"The first idea that popped into my head was a little play of words and numbers," Drobac says. "In Serbian, '70 years of НИН' is written as '70 година НИНа.' So I combined letters and the number 70 because of their similarities and created a single word [**b**].

"I did the same thing with the second logo, just welding two words together [**c**]. At this point, I stopped playing with words and concentrated on the numbers. I joined 7 with 0 into a single sign using the magazine's 'corporate' red color and just placed the НИН in the baseline [**d**].

"Since the magazine's layout is similar to that of *Time* magazine with a thick red outline around the cover, I decided to use that concept and place my previous design inside a red background to make it appear stronger and more affirmative."

Indeed, although Drobac's commingling of the negative spaces in *7* and *0* is the real brainstorm here, there is no doubt that reversing out the *7* clinched the deal.

As reported earlier, Drobac's visual identity proposal won the contest and appeared on the first page of every issue for a year, as well as being used in all promotional materials of the magazine during 2005. There's nothing like going out for a croissant, and seeing your logo on every newsstand!

The НИН logo etched in glass and filled, appropriately, with ink.

179

Bob Delevante
Designer

Relay Station
Design Studio

American Roots Publishing
Client

"This client said she wanted an ink bottle for her logo," says designer Bob Delevante. "If a client says 'I would like to see something like *this*,' I'm glad to experiment with it. It's their company, and the logo needs to say what they want it to say. To a large extent, clients hire you because you know how to do this stuff, but on the other hand, you still have to be a conduit for what it is you feel they're trying to get across. Ultimately, this client didn't care for my approach, and we amicably parted ways."

As the company's web site describes, "American Roots Publishing's mission is to preserve and celebrate American culture through literature and art."

"From the start," Delevante says, "I just had this other idea utilizing a pen nib, tree and leaves. I put it together using wood type from the Hatch Showprint company here in Nashville. I've worked with Hatch quite a bit. When I first came to town I wandered into the Hatch poster shop and it blew me away—it was everything I liked. I've since gone in and used their presses a number of times.

"So the type that I used in these American Roots Publishing logos is Hatch wood type. And the beautifully textured wood grain background behind the pen nib and tree resulted from printing the reverse side of the woodblock.

"I loved the combination of the pen nib and tree [Delevante's favorite, in the red-outlined box, upper left] that just seemed to express paper and words and a little company growing. But perhaps I became a little too fond of this idea that unfortunately did not really match the client's vision."

On the following page we'll see how American Roots Publishing finally got its ink bottle—and why.

Wendy Stamberger
Designer
The Stamberger Company
Design Studio
American Roots Publishing
Client

When Wendy Stamberger was first contracted to take over the design of the ARP logo, she listened to owner Tamara Saviano's request that the logo contain an ink bottle and duly agreed to provide that image … along with some other concepts of her own.

Like Bob Delevante's logos on the preceding page, all of Stamberger's roughs successfully evoke an appropriate mood. She has, in essence, brought the company's name to life, creating with type, symbols, and graphic touches a visual milieu that well expresses the company's gestalt.

Naturally, the client's final logo selection was one that contained the requested ink bottle. So the question remains, why the client's obsession with this particular icon? And for the answer we had to ask Saviano herself.

"When I was fifteen years old," she explained, "I first read the series of eight historical novels by John Jakes called *The Kent Family Chronicles* that follows several generations of the Kent family from our nation's beginnings in the Revolutionary War, through the Civil War. And over the last thirty years, I've found myself enjoying these books repeatedly.

"The head of the family, Phillip Kent, starts his own publishing company and its logo is a glass bottle partially filled with loose tea leaves salvaged from Phillip's shoes following the Boston Tea Party. That symbolic image—which was never actually shown in the books—has always stayed with me.

"When I founded American Roots Publishing, I wanted to create that logo that I have imagined all these years. It seemed fitting to our mission of our organization."

The moral to this story may be that we designers know design, but our clients know their markets and their minds.

MORGAN ROAD

Eric Baker / Eric Strohl
Designer

Eric Baker Design Associates, Inc.
Design Studio

Morgan Road Books
Client

MORGAN ROAD BOOKS

MORGAN ROAD BOOKS

MORGAN
ROAD

a

MORGAN ROAD BOOKS

MORGAN ROAD BOOKS

"**We wanted a spiritual connotation of a quest.** Not too New-Agey or religious though," Eric Baker says. "We were told that Morgan Road is a fictitious destination; a pleasant-sounding place, and that the road would go to different places in terms of publishing and new avenues of understanding."

It's not surprising then that Morgan Road, an imprint of Random House, publishes books by the likes of the Dalai Lama, books involving "established traditions made relevant and practical."

"That concept went along with a kind of a medieval or never ending knot, or infinity," Baker says. "We were inspired by a book of Eastern symbology that had such images as the hand of Buddah [a] and using this book, we tried to find keys to move off of.

"The final idea came from Eric Strohl, or 'logo boy' as we used to call him, an awesome designer who could take any crude sketch I might give him and turn it into a gem."

I asked Baker about his dealings with this client, and he replied, "Whenever a client hires somebody, it is a leap of faith, and it goes quicker when the client has confidence in you and does not micromanage. It was Mies van der Rohe who said, 'Great architects don't create great buildings, great clients allow great buildings to be built.'

"We gave Amy Hertz, the publisher of Morgan Road, just one presentation, and she was one of the most open and engaging clients. Still, we liked the knotted *M* mark best, but we didn't think she and her people would pick it, and we were most gratified when they did."

And why not—it's not only perfect, but utterly brilliant.

Eric Baker / Eric Strohl
Designer

Eric Baker Design Associates, Inc.
Design Studio

Gotham Books
Client

"Out our window is the Empire State Building, facing us," Eric Baker says from his office in Manhattan. "You can't help being affected by that. Boom! It's right there."

Certainly, when you think of "Gotham," you think of skyscrapers. And the eventual logo for Gotham Books, an imprint of the Penguin Group, USA, ended up evoking the most famous skyscraper of all time.

"A mark for a publisher must have what we call 'legs' to stand on for a long period of time," Baker says, "but at the same time have a contemporary look. Also, with publishing marks, I think it's important to note that, generally, you're designing a mark that is to be used very small on the spine of a book, which could be only one-half inch wide, meaning the logo must be readable at one-quarter of an inch.

"When we start a logo, we always try to key off the name, as far as what immediate visuals are suggested. If applicable, I'll even look for a dictionary definition of the word and try to be informed both by its meaning and context.

"For the Gotham logo, we were inspired by many images we saw out our window, such as the water tower, the street sign, and the skyline itself.

"Of course, there is the cliché of the book image—but you can still do something original with it. And we found that by combining the classic, open book with a skyscraper we'd created something unique."

And therein lay a problem, as well. The client's lawyers were concerned about the similarity in shape to the Empire State Building. "So we had to make a few modifications to satisfy them," Baker says, "but the end result is a dramatic image that almost literally communicates: 'Gotham Books.'"

183

a b c

Leslie Cabarga
Designer

Michael Grossman
Creative Director

Absolute Publishing
Client

The Absolute logo in use.
Art Director: Deanna Lowe

184

Logo design might be broken down into stages: There's the fishing stage [columns **a** and **b**] in which, having acquired client input, you play with various random ideas with the hope that one of them will click. In this case, my assignment was a logo for a new magazine aimed at upscale New Yorkers. It's so exclusive, I'm not sure you can even purchase a copy in New Jersey.

Then there's the second stage of logo development where the client sends you back to the drawing board to refine the comp he liked most. Sometimes, of course, the second stage is where the client hates everything you've done, and you feel like a complete idiot even though, really, the most carefully-prepared brief or client interview cannot necessarily verbalize the visual in its myriad manifestations.

But usually, the outer limits of what is possible boils down to the very group of comps you've presented, limiting further solutions to your designs within that group.

So next there's the stage where the client is almost happy but wants you to try some different approaches to various letters—such as the flourish at the beginning of the *A* and the style of the ascender tops [column **c**].

Finally, there's the stage where the job is accepted: it's all over and all those daily, friendly calls; those chatty weekend calls between you and the client cease, and you feel somehow jilted. You wonder if you gave too much, too soon. Were you or your sketches too "loose?" Were you respected for your own self, or just for your typography? And, the only kind of closure you can get is when the first issue hits the stands, and you get to caress its glossy pages in your greedy little hands. Not that I'm saying that happened to me.

a

Alejandro Agois
Designer
Que! Productions
Client

With simple logos, it's choosing the right type that makes all the difference. In Alejandro Agois' first attempts (row **a**) for Que, a large media group in Peru, the choice of fonts has yielded unimpressive results. Yet, in the final logo and symbol) there is a sense of excitement, and the feeling that *this* is a logo.

"The logo for Que was commissioned by a company that wanted to brand a new multimedia project that used all of its information and news resources," Agois says.

"The client had two specifications before the logo design began: It had to be readable both on print and online media, and it had to be flat red! The solution to me seemed pretty clear: A simple yet strong typographic logo.

"I suggested a number of different typefaces to them. Then they suggested some 'nice letters that we printed out in a Word document for you.' After telling them very politely that I would take them into consideration, I came up with a number of round logos which they liked very much.

"It seemed my work was done when they finally chose one of the logos, but two days later a very large telecom company entered the market with a strikingly similar round red logo, so unfortunately ours had to go.

"The final version of the logo ended up being what we were looking for in the beginning. It also incorporated both an exclamation mark as well as an accent on the letter *e* (the correct Spanish spelling). I also produced a round version, but this time only with the "Q!" because they really liked the round logos."

I love them, too. They have that indefinable Latin spirit.

185

ATLAS
BOOKS

ATLAS BOOKS

ATLAS BOOKS

ATLAS BOOKS

ATLAS BOOKS

ATLAS BOOKS

Eric Baker / Eric Strohl
Designer

Eric Baker Design Associates, Inc.
Design Studio

Atlas Books
Client

The New York publishing world is a small one, and the players tend to know one another. For this reason, Eric Baker, head of Eric Baker Design Associates, stresses the importance of building client relationships.

Case in point: "A number of years ago," Baker recalls, "we bid on a project we didn't get, but afterwards, I sent the publisher a scrapbook we'd prepared containing a visual survey of historic publishing logos. I think he was very taken that I would offer that, having not been given the job.

"Four years later, he left to start a new imprint division, and he called us for the logo. Not only that, but six months later, he referred us to James Atlas of Atlas Books.

"Atlas Books publishes very serious books on history, business and on eminent mathematicians, scientists and so forth. We started out depicting Atlas hoisting the earth, but that was too cliché, so we looked at maps and navigational symbols to instill the idea of charting a new direction. The final logo ended up being a very simple image of a sextant that was also suggestive of an initial *A*."

I asked Baker how he achieves what I consider to be a "timeless elegance" in his designs, but he rejected the idea.

"It all comes down to a very visceral reaction," Baker says. "It's either 'I like it' or 'I don't like it;' 'It works' or 'It doesn't work.' But I think you can say that simpler is always better than complex. Good design is often a very reductive process of taking away extraneous elements. As Paul Rand said, 'Design is so simple, that's why it is so complicated.' In a logo you're trying to get down to the essence of things."

There will always be trendy logos that wow us, but there'll also always be room for new classics, like Atlas Books.

Secret Directory of Contributors

700Gramos
Pages 70, 109
Raúl Santos
Madrid, Spain
Tel. (0034) 91 434 17 35
email: raul@700gramos.com
www.700gramos.com

Akins Parker Creative
Pages 37, 103
Jeff Parker
Costa Mesa, CA USA
Tel. (714) 754-1264
email: jeff@akinsparker.com
www.akinsparker.com

Alejandro Agois
Page 185
Alejandro Agois
Lima, Peru
email: aagois@epensa.com.pe

American Design Language
Page 145
Stacey Geller
Brooklyn, NY USA
Tel. (718) 965-9194
email: stacey@adlhq.com
www.adlhq.com

Archrival
Page 90
Joel Kreutzer
Lincoln, NE USA
Tel. (402) 435-2525
email: info@archrival.com
www.archrival.com

Astro Studios
Pages 17, 158, 159
Ian Myles
San Francisco, CA USA
Tel. (415) 487-6787
email: info@astrostudios.com
www.astrostudios.com

Jill Bell Design & Lettering
Pages 166-167
Jill Bell
Kansas City, MO / Los Angeles, CA USA
Tel. (913) 649-4505
email: jill@jillbell.com
www.jillbell.com

Bison Design
Page 152
Alexander Fjelldal
Oslo, Norway
Tel. +47 22362224
email: post@bisondesign.no
www.bisondesign.no

BlackDog
Pages 69, 112, 113, 176
Mark Fox
California USA
email: mfox@blackdog.com
www.blackdog.com

Bloomington Design
Page 146
Gary Anderson
Bloomington, IN USA
Tel. (812) 332-2033
email: rhinoart@insightbb.com

Michaelle Boetger Graphic Designs
Page 88
Michaelle Boetger
Decorah, IA USA
Tel. (563) 387-0978
email: mbdesigns@mbdesignsiowa.com
www.mbdesignsiowa.com

Breath of Fresh Air
Pages 44, 45, 75, 153
Andrew Wright
Pretoria, South Africa
Tel. +27 (0) 72 436 1213
email: andrew@bofagroup.com
www.bofagroup.com

Brook Group LTD
Pages 126, 127, 168
Kara Brook
Ellicott City, MD USA
Tel. (410) 465-7805
email: nfo@brookgroup.com
www.brookgroup.com

BuzzBizz Studios
Page 137
Anchorage, AK USA
Tel. (907) 272-2899
email: wilette@buzzbizz.biz
www.buzzbizz.biz

Leslie Cabarga
Pages 28, 41, 65, 118, 119, 178, 184
Leslie Cabarga
Los Angeles, CA USA
Tel. (323) 549-0700
email: lescab@flashfonts.com
www.flashfonts.com
www.logofontandlettering.com

Carol King Design
Page 31
Carol King
Brooklyn, NY USA
Tel. (646) 337-7062
email: cbking@mac.com
www.carolkingdesign.com

Karen Charatan Lettering & Design
Pages 84-85
Karen Charatan
Montvale, NJ USA
Tel. (201) 930-9608
email: karen@karencharatan.com
www.karencharatan.com

Chase Design Group
Pages 20-21
Margo Chase
Los Angeles, CA USA
Tel. (323) 668-1055
email: margo@chasedesigngroup.com
www.chasedesigngroup.com

Krista Cojocar
Page 77
Krista Cojocar
Macomb, MI USA
email: kcojocar@gmail.com

Contusion Design
Pages 54-55
Jaimie Muelhausen
Vista, CA USA
Tel. (949) 500-4583
email: jaimie@contusion.com
www.contusion.com

Design Elements, Inc.
Pages 29, 68, 142
Sara Pickering
Seattle, WA USA
Tel. (206) 281-4004
email: info@deicreative.com
www.deicreative.com

Designiq
Pages 61, 86
Filip Blažek
Prague, Czech Republic
Tel. +420 283 871 781
email: studio@designiq.cz
www.designiq.cz

Device
Pages 50, 51, 52, 58-59
Rian Hughes
London UK
Tel. from UK: 0208-896-0626
Tel. from US: 347-535-0626
email: rian@rianhughes.com
www.devicefonts.co.uk

Dotzero Design
pages 46, 124, 170
Jon Wippich / Karen Wippich
Portland, OR USA
Tel. (503) 892-9262
email: jonw@dotzerodesign.com
www.dotzerodesign.com

Eisbrenner Public Relations
Pages 136, 165
Nathan Rowe
Troy, MI USA
Tel. (248) 641-1446
email: nrowe@eisbrenner.com
www.eisbrenner.com

Eric Baker Design Associates, Inc.
Pages 182, 183, 186
Eric Baker
New York, NY USA
Tel. (212) 598-9111
email: eric@ericbakerdesign.com
www.ericbakerdesign.com

The Felt Hat
Page 14
Paul Mort
Portland, OR USA
Tel. (503) 223-6782
email: mort@felthat.com
www.felthat.com

Mark S. Fisher
Page 33
Mark S. Fisher
Lowell, MA USA
Tel. (978) 452-0977
email: fisherm6@verizon.net
www.marksfisher.com

Glitschka Studios
Page 23
Von R. Glitschka
Salem, OR USA
Tel. (971) 223-6143
email: von@glitschka.com
www.glitschka.com

Hoffmann Angelic Design
Pages 111, 114, 115, 132
Andrea Hoffmann / Ivan Angelic
White Rock, BC Canada
Tel. (604) 535-8551
email: contactus@hoffmann-angelic.com
www.hoffmann-angelic.com

Inertia Graphics
Pages 34, 89
Jeremy Bohner
Hagerstown, MD USA
Toll free tel. (866) 577-0842
email: info@inertia-graphics.com
www.inertia-graphics.com

J H I
Pages 43, 62-63, 169
John Homs
Richmond, VA USA
Tel. (804) 340-5200
email: johnhoms@jhigoodidea.com
www.jhigoodidea.com

Jelena Drobac IdeaShop
Pages 22, 140, 141, 179
Jelena Drobac
Belgrade, Serbia
Tel. +381 11 30 96 972
email: ideashop@verat.net
www.d-ideashop.com

Doreen Kennedy
Page 144
Doreen Kennedy
Dublin, Ireland
Tel. +353 87 2843177
email: doreenkennedy@yahoo.co.uk
www.doreenkennedy.com

Logo Works
Pages 32, 102
Brad Kopelson
Lindon, UT USA
Toll free tel. (800) 210-7650
email: brad@logoworks.com
www.logoworks.com

Master Promo
Pages 66, 67
Marcos Minini
Curitiba, Brazil
Tel. 55 (41) 3029-5080
email: marcos.minin@master.com.br
www.master.com.br

Matchstic
Pages 48, 49, 64
Craig Johnson
Atlanta, GA USA
Tel. (404) 446-1517
email: info@matchstic.com
www.matchstic.com

Mattson Creative
Pages 106, 107, 122, 123
Ty Mattson
Irvine, CA USA
Tel. (949) 936-2555
email: info@mattsoncreative.com
www.mattsoncreative.com

theMechanism, llc
Pages 116, 154, 161
Dave Fletcher
New York, NY USA
Tel. (212) 404-3150
email: dave.fletcher@themechanism.com
www.themechanism.com

Michael Doret Graphic Design
Pages 56, 97
Michael Doret
Hollywood, CA USA
Tel. (323) 467-1900
email: michael@michaeldoret.com
www.michaeldoret.com

Michael Samuel Graphics
Pages 82, 83, 133
Michael Samuel
New York, NY USA
Tel. (212) 722-8125
logosam@earthlink.net
www.mikesamuelgraphics.com

Mirekulous Graphics
Pages 96, 177
Mirek Janczur
Albany, NY USA
Tel. (518) 456-3738
email: mirekulous@hotmail.com
www.mirekulous.com

Murillo Design
Pages 80, 81, 91, 173
Roland Murillo
San Antonio, TX USA
Tel. (210) 215-8789
email: ideas@murillodesign.com
www.murillodesign.com

Natoof.com
Page 108
Mariam bin Natoof
Dubai, UAE
Tel. +971 50 8789980
email: mariam@natoof.com
www.natoof.com

New Level Design
Pages 16, 163
Tobin Dorn / Isabella Dorn
Curitiba, Brazil
Tel. 55 (41) 3336-2324
email: tobin@newleveldesign.com.br
www.newleveldesign.com.br

p9
Pages 150, 151
Denise Spirito
Edgewater, NJ USA
Tel. (201) 313-9522
email: spirito@p9design.com
www.p9design.com

p11creative
Pages 106, 123, 128, 129, 143, 156
Lance Huante
Santa Ana Heights, CA USA
Tel. (714) 641-2090
email: info@p11.com
www.p11.com

Paragraphs
Page 117
Gretchen Norman
Chicago, IL USA
Tel. (312) 327-9032
email: gnorman@paragraphs.com
www.paragraphs.com

Polaris Construction, LLC.
Pages 120, 121
Trish Schaefer
Phoenix, AZ USA
Tel. (602) 437-9589
email: trish@nogaproperties.com
www.polarisconstruction.net

Raidy Printing Group SAL
Page 60
Marie-Joe Raidy
Beirut, Lebanon
Tel. +9613234411
email: mj@raidy.com
www.raidy.com

Relay Station
Pages 27, 157, 180
Bob Delevante
Nashville, TN USA
Tel. (615) 400-0296
email: bob@relaystation.tv
www.relaystation.tv

Claudia Renzi
Pages 40, 92, 93, 117
Claudia Renzi
Chicago, IL USA
Tel. (312) 296-7734
email: crenzi@sbcglobal.net
www.claudiarenzi.com

Retna Media, Inc.
Pages 47, 53
Fritz Colinet
Houston, TX USA
Tel. (917) 686-0502
email: fritz@retnamedia.com
www.retnamedia.com

Ricksticks Inc.
Pages 36, 95, 138, 139
Rick Sato
Toronto, Ontario Canada
Tel. (416) 782-5319
email: info@ricksticks.com
www.ricksticks.com

Rod Dyer International
Pages 97, 100, 110
Rod Dyer
West Hollywood, CA USA
Tel. (310) 652-2670
email: info@roddyerinternational.com
www.roddyerinternational.com

Snap Creative
Pages 18, 19, 101, 162
Shirley Hill
St. Charles, MO USA
Tel. (636) 949-8686
email: shill@thesnapgroup.com
www.snap-creative.com

Felix Sockwell
Pages 130-131
Felix Sockwell
Maplewood, NJ USA
email: felix@felixsockwell.com
www.felixsockwell.com

The Stamberger Company
Pages 42, 125, 181
Wendy Stamberger
Nashville, TN USA
Tel. (615) 292-7582
email: stamco@bellsouth.net

Stephanie Lucas Creative
Page 171
Stephanie Lucas
Fremont, CA USA
Tel. (510) 325-1164
email: stephanie-r-lucas@hotmail.com

Tactix Creative
Pages 15, 71, 74, 94
Paul Howalt
Mesa, AZ USA
Tel. (480) 225-1480
email: mail@tactixcreative.com
www.tactixcreative.com

Tim Frame Design
Pages 30, 147, 155
Tim Frame
Cedarville, OH USA
Tel. (614) 598-0113
email: tframe@timframe.com
www.timframe.com

Todd Rosenthal Design
Pages 87, 160
Todd Rosenthal
Elk Grove, CA USA
Tel. (916) 714-8991
email: info@t-rodesign.com
www.t-rodesign.com

Joe Turner
Page 172
Joe Turner
Edmond, OK USA
Tel. (405) 706-6201
email: joefeenus@turnerart.com
www.turnerart.com

Tyson Mangelsdorf Illustration
Pages 35, 99, 164
Tyson Mangelsdorf
Portland, OR USA
Tel. (503) 579-5997
email: tyson@pixelgarden.com
www.pixelgarden.com

Up Design Bureau
Pages 26, 78, 79, 98
Chris Parks
Wichita, Kansas USA
Tel. (316) 267-1546
email: cp@updesignbureau.com
www.updesignbureau.com/

Yantra Design Group
Page 76
Patsy Balacchi
Miami, FL USA
Tel. (786) 262-6362
email: info@yantradg.com
www.yantradg.com

Brian Zick
Pages 24-25, 57
Brian Zick
Los Angeles, CA USA
Tel. (323) 876-0402
email: zick@brianzick.com
www.brianzick.com